Photo Nomad

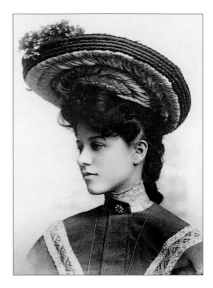

dedicated
to
My First Heroes

Mother in Paris, 1906
(secret) xxxx - 1976

Kenneth Stockwell Duncan -- Florence Watson Duncan

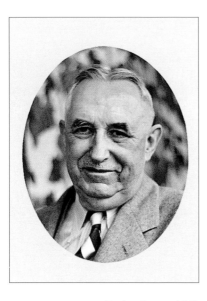

Dad at home, 1952
1880 - 1953

Kansas City to Everywhere
Memories -- Memories

Lindbergh had just flown alone across the Atlantic Ocean to Paris.

The Great Depression was paralyzing countries everywhere.

At home, my father and mother never once spoke of lost family resources – with their five children around the dinner table unaware of reality.

My daydreams were of pyramid explorers, deepsea diving zoologists, world champion prizefighters and of finding the fabled emerald Incan statuette-idols -- hidden centuries ago by looting Spanish *conquistadores*.

Photography?
There wasn't a camera in the house -- not even a Box Brownie Kodak.
That came later.

I kept dreaming of desert sunsets . . . boundless oceans -- other worlds.

Until I got there.

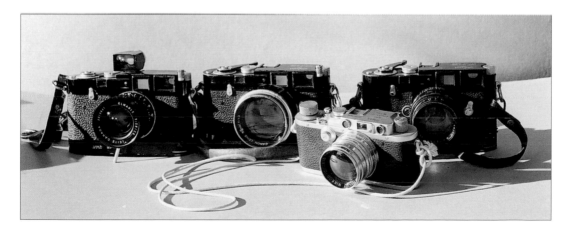

(foreground): My Leica F with the F1.5 Nikon/Nikkor 35mm lens that was used in the 1950 Korean War, the birthyear of Nikon's acclaim.

Three custombuilt Leica M3Ds with the Leitz and Canon lenses used to photograph Picasso painting and his intimate family relationships.

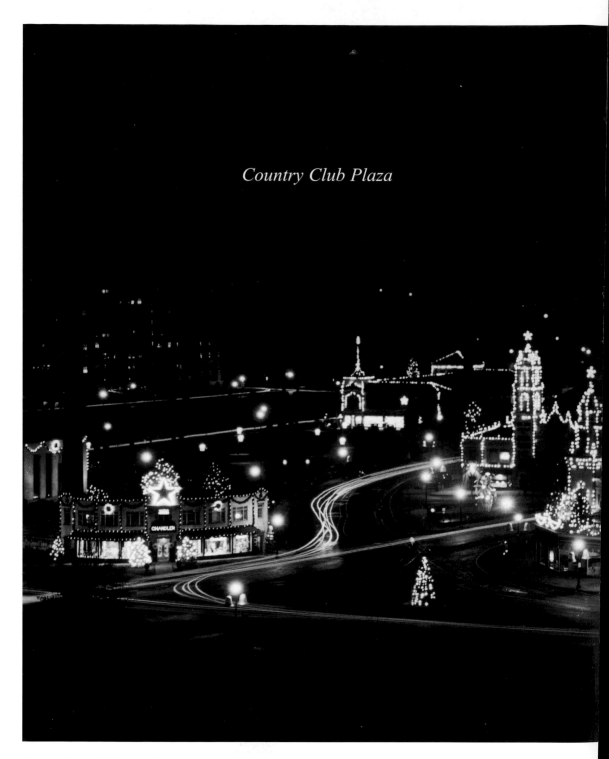

Country Club Plaza

Kansas City -- 1936 -- my hometown.

Thanksgiving - Christmas - New Year's Eve

Holiday lights almost unchanged today.

Introduction

Five gifts blessed my life as a photojournalist:

the eyes of a born-nomad forever searching far horizons --

those 3-Ds of my now decades-old byline --

a $0.39 eighteenth-birthday camera from my little sister --

my constantly faithful star . . . my lucky star --

arriving on this Earth into a love-secured caring family.

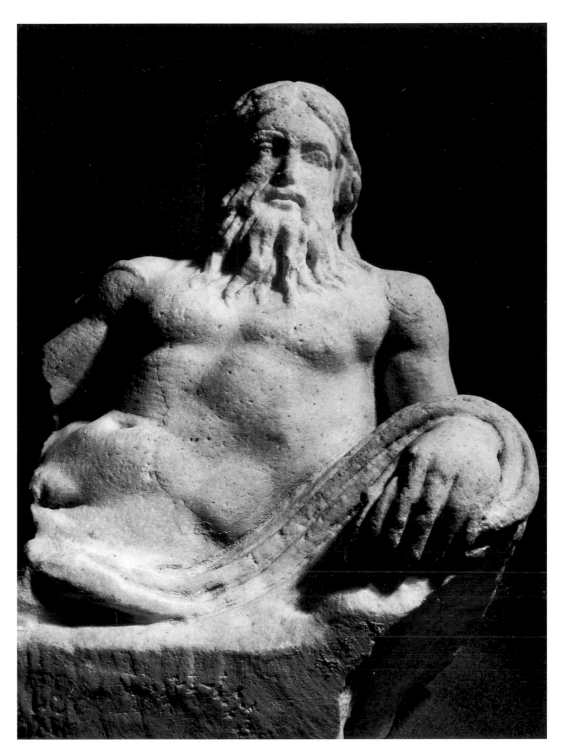

Poseidon or Neptune
Greek 1st-century A.D.

Sculpture found in Bosphorus,
on 1946 Turkish army story.

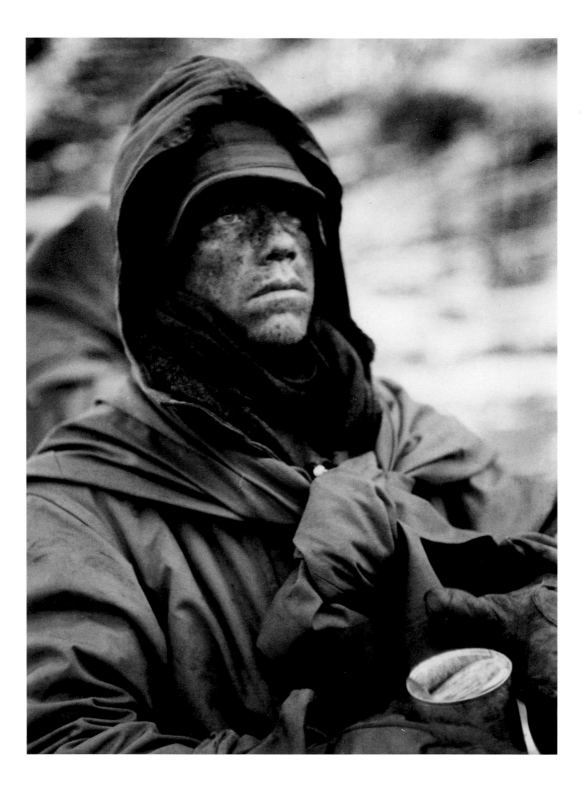

Manchurian
winds unknown to most mortals
never – forgiving
hurricane ferocity
(chill factor unknown)
– 40 F.

Somewhere South
of
The Yalu River
North Korea
9 December 1950 . . . dawn

I asked the rigid Marine

(age also unknown)
teenager or grandfather

the
Question
idiotic or sacrilegious
under normal circumstances
quite normal there.

IF
I were God
what would you want
for Christmas?

His answer took almost forever

"Give me Tomorrow"

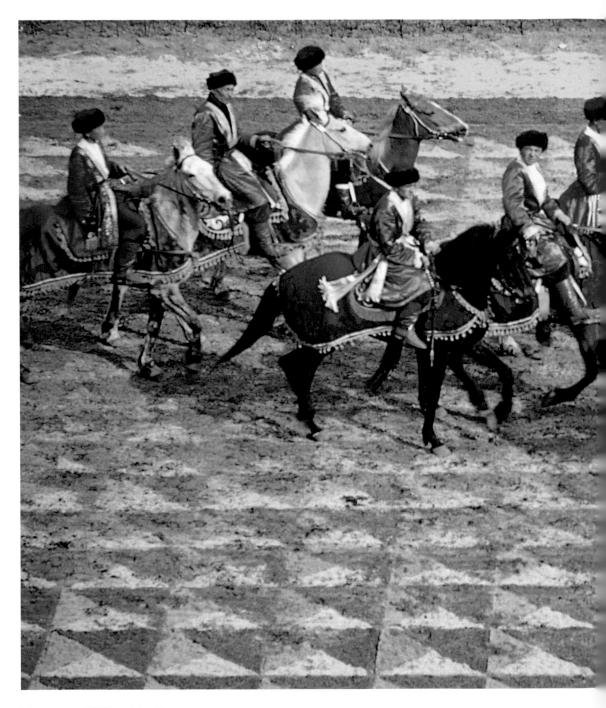

Moscow . . . 1958 . . . May Day.

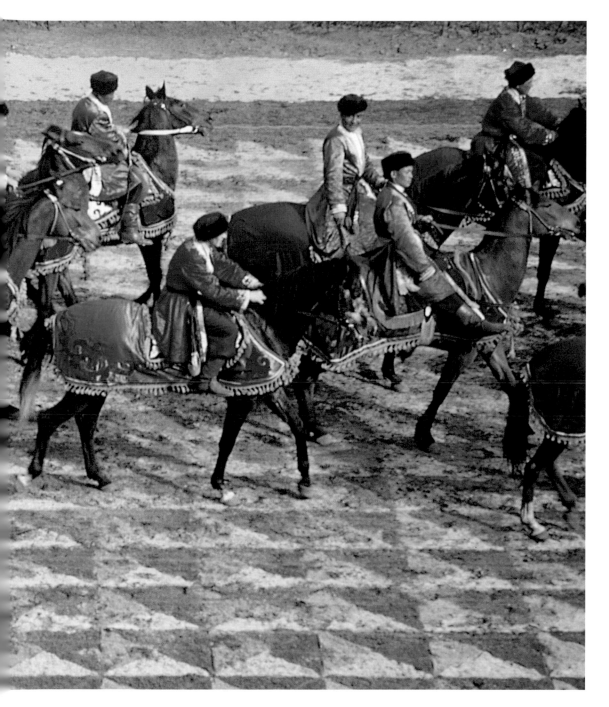

Racetrack of Painted Sand.

Now -- looking back – all so normal! War photographer colleague Bob Capa said he'd introduce us -- killed in Indochina -- so had double reason to say hello: my welcome would be eternal.

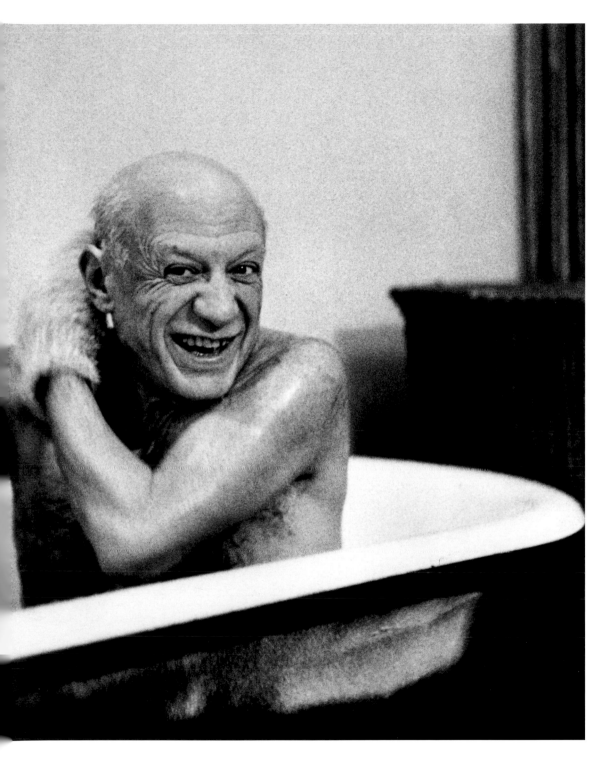

First shot of soon thousands, *Villa la Californie*, Cannes, France, 8 February 1956.
Jacqueline, Claude, Paloma, bullfighters, poets, other artists -- a galaxy once seen, now gone.

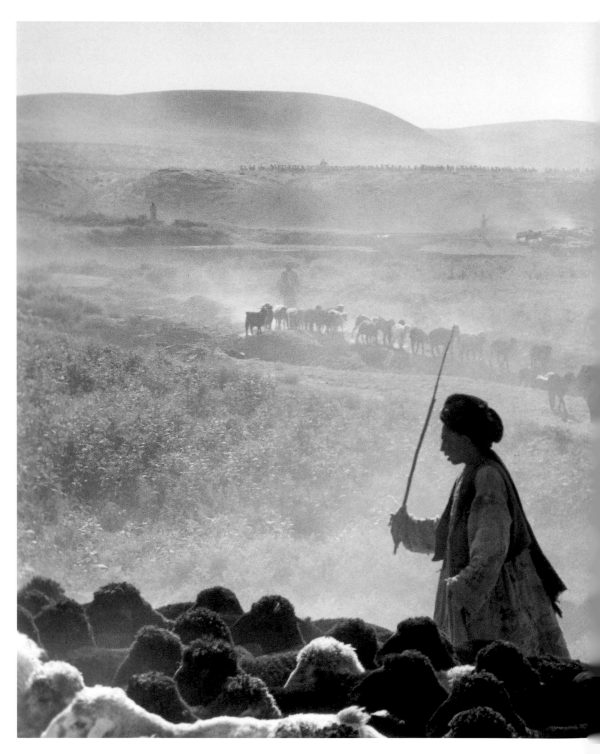

Desert Requiem for Shepherds

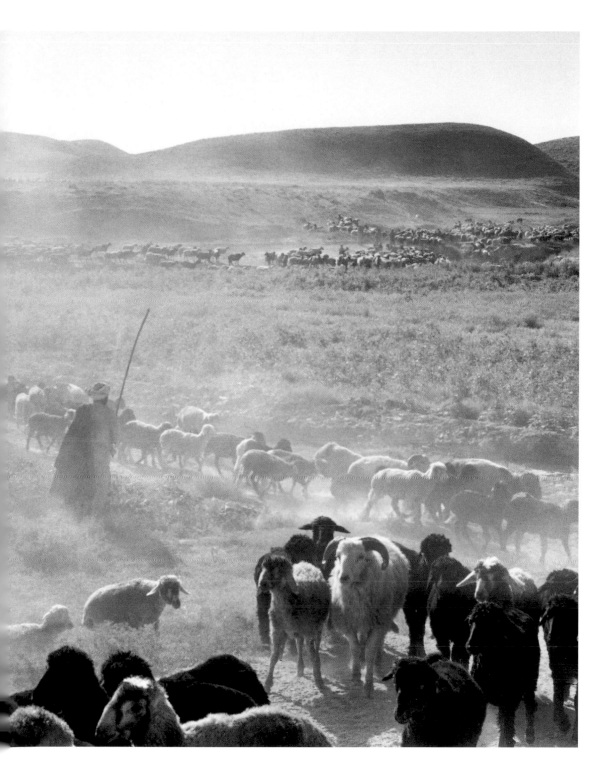

Afghanistan -- 1955 -- Peacetime

15

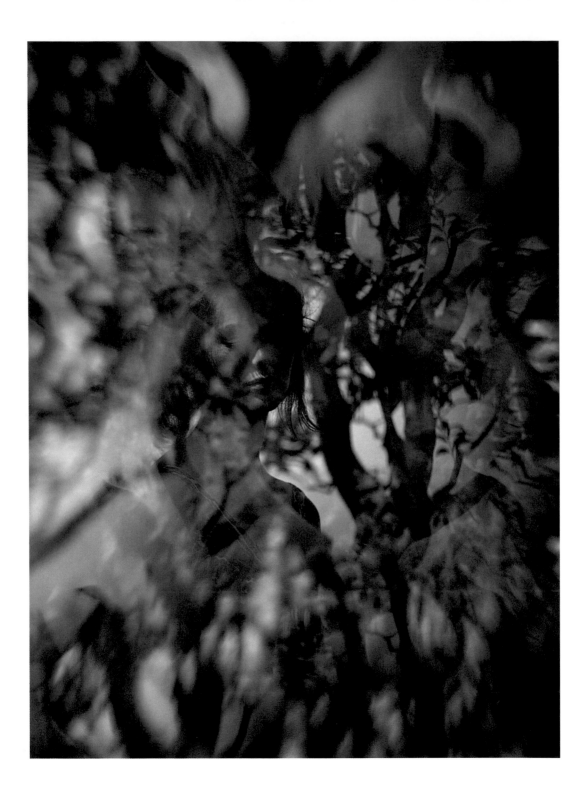

Visions
of
Another Paris

Picasso
pointed to my camera:
"Ishmael --
your problem is there!
Sometime do them your way."
So I flew to Berlin -- Astro --
modified some fancy movie gear
of spinning cogs and prisms
made a contraption
named it "Bazooka" aimed at
Les Invalides -- tried to evoke
memories and majesty then
focused on Maria Cooper Gary's
in-mourning daughter to etherealize
heartbreak.

I thanked Picasso
for giving me another language
still beyond my skills
but I hoped
one day to master.

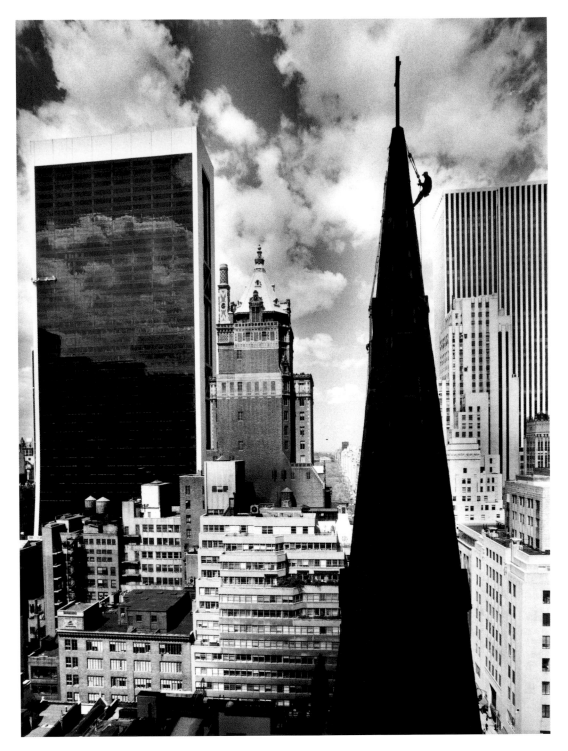

Steeplejack Andrew F. Collins high
above New York on 9th May 1975.

100th Anniversary of Fifth Avenue,
Presbyterian Church on 11th May.

Alone

Another World
in
His Eyes

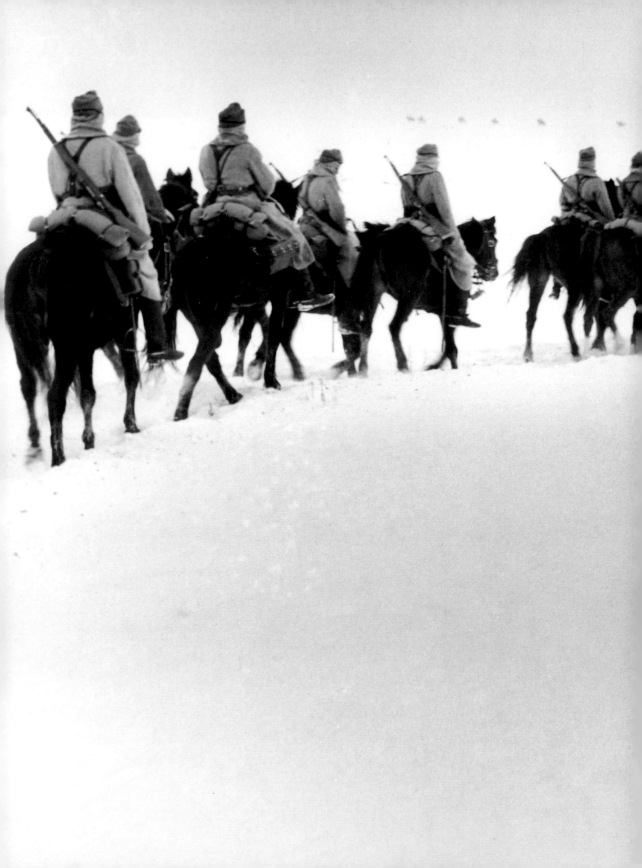

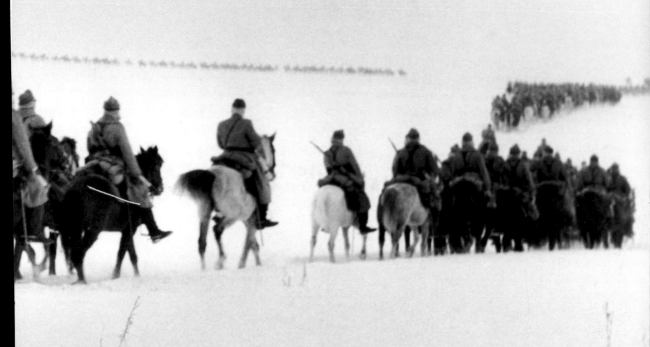

Photo Nomad

David Douglas Duncan

W.W. Norton & Company
New-York - London

Photo Nomad
David Douglas Duncan

Design Computer Control
Franck Follet
Antibes - France

Copyright 2003 by David Douglas Duncan

Manufacturing by Mondadori Printing, Verona, Italy
Book design and composition by David Douglas Duncan

ISBN: 0-393-05861-1

Library of Congress Cataloging-in-Publication Data
Duncan, David Douglas.
Photo Nomad / David Douglas Duncan.
p. cm.
ISBN: 0-393-05861-1
1. Duncan, David Douglas. 2. Photography, Artistic.
3. Photojournalism. I. Title.

TR654.D86 2003
779'.092 – dc21 2003056156

W.W. Norton & Company, 500 Fifth Avenue, New York, NY 10110
www.wwnorton.com

W.W. Norton & Company Ltd., Castle House
75/76 Wells Street, London, WIT 3QT

1 2 3 4 5 6 7 8 9 0

In Appreciation

Normally, a page such as this involves "Thank you" words of gratitude and the names of esteemed contributors to the book. The extent of my gratitude is wide and complex. The evolution of this book, far from normal, might have stymied old Darwin himself had he been in publishing – or geology, peering at strata of correspondence searching for contracts, wondering how it all began. I could have saved him countless hours. There is no contract and my final line of copy must be sent to the Mondadori presses in Verona (Romeo and Juliet's hometown) *now!*

This picto-book's odyssey began fifteen years ago in Germany at the International Book Fair. I was showing my first design layout (dummy) to John Baker of *Publishers Weekly*, the universal trade journal. Today, thirty-four dummies later, Baker must feel like *Nomad's* godfather, having followed every stage of its life. During mid-journey it was once under contract with Benedikt Taschen, the blockbuster German publisher, with a $100,000 advance – returned, contract canceled by mutual agreement when I decided I wanted to switch from coffee-table format to standard book size: an attempted assault on that vast audience now dominated by bio-historical authors exemplified by data-to-drama David McCullough and books like his *John Adams*. I felt that a world photo-biography of my century might have a chance if handheld, on planes, in bed – *anyplace!* I next turned to National Geographic Books, having sold my first-ever magazine story (1938 and included here) to Dr. Gilbert Grosvenor, himself, founder of the magazine. That contract lasted until 9/11, when the book market went into a tailspin like so much of our world, National Geographic Book's division editor Kevin Mulroy tested the breeze in his office, decided to go for 2004 – that contract went out on the breeze.

Photo Nomad is now with old friends at Norton, where I had published earlier books. No contract – phoned agreement – it'll come sometime. And Mondadori of Verona? My faxed order for $240,000 worth of *Nomads* soon left technical director Enrico Battei almost floundering in color proofs; production manager Giuliano Pacchera, computer-shifting always crisis-confronted worldwide clients, while meeting their fixed schedules; and Barbara Bonfanti, costs expert, striving to save me pennies with my dollar falling against their new euro – without a signed contract.

That left Franck Follet – Black Belt judo champion, lyrical (also wild) photographer-friend who Nikoned my ransom-confrontation with Marseille gangsters when little Yo-Yo was found — concentrating on endless text and layout problems with this book after grinding days programming his own assignments, which left him nearly sleepless night-after-night hitting *my* deadlines. My next book, professor Darwin . . . *The Geology of Friendship*.

13 July 2003, Castellaras, France D.D.D.

My 20th Century

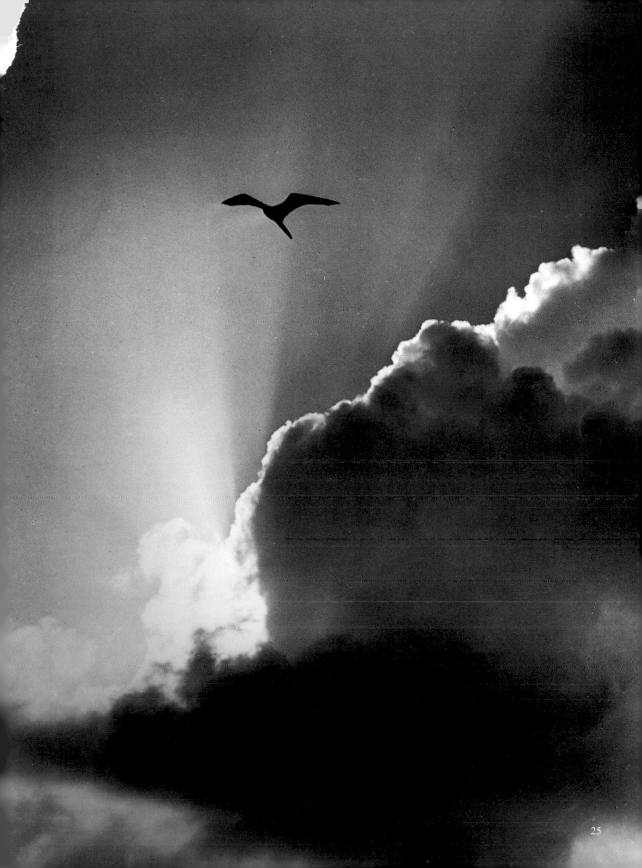

One life

Contents

1934 Mexico

1939 Yucatàn

A Father's Legacy

Preface

My father had saved every letter and snapshot sent home by a young vagabond who never would have recognized himself later -- a man with cameras mostly focused

1938 Missouri

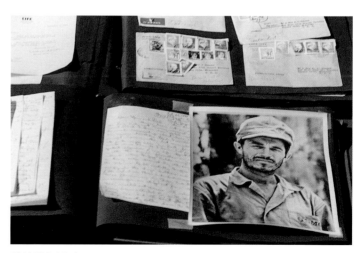

1944 U.S. Marines Solomon Islands

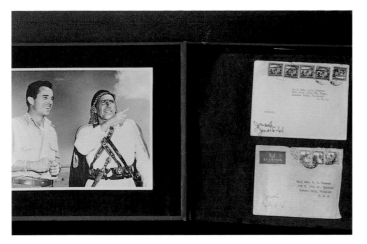

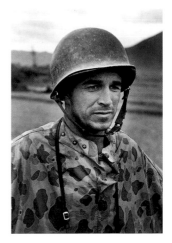

1946 Palestine

1950 Korea

In a Family Attic

on faces, grand adventures and violence, recording a kaleidoscopic journey through much of his century . . . seen once again, today, as if only yesterday.

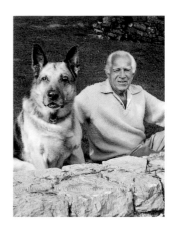

Thor 1980 France

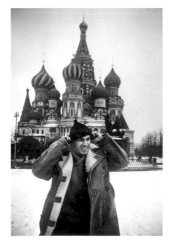

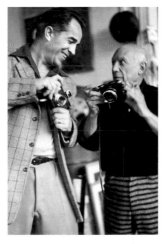

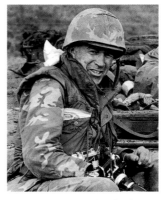

1956 Moscow

1957 Picasso

1967-68 Vietnam

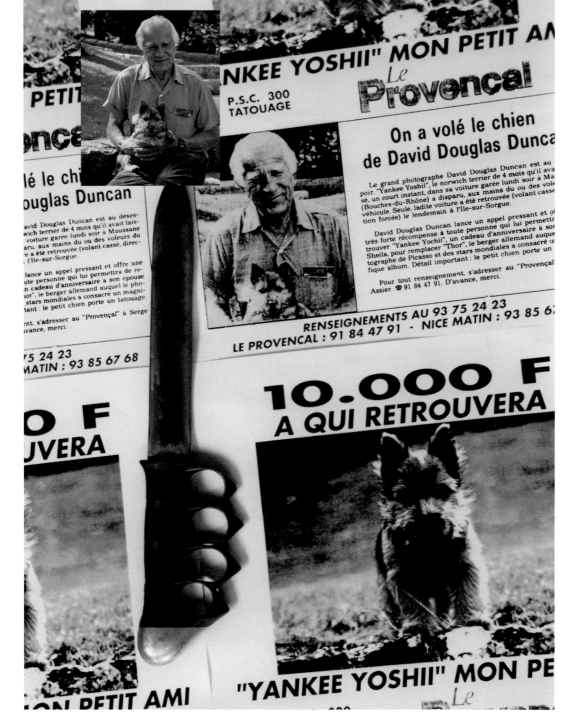

$2000 reward for Yo-Yo / my wartime fighting knife. Marseille's *Provençal* interview Yo / DDD as a poster.

The Saga of Yo-Yo Kidnapped in Provence

Childhood friends from Kansas City were walking through Van Gogh's France -- a dinner invitation among Roman ruins near St. Rémy, no tourists, off-season tranquillity . . . nobody -- except invisible lock-breaking shadow-silent Marseille's - notorious "Black Gypsy" carjacking professionals who earlier spotted our new Audi station wagon, rolled it in a flash and were gone … not aware that they had also heisted the only eyewitness of their crime -- a sleepy, already wild tiny character who would have opened every door if possible when he was awakened, because he was -- *Yo Yo!*

Those hoods had targeted the wrong man … who also worked fast.

Everything as a Marine combat-veteran-photojournalist with worldwide colleagues in the editors' chairs of newspapers, magazines and television networks came into instant focus and made me appreciate the firepower of my profession, ready to fight for five pounds of three-months-old untamed joy.

First photo/two months old. He bit me.

Preface

Born a Norwich terrier but more
furry little bumblebee on over-
size bear paws, with license-
plate - ID - numbers tattooed on
his always demanding stomach,
Yo took over the house/us from
his day of arrival -- but so tiny!
Like giant Thor, beneath his tree.

My War for Yo-Yo Was Fought by Friends

Serge Assier, chief photographer at Marseille's *Provençal*, ran Yo's story through his art-page editor pal as a heart-twister involving a friend of Picasso. Franck Follet, our nearby Black Belt judo champion recently of the army, an avid amateur photographer and digital computer expert, made Assier's story into a YO-YO WANTED poster with that huge ransom (in anyone's currency) bold type . . . Wild West -- Jesse James style.

British-French-Australian neighbors, Audrey Billam and son Bobby -- Babba, their lady-of-a-certain-age Norwich on one arm -- necklaced Provence with Franck's posters, even on Arles' Roman arena next to those of Gypsy guitar festivals! Lucien Clergue — Arles' hometown photo-hero (founder of its world-attended annual camera conference), born with the nearby Camargue Gypsy world accepting him as one of their own -- introduced me to the famed mother of even more famous sons, "The Gypsy Kings" guitar superstars.

Clementine Reyes (Kings), listened to Clergue without a word, took my posters, handed them to her grandchildren to start pasting-up, turned to me, a warning -- "There are Black Gypsies … they have Yo-Yo. We are White Gypsies. Your posters will be seen *everywhere!*" Then Lucien Clergue hugged her, the children … returned home smiling to himself.

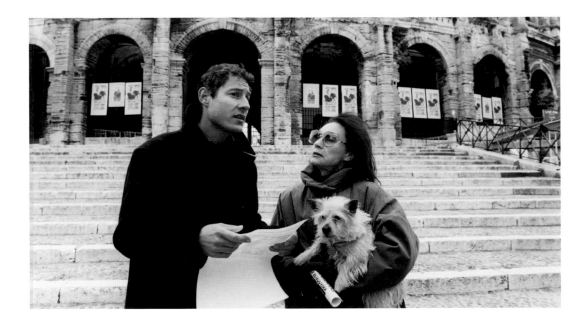

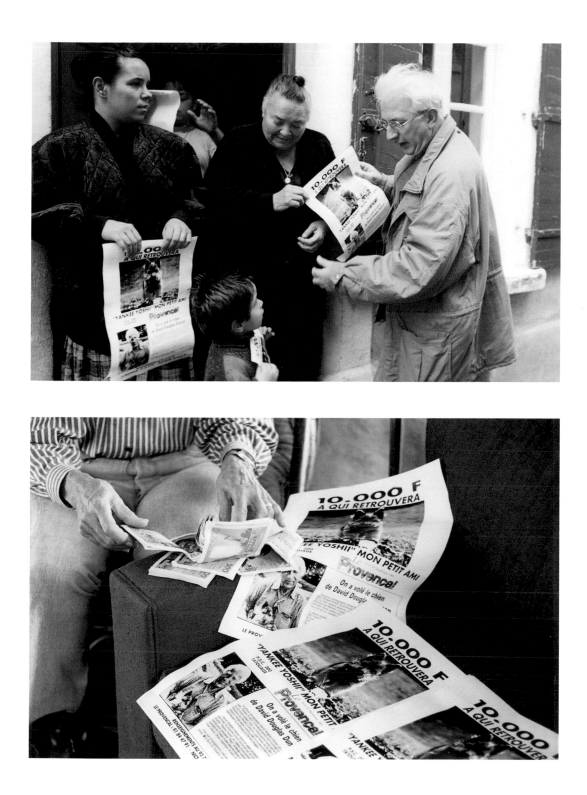

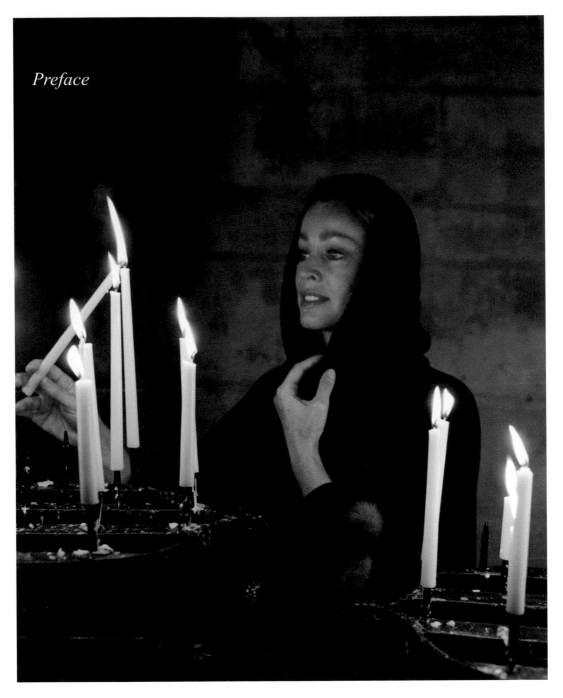

Preface

Heidi Goulandris
Yo's optimistic neighbor
sought help from Above

Michel Sola, veteran managing editor of *Paris Match,*
commanded his battle for Yo as a personal war story
never seen before/again in the pages of his magazine.

**DAVID
DOUGLAS
DUNCAN**
A PERDU
YANKEE YOSHII

Sa renommée mondiale
ne peut le consoler
David Douglas Duncan, l'un
de plus grands
photographes du monde,
celui qui a réalisé les plus
beaux portraits de son ami
Picasso, a perdu son chien.
Alors qu'il était au
restaurant, on lui a volé sa
voiture, où l'attendait son
norwich-terrier de 4 mois. Il
venait de l'offrir à son
épouse Sheila pour tenter
d'adoucir leur chagrin ; il y
a un an, mourait Thor, son
berger allemand. C'est
Martin Gray qui le lui avait
donné en 1970 quand
D.D.D., comme on le
surnomme, avait réalisé le
célèbre cliché qui montrait
Gray avec sa chienne,
seule rescapée de l'incendie
qui a tué les siens. Thor était
le fils de cette chienne.
Maintenant, D.D.D. n'a plus
de compagnon. Une forte
récompense est promise à
qui retrouvera Yankee
Yoshii. Téléphoner au
40 74 75 08.

Notre Dame de Paris
Pope-King-Hero
— all prayed for here —

photographed and written about in *Paris Match*

But — for a three-month old five-pound bundle of bared teeth and apparently satellite-powered energy, behind a primeval mask of fur concealing sometimes loving, limpid eyes — to be prayed for at the same altar, with similar candles, under the famed rose window -- then to be deliberated over and written about with words crafted to make him sound like a nation-sought prisoner of war, by the editor of the greatest photo-news magazine in journalism today, determined to free him … one might have wondered during those endless search-days how Yo-Yo would express his appreciation, if ever found and freed. Probably with wild shrill barking and by biting them!

And I also imagined their response had I pitched Yo's story to my editor-colleagues -- even during a lucky year of filled pages at long-gone LIFE.

39

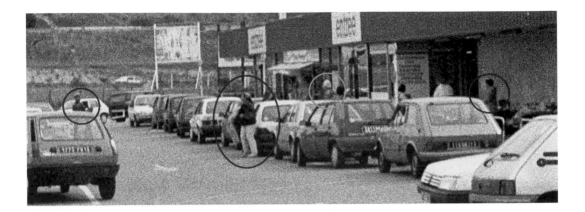

Preface

Yo-Yo Ransomed in Provence

Bobby Billam took that long-awaited phone call at dinnertime -- his home number had been on Yo's poster from search day Number One. Answering Bobby's first concern a rasping flat voice replied: "No worry … he's asleep with my little girl. She calls him Jimmy." Then it turned to the ransom and the rendezvous in front of a supermarket near Marseille at exactly 1400 Thursday -- no *flics* (cops) one car. The ransom? He knew he had a sucker -- *five times* the poster offer. Bobby knew me, he doubled it.

We (Audrey and Bobby and Yo-Yo's lady, with Babba in lap) drove into that supermarket parking slower than slow, crawling, sure but unknowing how many gimlet eyes were tracking us and all other cars just behind. Surprise -- gangster boys!

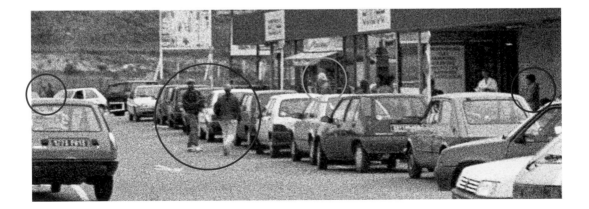

It looked like Korea/Vietnam

Franck Follet, Black Belt (in case we hit a few non-Marine tank traps or unshaven local sticky-fingered creeps) was indeed so close behind us he shot the whole shebang with a hidden wide-angle Nikon through his windshield *so close* he later was angry with himself for not firing when I had Yo in my arms and just turned away from the Gypsy capo -- a perfect "Got him!" photo. "David, those guys were standing right beside me, would have heard my shutter -- that would have been *crazy!*" I took his film to the LIFE lab in New York. Using a hi-tech enlarger, images were projected on the darkroom floor. Nine feet wide. These fragments are the results. LIFE's editors said :"Dave, your French friend is mad!"

And the money? Bobby's accepted ransom seemed about right if shared among the twenty-two silent characters we had counted surrounding us, then vanishing. Just fifteen minutes. A good day's work for them. And Yo came back with a brand new Hermes collar on a six-foot silver leash and *housebroken*. After a moment at home he happily bit me.

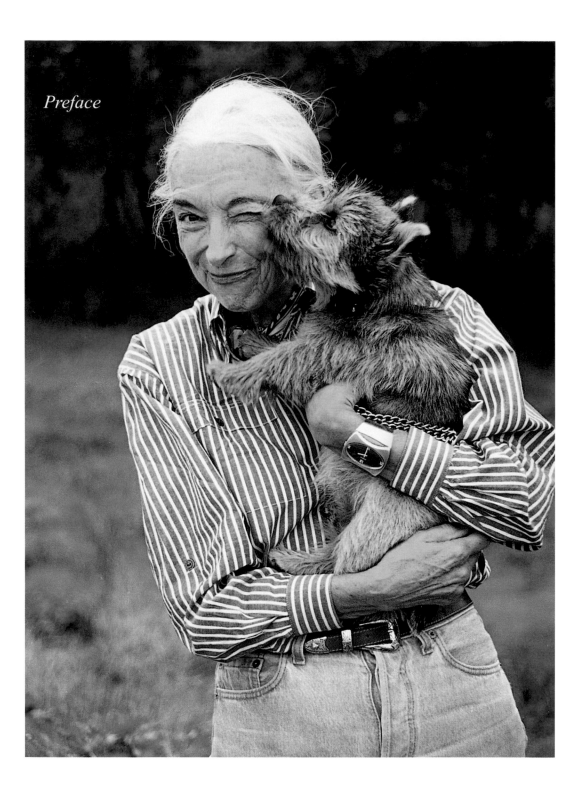

Preface

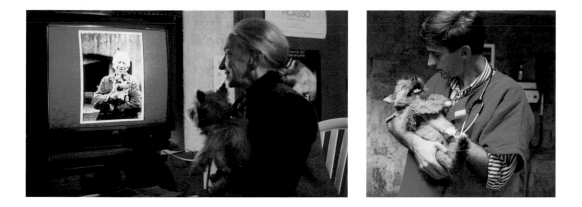

"You Found Him!"

Precisely thirty minutes! Gypsy *rendezvous* to *autoroute* tollgate near Aix en Provence. Yo-Yo safely in her arms -- even kissing her. Soon home he saw his 15-minutes of TV-fame taped by a neighbor pal, André Villers whom he never bit. Then was checked for damage - zero - by another pal, Dr Alain Petitprez, not fooled by that toothy grin, holding him like an infant razor-jawed tiger.

Other combat buddies -- gendarmes of Provence who had tracked Yo since he first disappeared into the Marseille-Gypsy-car-stealing netherworld -- viewed him like a miniature crime-busting veteran, welcoming him into their elite ranks. "He's the first to come back from there."

The
Last Leaves
of
Yo-Yo's First Autumn

Paris Match announced
his safe return home
…a family victory.

then we celebrated

His Birthday

Five Months Old

Kansas City to Castellaras Yo-Yo's hilltop village in France.

Home of memories from my earlier life everywhere.

Yo-Yo's Saga and My Odyssey

Today
Archives in America

It was not easy.

Despite my early *National Geographic* world-exclusive deepsea fishing stories of which I was so proud, LIFE's Korean and Vietnam war photo-essays that had national impact, those photographs of Kremlin treasures unrecorded by anyone and shot only after the eye-to-eye okay from a very *very* tough character who ran the Soviet Union during the coldest of those freezing Cold War years -- Nikita Khruschev himself; and even including my multi-thousand negative hoard of closeups revealing the private world and squirreled-away stacks of unknown paintings bracketing an entire career of the "artist of the century" Picasso, of course, and much more, I'd spent years trying to find a future home for my complete archive . . . offered as a gift.

Six thousand pounds -- three tons! -- of prints and negatives, book production records and dummies, first editions of the books themselves, also my custombuilt prismatic camera and custombuilt Leicas with which I silently worked beside Picasso, and that other Leica fitted with a then-unknown Nikon lens that I used during the Korean War and launched the 1950 camera "revolution."

Nothing but courteous-to-indifferent responses came back from any art museum or photography institution – or from those universities where I was still remembered and even sometimes honored. Dead-end streets.

Then it happened. Stanley Marcus, of Dallas Neiman-Marcus fame, America's premier merchant king of affordable-to-capricious Christmas gifts, and one of the New World's Old World Renaissance Men who dealt in reality and dreams, walked into our home, heard of my futile search – picked up the phone, called Texas, to the Harry Ransom Humanities Research Center, University of Texas at Austin, explained to somebody that he had a little suggestion. Described the package. Hung up.

Two weeks later, Dr. Thomas F. Staley, Director of the HRHRC, world authority on the works of James Joyce, arrived in our village, looked at my lifelong packrat's matrix of work and memories. We went to another nearby village for dinner . . . after he had phoned Texas.

Two weeks later, Roy Flukinger, Photography Curator, the Harry Ransom Humanities Research Center, University of Texas at Austin, ambled across our front steps out of a taxi from twenty-five-mile away Nice airport, nodded hello, recognized shot after shot among my most obscure photo-stories, shared dinner with Yo-Yo underfoot and not biting anyone – flew back to Austin the next morning.

That was five years ago. My gift offer had found its home.

I had never been in Austin, Texas, in my life.

All of my negatives, prints, Marine Corps combat gear, letter albums and notebooks, gifts from Picasso, even tape recordings made on Vietnam battlefields and most of my life's souvenirs from everywhere are at the HRHRC . . . fastidiously catalogued and conserved, while also being immediately available for my personal use – this book. There is a just-dedicated research and conference room for aspiring photojournalists, in my name, with my entire archive at their supervised disposal. Near Roy's office there is a unique exhibit: the world's first photograph.

Stanley Marcus – Someplace Special – must hear my thanks.

Now, having already shipped Yo-Yo's childhood Hitchcock-escapade to Texas, I am reliving all of my memories of yesterday, today.

"Only Yesterday"

Arizona to Acapulco

1934
my first "photo story"

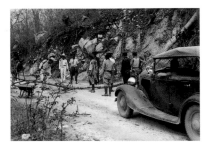

Life as an archaeologist, University of Arizona, Tucson, beckoned for only a few semesters then faded away under the demands of classrooms-not-excavations in nearby Mexico.

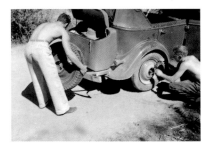

With two other horizon-hunters, Brock of Rhode Island and Frank, New York, I aimed my beloved $400 second-hand Ford *Dreamwagon* south, toward a stretch of sand trimmed by a sagging one-hotel paradise-village almost nobody outside Pancho Villa country had ever heard of: Acapulco. Just the four of us, *Dreamwagon* was always included, had an empty beach to ourselves.

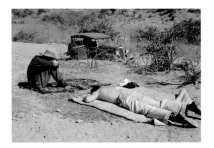

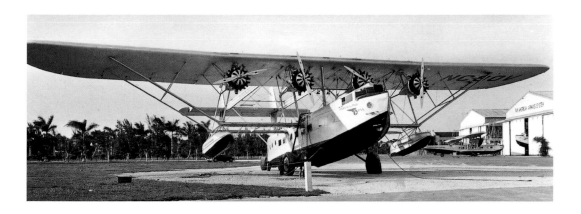

Then I switched to a real-life paradise university where dreams of another world beckoned. The University of Miami, Coral Gables, Florida, housed in a triangular three-floor Great Depression-abandoned hotel, attended by five hundred usually broke students from all America; most on scholarships thanks to dedicated professors who solicited for funds everywhere, and got them; resulting in national champion debating orators, tennis, boxing, wrestling, football stars, a highly respected orchestra and internationally esteemed professors of Spanish, constitutional law and marine zoology; every weekend laboratory forays out probing the neighboring myriad challenges of the Atlantic Ocean discovering everything, alone, while in Miller-Dunn diving helmets – *underwater*. My class of 1938 graduated from a place never to be seen again.

Just next door in Coconut Grove, new-born Pan American Airways was testing the wings of an incredible four-engine monster that could land on water then lumber back ashore, the *Caribbean Clipper*. Up at Daytona Beach, Sir Malcomb Campbell was breaking the world land-speed record in *Bluebird II* while our football captain pushed our tennis champion around the building to win the school fruitbox-car race. Almost no one else had a *Dreamwagon*. Mine had more than one hundred thousand miles behind it, diving helmet in the trunk. Not one of us had ever flown in an airplane.

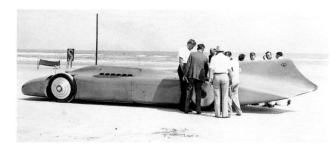

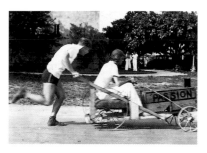

Snapshooting
a
Hurricane
1935

Devastated Miami
Killing Hundreds Nearby

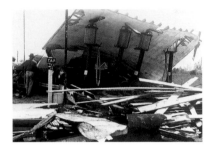

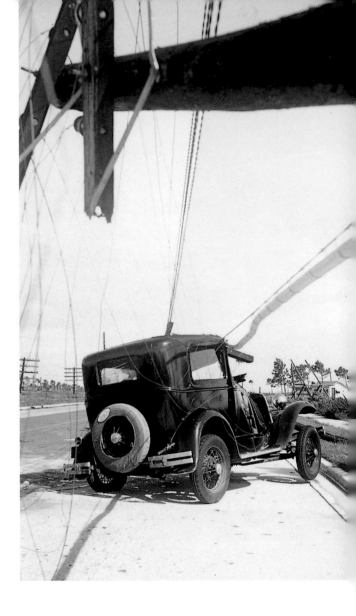

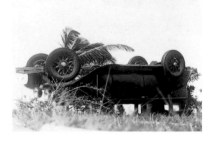

Storms are Easy

seeking the invisible

Dreams

Dreamwagon survived / 2 September 1935 Miami Beach

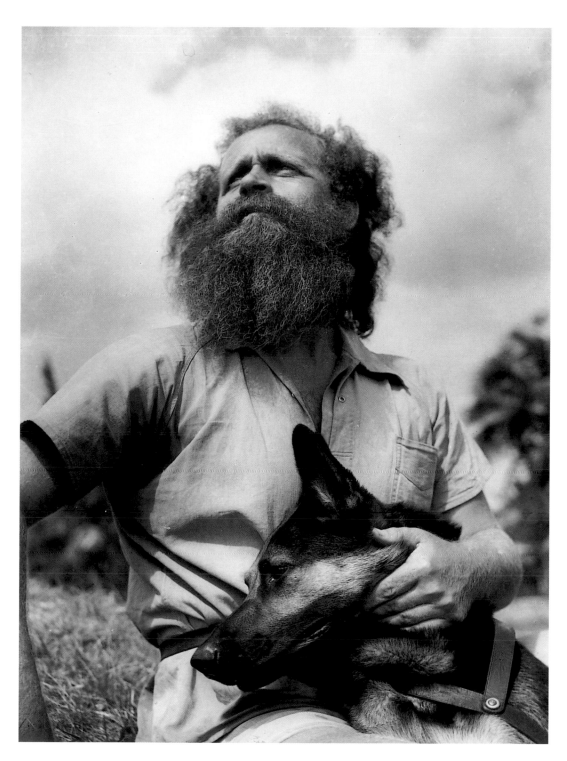

Everglades nomad

Learning About Light
Backlight – Candle/Match
Artificial Light

Love
Light from Within

1936

My older brother Bob – tone deaf,
pretending to play like Ken,
my eldest self-taught composer brother;
next brother, John tennis/golf
champion:
broken-nose baby brother
boxed for fun.

My friend, Henry Beardsley, first post-war job: FBI

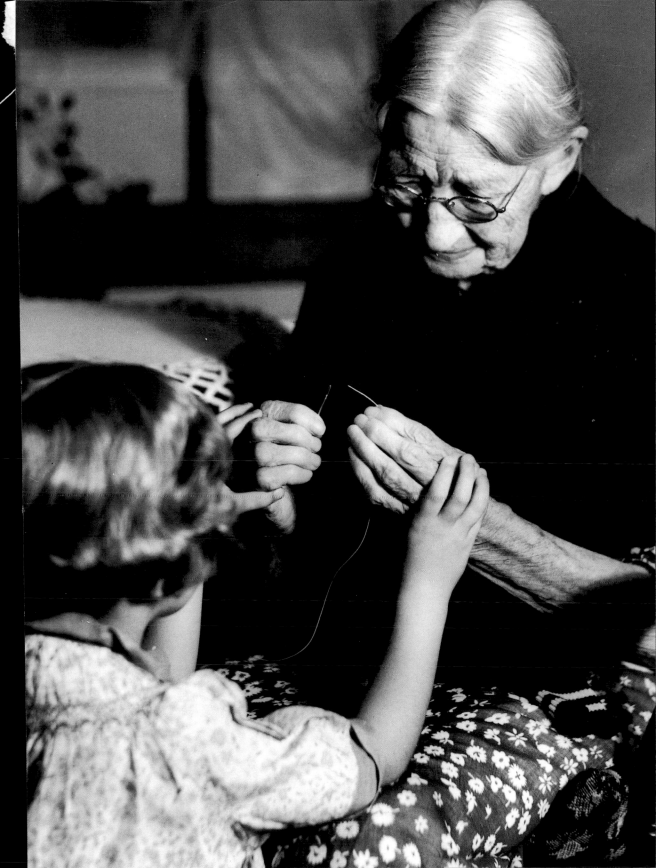

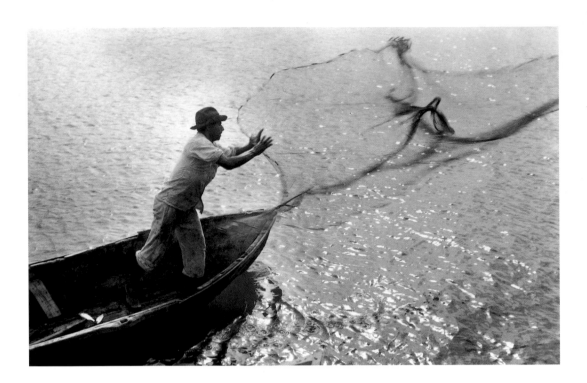

Split-second Timing

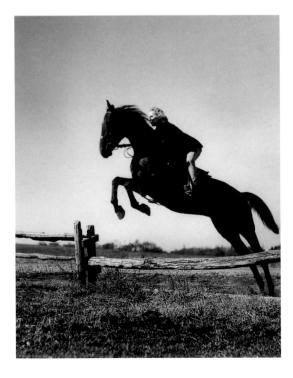

"The Netcaster of Acapulco" won the Eastman Kodak 1937 national photo contest's travel $250 second prize. I bought a super Graflex-D. Photographed my neighbor Shirley Irwin soaring; barehanded rattle-snake catcher Ross Allen in the Everglades . . . and was on my way.

Life with cameras.

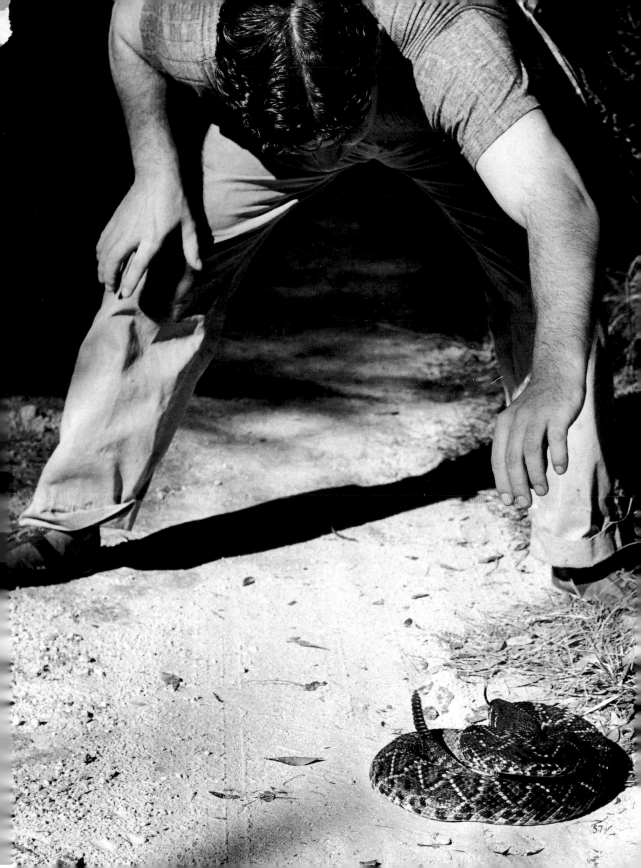

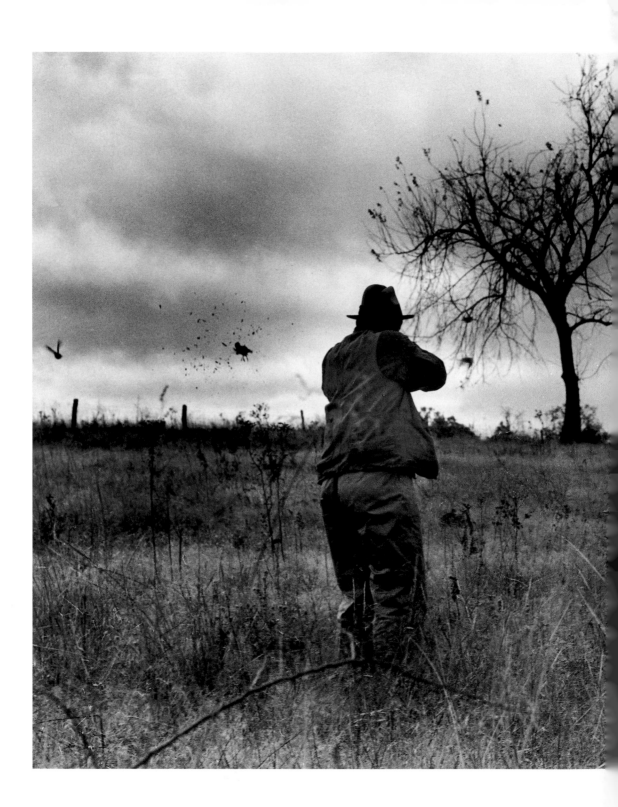

Photojournalism

Discovering My Dream World

It all seemed so natural, so easy — just see *it*, aim at *it*, shoot *it!* Speak a new language not saying anything, but know the words. Thanks to my brandnew, Kodak prize Graflex-D and Scott Harrison of hometown KC feathering a quail at 1/1000-second, I scored a Sunday frontpage in the *Kansas City Star.* A fabulous 10-shot mosaic thanks to photo-editor Cal Eby, a too-exhausted St. Christopher who carried my infant career on shoulders already loaded with shots by staffers aiming at that page. Then he targeted Wilson Hicks, earlier at the *Star,* now picture tzar of new LIFE magazine. I hit the jackpot – one full page!

My future was being crafted by a crew-cut bespectacled man with eyes rarely off the work covering his edit-desk, photos upon photos from guys all over the world, meeting deadlines every hour.

Today -- Yesterday

Collision in Yucatan

Carlos and I wandered Yucatan -- Mayan ruins galore -- without leaving memories of heat, thirst, mosquitoes, just what he shared with me of his land's legends -- mysteries *he* sought among those undulating scrubtree-concealing limestone hills; pacing silently among stiletto thistles, unwavering in our search for *quetzals*, most glorious and rarest of birds -- sharing laughter -- unheard by a lonely soldier left to guard the hulk of an upside-down jalopy abandoned by a speed-lunatic young villager who at ten-miles-an-hour took out a part of the only river bridge to prove to his girl he knew every turn in that burro trail, which he had promised her would lead to their future.

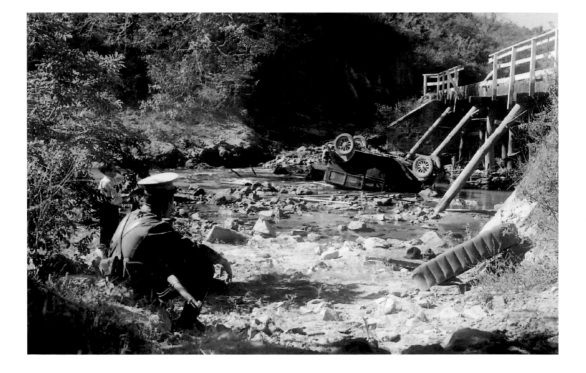

Great Pyramid of Chichen Itza

Advice from a Father

"Don't Waste Words or Film"

Shoot and Write
Closeup

Plowman and Patriarch of Patzcuaro

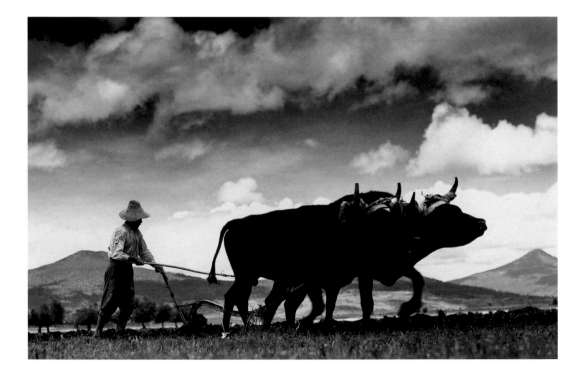

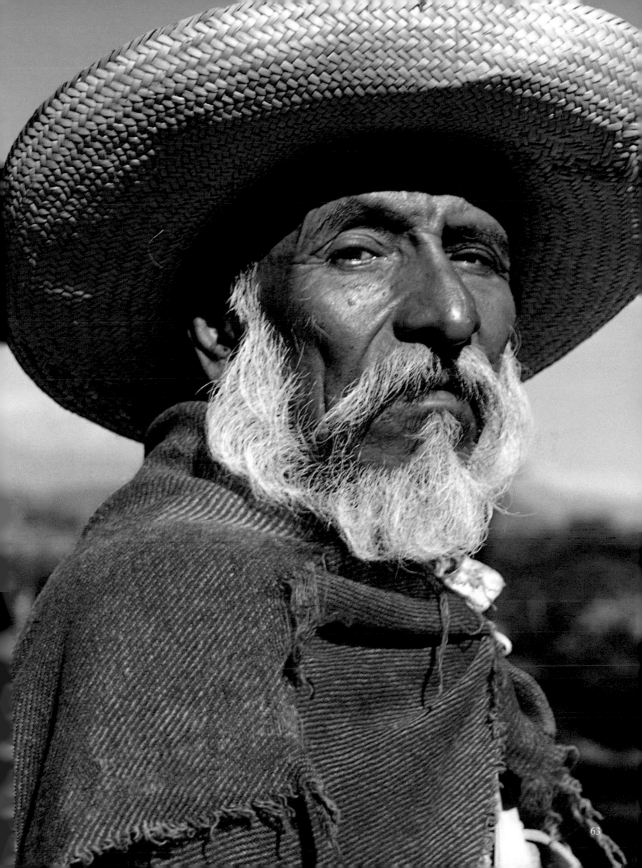

Sunlight and Shadows
— Visions of the Future —

My next-door neighbor Sally Kaney, dog on leash, landed as *PopPhoto's* ($35) cover.
That Coke girl born before "The Pause That Refreshes" drove me crazy!

I saw Helen Johnson there in my Kodachromes not as a painting. We never made it.

But who was that silent Marine just over my shoulder?

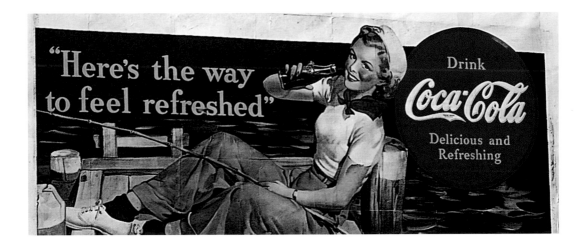

Hollywood Superstars?
— Hometown Patient Neighbors —

Burleigh Wolferman – Claudet Colbert-cheek-boned, equally as beautiful, never realized her impact upon the brother of her friend Jean – my sister – who faked shadows when fixing that ribbon in her shadowless hair. Shot only for me!

Luminous-lanky-always laughing Helen J – never in a plane, nor I, phoned her folks for their okay and off to KC's Municipal airport where Joe Jacobson bounced a real student from his flying class and up we went. Joe Jacobson in awe . . . "Dave – she could have soloed that first day". Cal Eby put them on his front page the next Sunday. LIFE saw her. Hollywood called : "Thanks – no!"

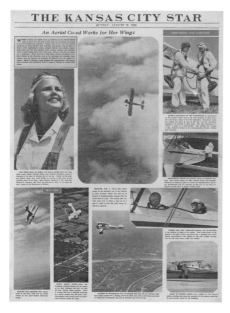

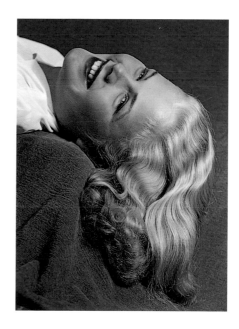

"Leave Space For Merry Christmas"
— Joyce Hall —

Cal Eby had shoved my offered six-to-ten print stories into a heap, leaned back in his chair, hands clasped behind his head – eyes boring straight into mine. I'd never seen them so clearly before.

"Okay – okay – okay . . . shark fishing, more rattlesnakes and gators in the Everglades, kids up at Southwest High watching the Indians without any footballs in sight – naturally Sally Kaney again, as a drum majorette, old mayor Beach's grand-kid carving the Halloween pumpkin – and I'll buy 'em. But – it's time to go *big time!* Go up McGee and show your stuff to J.C." . . . "Jaysee?"

"Not Jaysee, Dave . . . J.C . . . like in and never forget it – J.C. Hall of Hallmark, just up the street. I'll phone you're on your way."

One hour later – eyes drilling straight into my gizzard – *slowly* turning my prints – asking had I any snow shots . . . you know . . . Santa Claus country . . . no! How about flying to Boston Monday? I saw that page on Helen and Joe. Have you been in a *big* plane, TWA's two-engine job? Take our old company Pontiac – warm clothes – drive through New England shooting whatever you want – BUT – always – remember: leave space for our *Merry Christmas* to run across the bottom of our next greeting cards.

Cal Eby was editing my pumpkin story when I went to thank him.

My snow shots became Hallmark's first gift box of photographs.

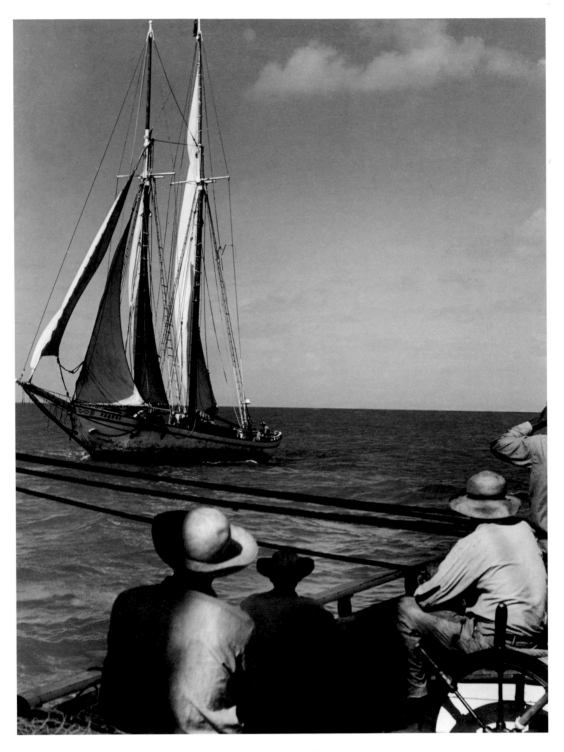

Aboard schooner *Adams* fastest of turtle fleet 36 meters / maiden year.

First Voyage
Key West to Cayman Islands

Graduation Day University of Miami

1938

At last! Wind and waves. What a way to escape surely good advice about facing my future life. With no engine, no lights, no privy, no other passenger. Headed for Georgetown, her home port somewhere between Cuba and Jamaica, then to the Swan Islands? Finally, straight west to the coral-reef lairs of giant green turtle – 200 pounds-and-up. Snared by my buccaneer, deep-water, cowpoke, shipmates aboard schooner *Adams*; the most gentle and yet toughest of men I had ever met in my life. Those waiting horizons were now in sight.

I needed no sextant – nothing!

Turtlemen of the Muskito Coast

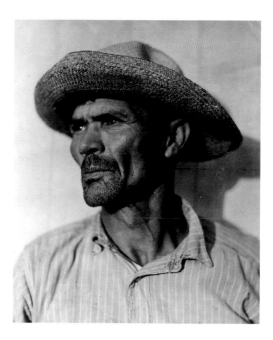

Henry Ebanks, First mate

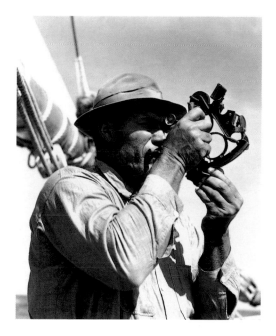

Allie Ebanks, Captain

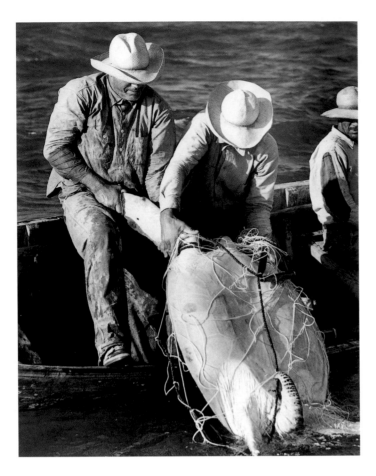

Key West - Cayman Islands - Muskito Coast - Key West

Those ever-circling silent schooners
now long-gone
only memories in my photographs

The Kansas City Star and the *National Geographic* after which I roamed Peru and then Chile's Humboldt Current photographing mammouth swordfish and cannibalistic giant squid for The New York American Museum of Natural History.

Expedition sponsor Michael Lerner / Capt. Doug Osborne / 600-pound swordfish.

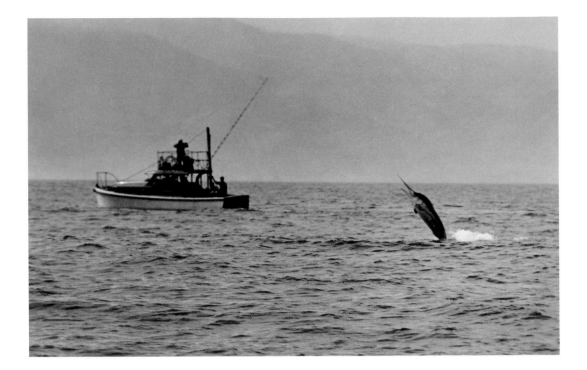

Pacific Ocean!
I saw it *explode* off Peru just before World War II
1939

Forget U-Boats and oil tankers and torpedoes. I'm talking about that mysterious undulating Antarctic river -- the Humboldt Current -- unseen but surging north, Patagonia to Equator, so burdened with sub-surface traffic it somedays resembled Nature's Acrobat Carnival dedicated to Old Darwin himself, with creatures weird-to-exotic hurling themselves aloft - marlin and swordfish, 20-foot wide manta rays to 60-foot whales . . . slicing the surface, big sharks, little sharks – and dreadnaughts that ate the others alive -- but wait -- at night, there were super-horrors that devoured *anything* alive -- luckless creatures falling into their parrot-beak jaws, knife-toothed steel-rope tentacles . . . watched by unblinking midnight-blue fried-egg eyes. That teeming world belonged to them after dark: *"Jivia,"* to terrified local night fishermen. Just one more Humbolt legend? Flip the page.

Flip another and listen to a million wings of heaven.

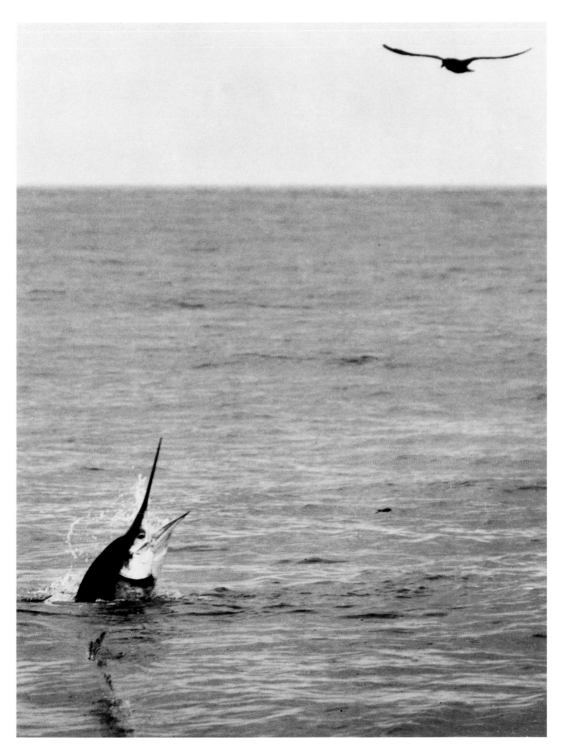

200-1b striped marlin off Tocopilla, Chile, watched by albatross.

Gaffed 20-ft giant squid.

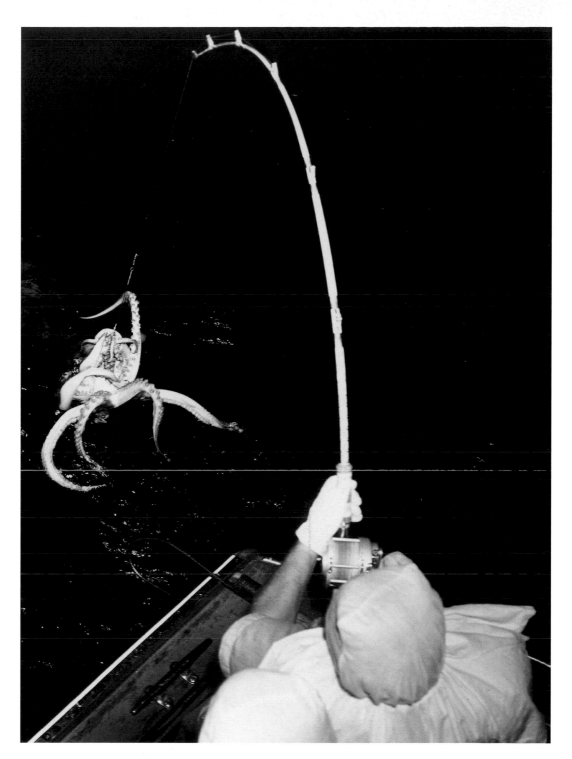

Michael Lerner fighting giant squid at midnight, thirty miles off Talara, Peru.
Pillowcase/gloves protected eyes against unknown effects of fire-hose ejections of sepia ink.

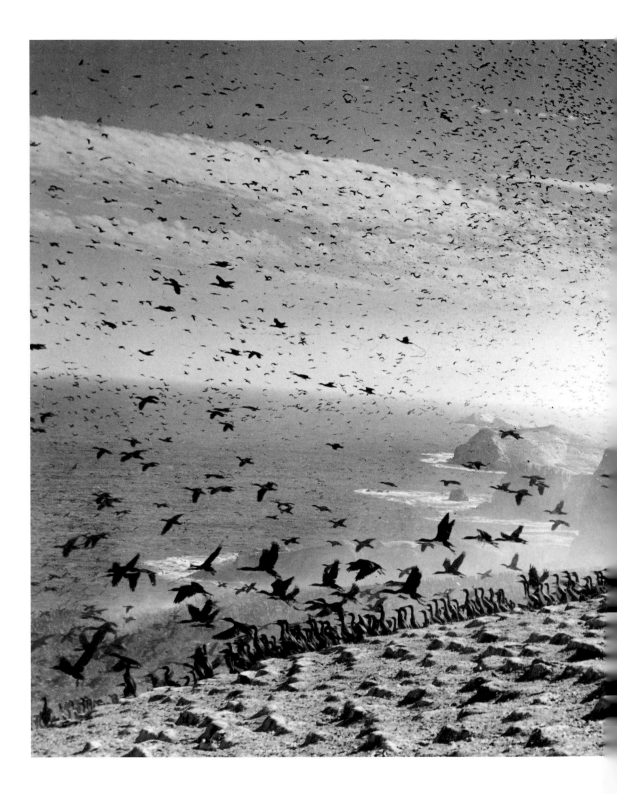

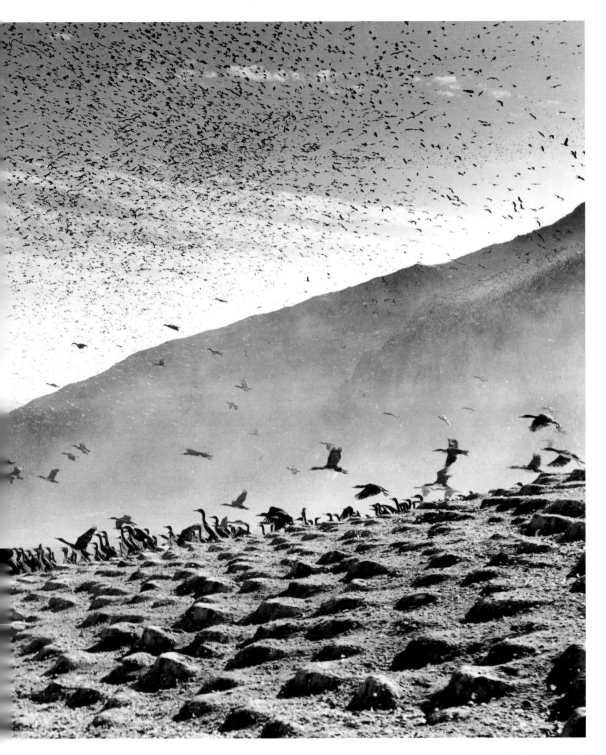

Cormorant nesting slopes / San Lorenzo Island, Peru, 1939.

THE KANSAS CITY STAR

SUNDAY, JULY 9, 1939.

Summertime Vagaries of Youngsters

THE lazy somnolence of warm and humid summer days literally is reflected in these photographs from the camera of David D. Duncan, 629 West Fifty-seventh street terrace, who has roamed much of the western hemisphere in quest of picture subjects since the end of his university studies in 1936. Back from chasing and photographing the dragon-like iguana in the remote Caribbean, he found more enchanting, if less unusual, material when he made these camera studies of the children of his own neighborhood in vacation-time freedom from classroom routine.

A DREAM THAT SAILS ON ANY SEA—Of geography Masten Gregory has never heard and to him factual information could be only narrow nonsense. From his own playroom, where his picture was made, to the remote Caribbean, where the schooner Reinbro spreads her canvas, is just the rounding of a sentence in his storybook. Masten's dreams are conjured up at 6056 Mission drive.

(Left)

SECOND SUMMER for Wendy Beach who sits crowned before her first birthday cake, which somehow suggests the Liberty Memorial. More interesting to Wendy is a crumb upon the table. She is the daughter of Mr. and Mrs. Marshall Beach, 6722 Locust street, and the granddaughter of the late Albert I. Beach, former mayor of Kansas City.

STUDY IN HYDRAULICS—The loser in this water fight wins the delight of a cold dash of water straight to a freckled nose. Junior Majors, 4425 Virginia avenue, likes it. You can tell by the grin that exposes a missing tooth. Ward Kelley (left) is the victor in this battle of the drinking fountain.

PETAL BY PETAL the daisy disintegrates in the fingers of musing Sally Kaney and you can fit your own refrain to the plucking process. It's a safe guess she isn't deciding whether she'll drop mathematics or Latin when she enters her senior year at Southwest high school next year. Sally is the daughter of Mr. and Mrs. J. C. Kaney, 629 West Fifty-seventh street terrace.

(Left)

"ICE COLD"—Business enters the story of vacation days by way of the "pop" stand. A lot of such enterprises in early summer would be long, dwindling rapidly with the advance of the season. Here's Bobby Hirsch voicing the cry of "the trade" at his crate-fashioned stand at Fifty-ninth street and the State Line.

"MEDITATING WITH A VAGRANT MIND"—With that Al Ossetti once described a principal delight of fishing. "Porky" Holton, 407 East Meyer boulevard, and Frank Hood, 6424 Rockhill road (nearer to camera), might not realize it but here they are dramatizing, in juvenile style, the lawyer-philosopher's phrase.

(Right)

WATCHMAN ALERT—If Stitches weren't the sprightly sort of dog all wire-haired terriers are, he wouldn't be tied up in the car watching toy yachts cruise the wading pool in Ward parkway. If he were free, it would be just like Stitches to dive in and take a serenely sailing boat in his teeth. He's done it. Consequently he serves time—as prisoner and car watchman. Joseph Limb, 4243 Clark avenue, owns Stitches.

Masten daydreaming in my first photo-montage Cayman Islands schooner in 1938 off Nicaragua.

Masten Gregory was the first American Grand Prix race driver to win the fabled 24-Hour Le Mans.

Adiós Innocence

Hello Reality

1943

James Montgomery Flagg 1914 poster
2nd lieutnant U.S. Marine last day in the States

"Goodbye"

California - South Pacific

Not One Tear

— visible —

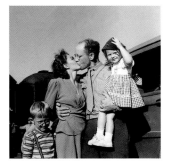

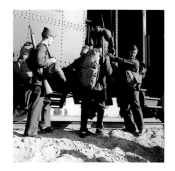

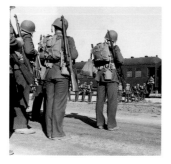

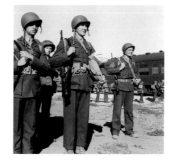

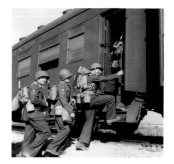

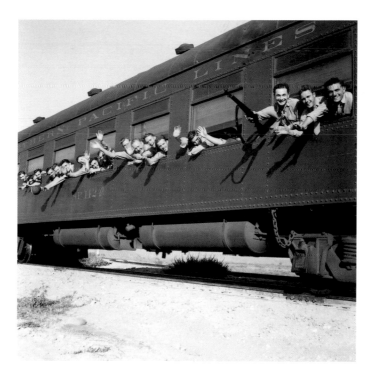

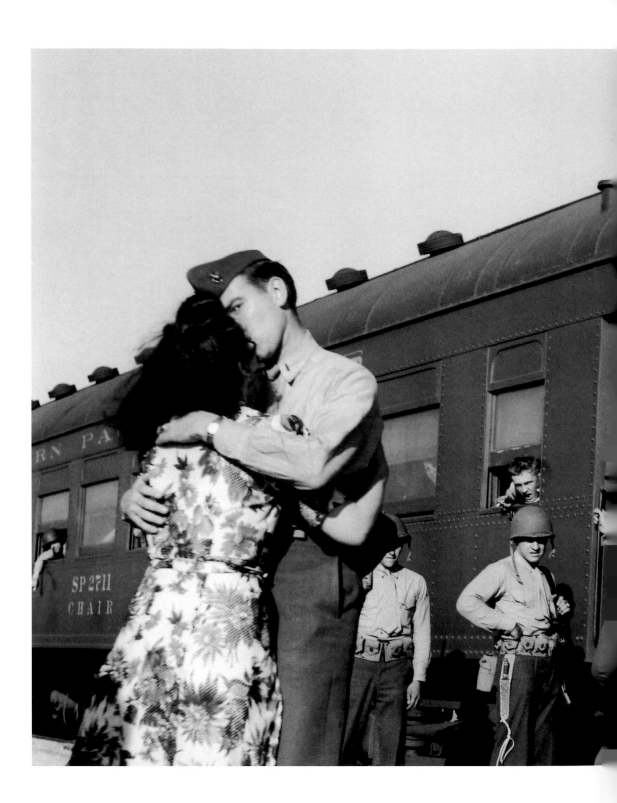

The engineer held the train,
every Marine agreed.

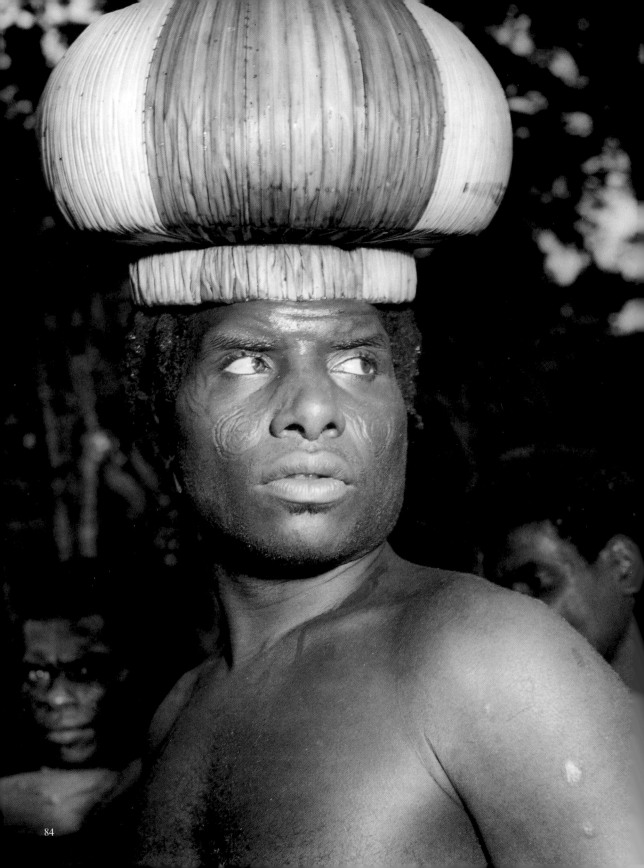

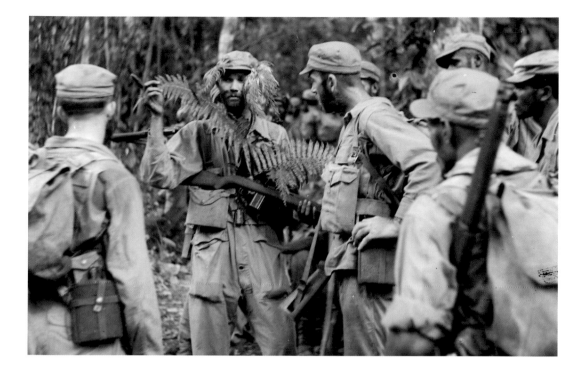

1944

Bougainville
Solomon Islands
with
Fijian Guerrillas
New Zealand Officers
behind
the Japanese lines

— *every man returned* —

the war for Bougainville
had just begun

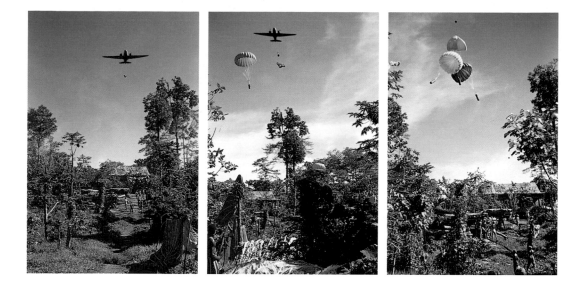

Those Stone Age Men
loved their new parachute
wardrobes

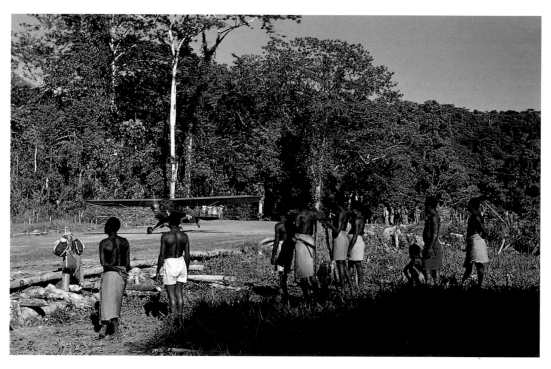

Bero
Papuan Killer-Tracker
guided
Fijian Jungle-Fighters
to set
Most Deadly Ambushes
on
Bougainville

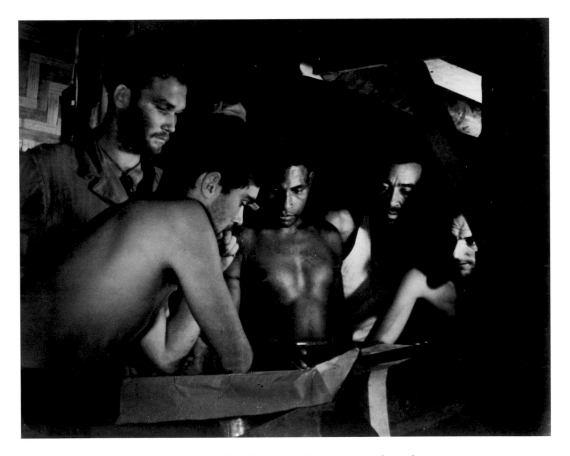

Ibu, once a missionary jungle outpost / Fijian observation base near an active volcano.
Every man was fighting malaria as well as the Japanese.

Jungle warfare usually invisible -- forget photography.
Ibu fell while I was on ambush cameras long abandoned.

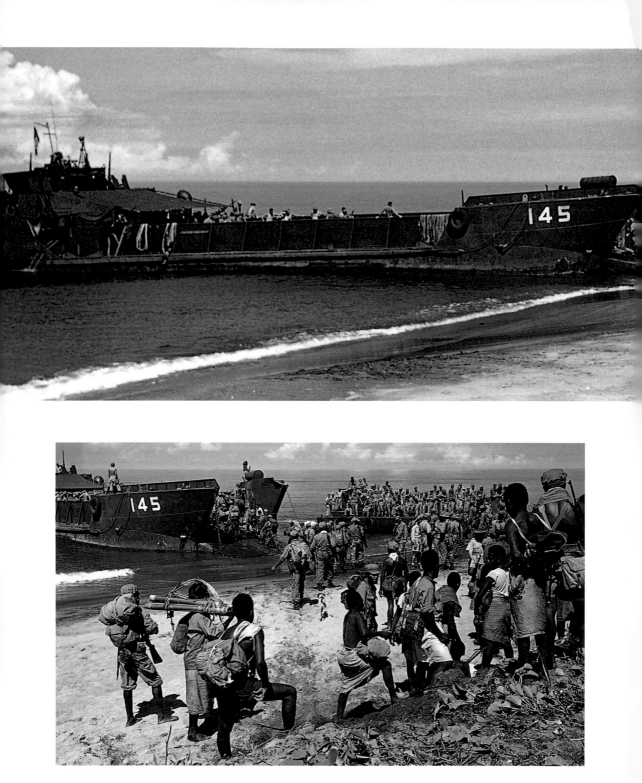

Lovely landing craft came from Torokina Perimeter and offered everybody a free cruise home.

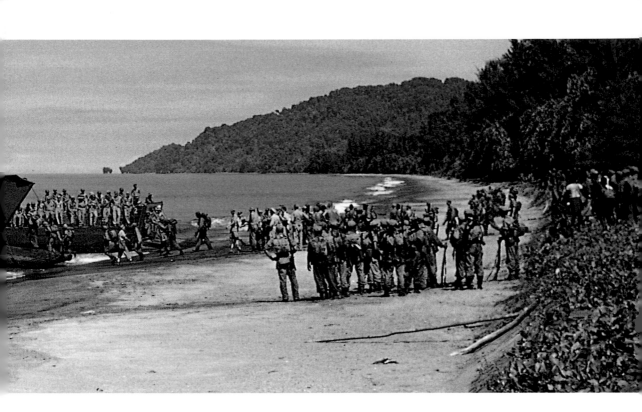

Evacuation
Goodbye Fijian Ambushes
Adiós Stone Age Man

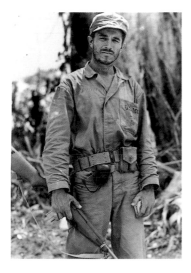

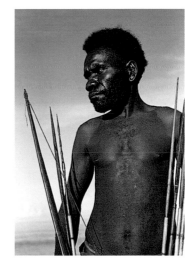

Okinawa

Chasing
Marine Corsairs
rocketing
Japanese pillboxes
at
tree top
300-miles-an-hour
slung under the wings
of
Ed Taylor
in his
"Eyes of Texas"

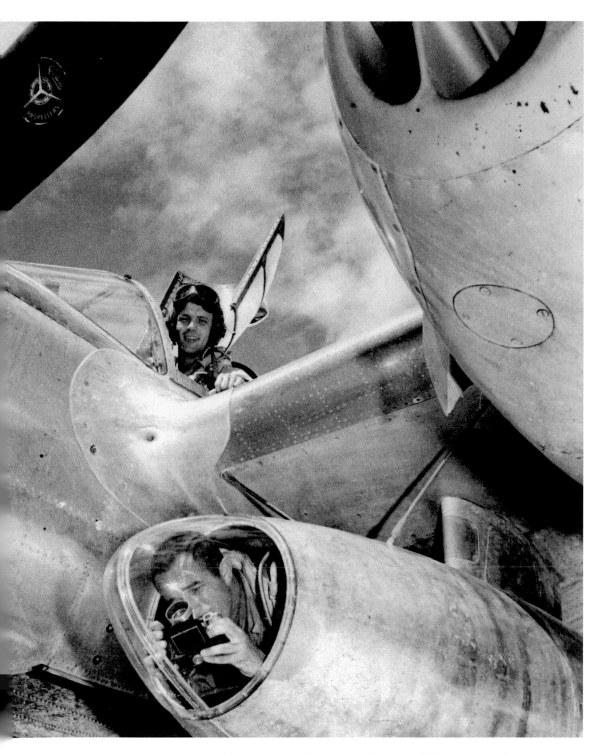

Lightning P-38 photo-recon pilot Major Ed. Taylor put us front-row center
when Corsairs blasted pillboxes while I shot from my cosy little cocoon.

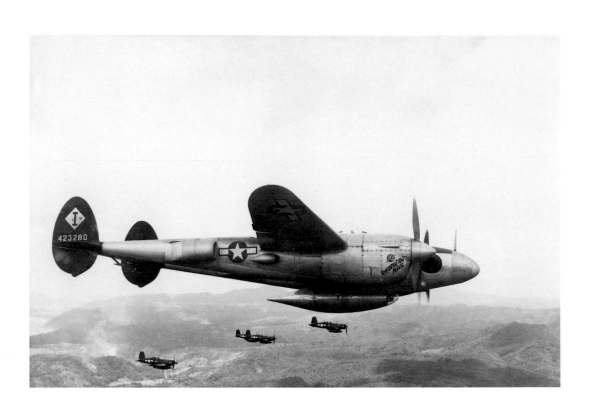

Spring 1945 Okinawa

The last battles of World War II were being fought, every day seemed worse than the day before. *Kamikaze* suicide pilots sought another life crashing into American warships both laden with instant infernos -- which they detonated while praying for their Emperor.

Half-a-century before Palestinians sought Eternity and Love in the Eyes of their God.

No Marine was ever more out of uniform, yet no brass, even generals, ever chewed me out.
Fijian guerillas made me an honorary officer, with gift hat with gold-and-silver emblem . . . salutes!

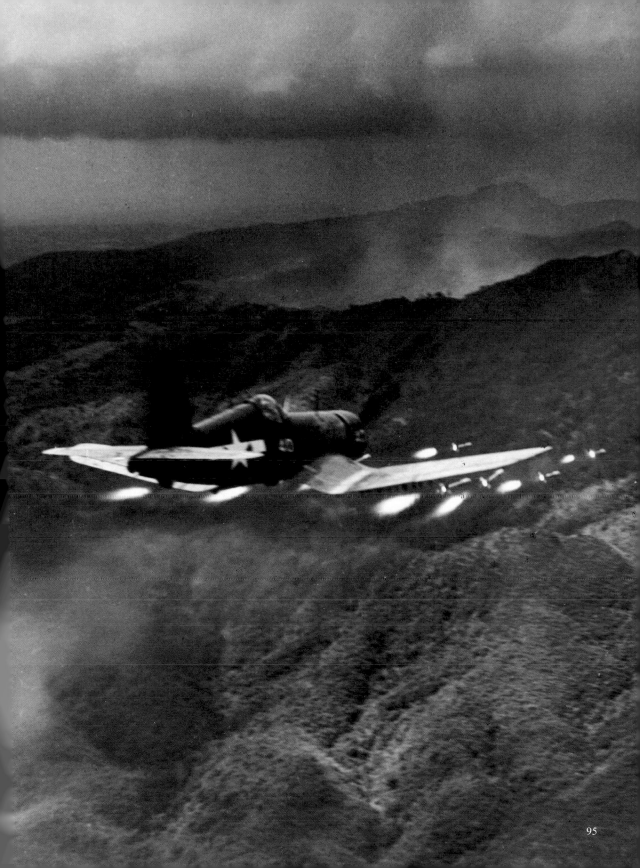

After a day of briefing incredulous-but-convinced intelligence brass and bomber crews, then stationed at the waist gun-port of a special B-25 . . . radio plugged into the interpreter with pilot and navigator, in perfect weather over Mindanao, a Japanese officer led an enemy bombing of his sacred Emperor's Honor and Army far from country and home – recorded forever. The Soviet Union had declared war against Japan and America dropped its second atomic bomb, to incinerate Nagasaki, once – instants before – a city.

The Face of Treason

U.S. Marine Corps Headquarters
Prisoner-of-War Camp Zamboanga
Mindanao Philippine Islands
9 August 1945

The pathetic little guy -- officer's field cap properly in place, had emerged from the jungle, saluted, then signalled for an interpreter . . . and solemnly offered to lead his enemy in bombers and fighters on attack-strikes against his headquarters and fellow officers deep in their bunkers.

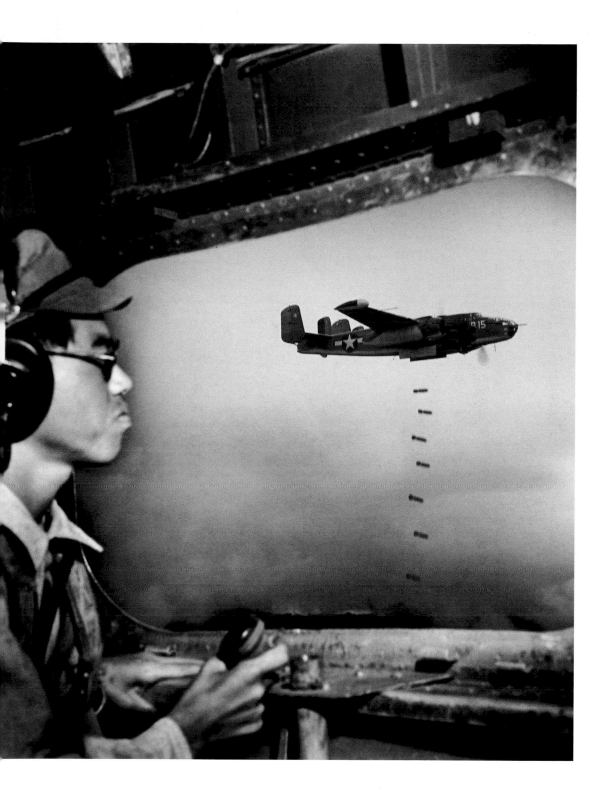

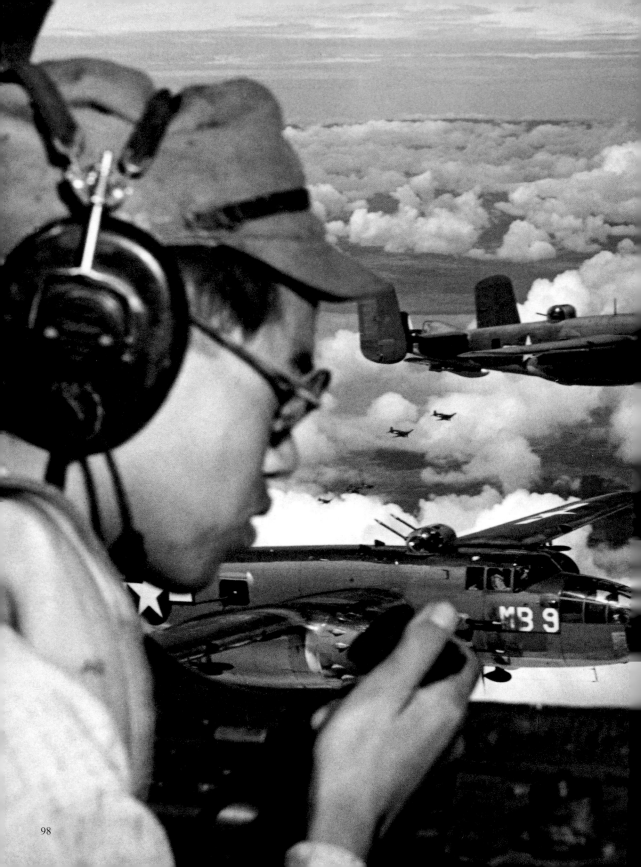

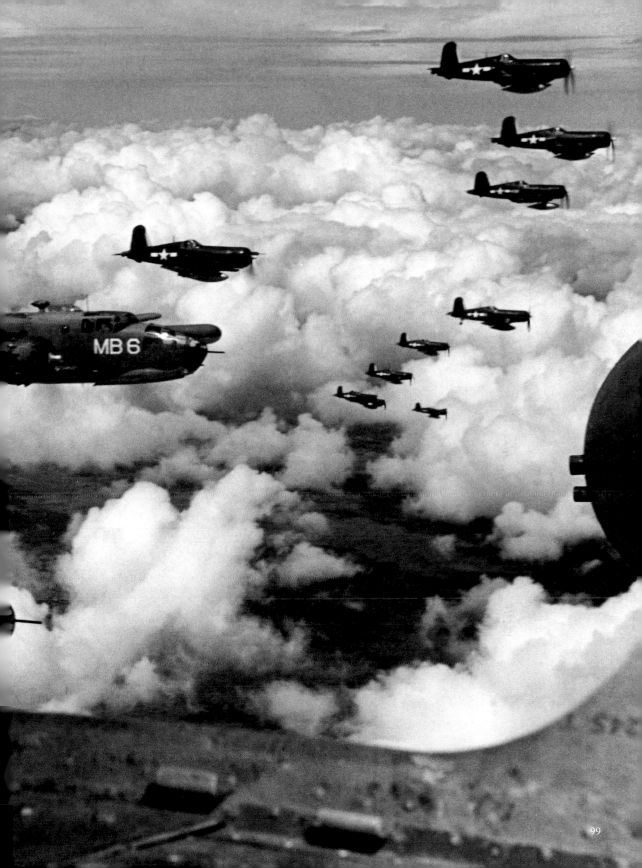

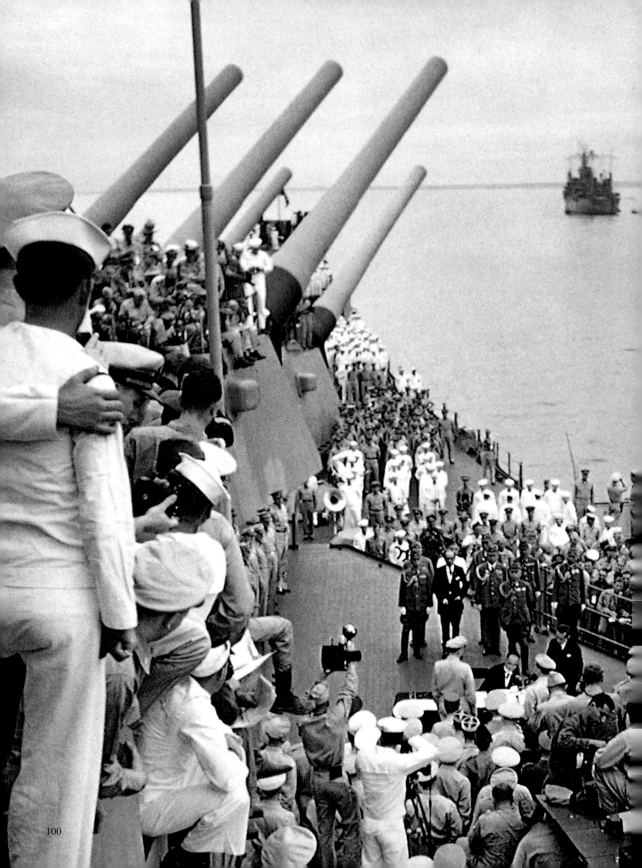

U.S.S. Missouri
Tokyo Bay
2 September 1945

Dear Mother and Dad
This is the day
Love
Dave

The Sunny First Week of Peace
Japan

Central Tokyo 1945 September

Who are they? . . . *that* was our enemy!
Two armies asking the same question.
The lucky vertical, still two arms two legs
and everything vital in-between, walked
through those first days of peace in a
dream made almost real while learning to
adjust -- practicing funny words and even
really *queer* ways to pinch rice -- even
C-rations with sticks . . . if a guy could
still walk -- also on sticks -- and had the
appetite for anything at all . . . except
finally being home -- America, Australia
. . . Japan . . . *going home!*

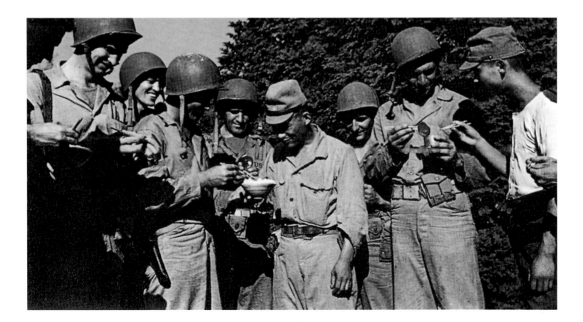

Going Home

Just Great!

Every plane, troop transport, aircraft carrier out of *kamakaze* waters, crammed to their gunwales and hatches, and bucket-seat overloaded. Stateside-bound. Dead/alive America was finally going home.

And every flight westward empty . . . China!

MacArthur signed that near-sacred parchment a million years after Pear Harbor Day. September 2nd calibrated in normal time, leaving three whole months before Santa Claus targeted Kansas City and my waiting family whom I surprised by walking in the front door Christmas Eve . . . back from war -- then Fairyland -- the bazaars of a Forbidden City Peking. Japan's army of occupation of China late-date surrendered, unphotogenically. No one cared in Marine Corps headquarters who'd lost me anyway after the *Missouri* where I did work, then disappeared. It was history. For me it had just begun.

Back in Washington, last day in uniform and sad goodbye to dreams of a *National Geographic* job, my idol Tony Stewart asked "Fiji?" on the roof looking toward the White House. I went to New York, early on a Friday, and was on my way again, to Persia, Monday. Ex-*Kansas City Star*'s Wilson Hicks had just signed me aboard, aimed east as his new, crewcut LIFE photographer.

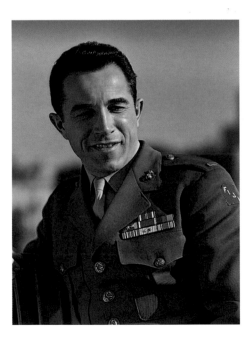

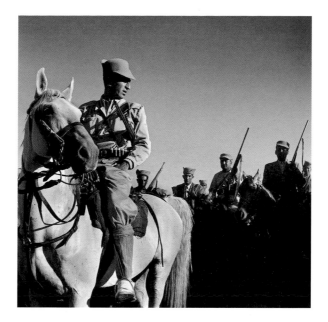

Nomads
1946
Horizon to Horizon

Kansas City boy scout weekends at Dick Miller's grandfather's farm to *here* -- southern Persia (when Dad was collecting oriental carpets) -- Iran, today, where I'd arrived on my first LIFE assignment. Grab shots of a Russian invasion from Azerbaijan threatening Persian Gulf Abadan oil fields. Knocked that off with a couple of hill-clipping runs with a local American Embassy hot-rodder pilot I'd met somewhere much-much hotter. Then was included in a "family outing with friends" by an Oxford graduate. A bronzed, hawk-beaked man, saber-slim and probably of equal steel strength sitting next to me at an embassy dinner, asked only because I was one of few Yanks in town . . . *with my lucky star!*

I'd just been invited by Malik Mansur Khan Qashqhai to join the history-fabled semi annual tribal migration (south-to-north this time) across the "Persian" desert-joining his family in their tents then scattered near the ruins of Persepolis (Alexander the Great also camped there in 331 B.C. with his eastbound legions during his thrust to conquer India – and because of that I met Pablo Picasso). After a few days hunting we'd head north toward Isfahan with the flocks which might take some time. A couple of months because it would be on horseback . . . "your own."

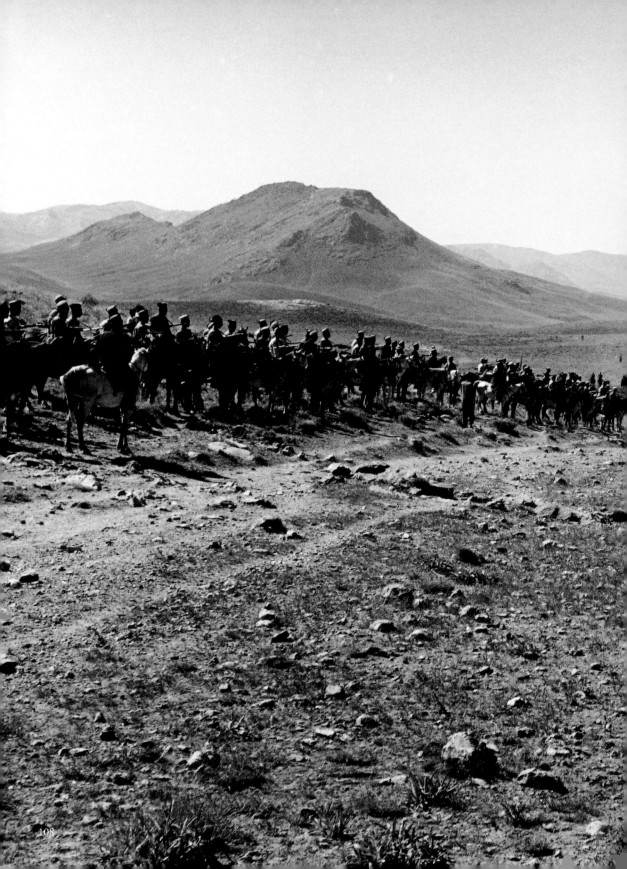

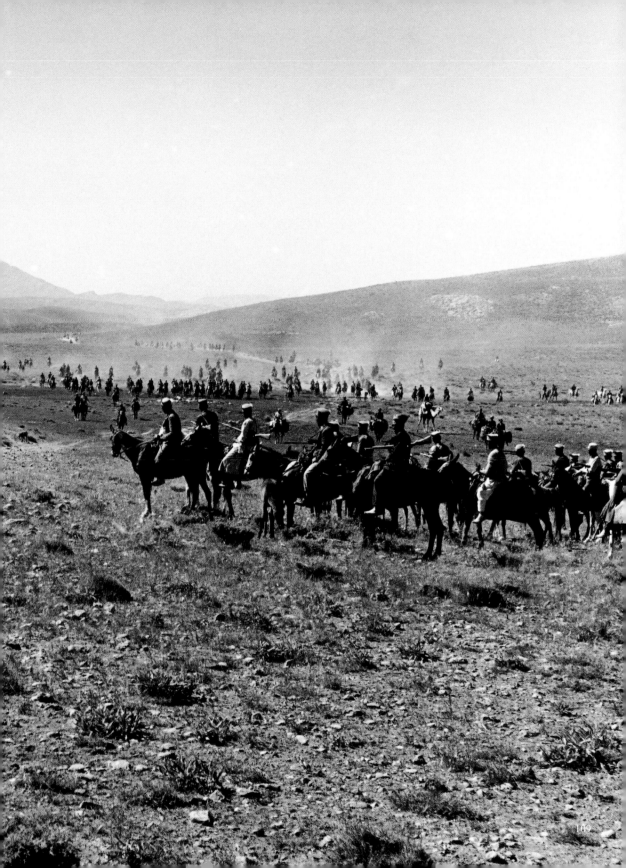

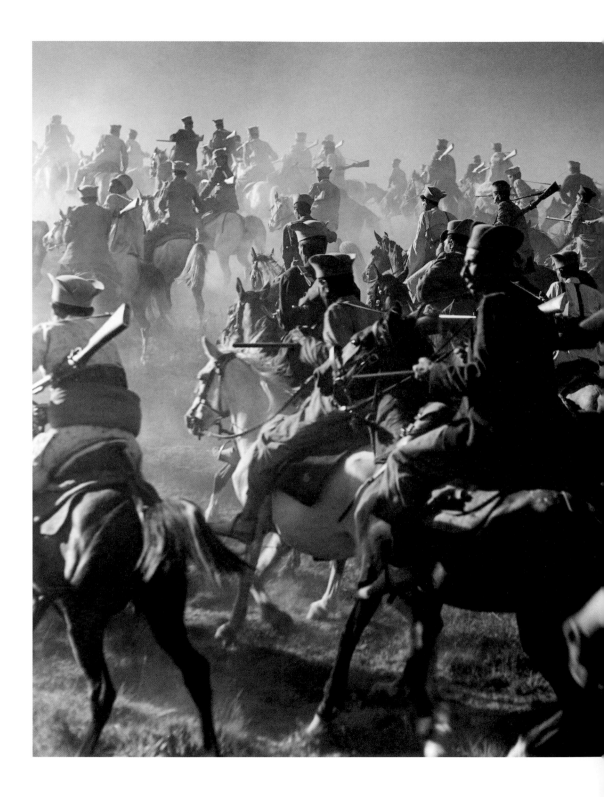

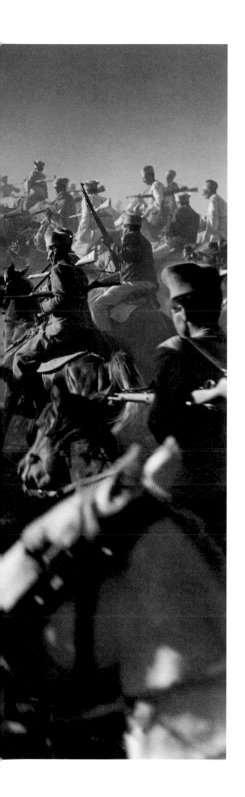

Qashqhai
cavalry as far as eyes see
surrounding me
almost brushing my horse

I was chocking
on nomad-churned dust
headed back to
Persepolis
to bathe in a massive silver bowl
of spring water
on which floated rose petals
then
dined on fire-grilled-grouse-antelope
or baby lamb
dessert
melon chilled in snow
leaving campfires
to sleep
in the black-goathair tent
of my own.

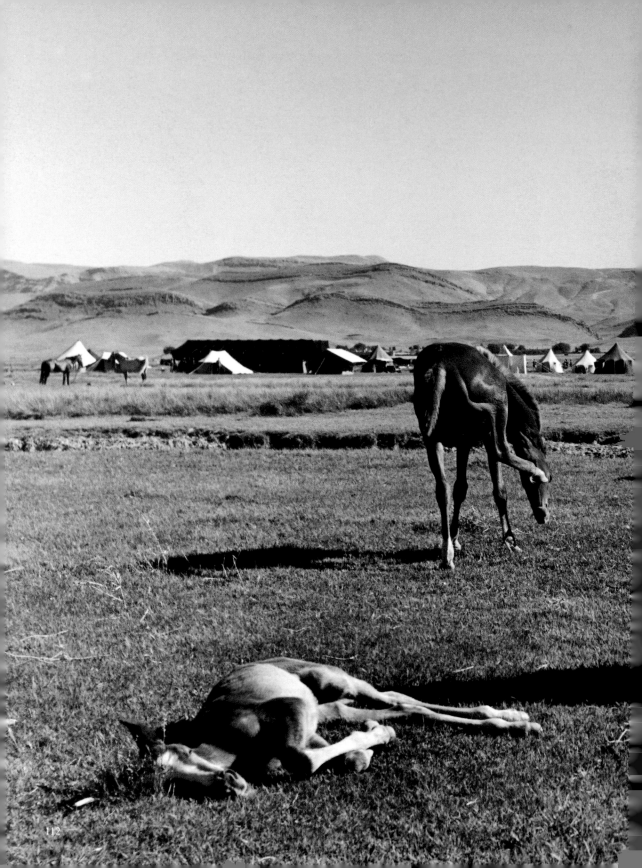

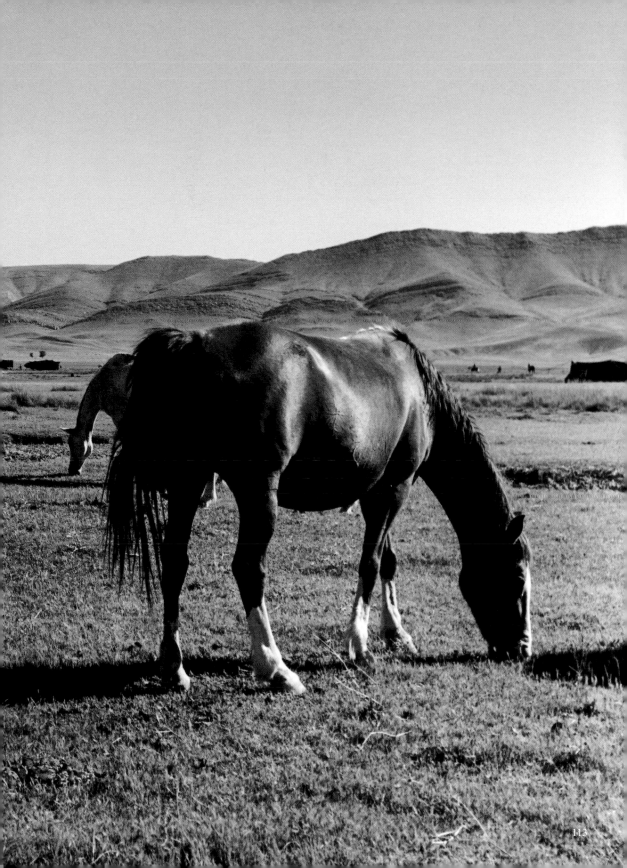

Man - mountains - his flock and sky… all are one.

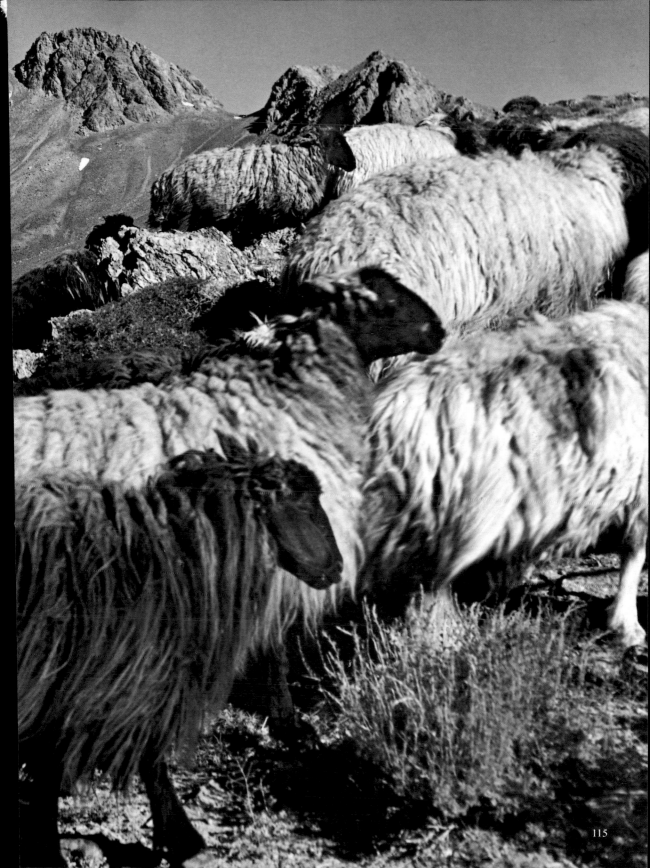

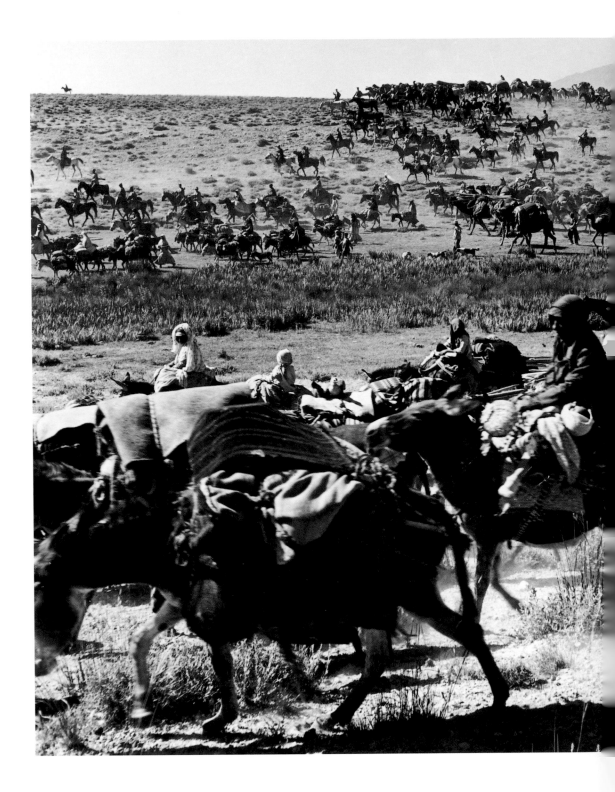

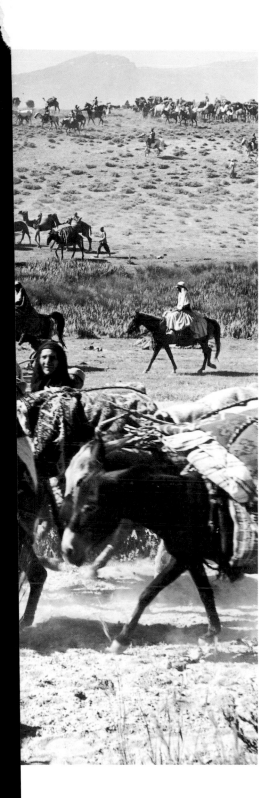

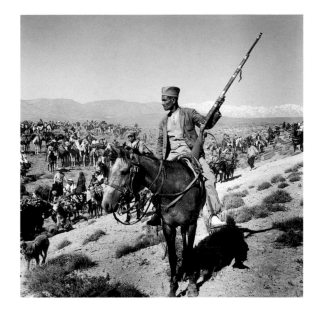

Iran
Qashqhai Migration
1946

In Spring and again Autumn as far back as any
grandfather of all grandfathers could remember
it was unwritten law of nature and tribe... grass-
lands of April – flee ice storms of Winter when
all life may perish and we are legend.

*The
Promised
Land*

Imagine
Farming
Living
Loving

Fighting
and
Dying
and
Yearning

For *This!*

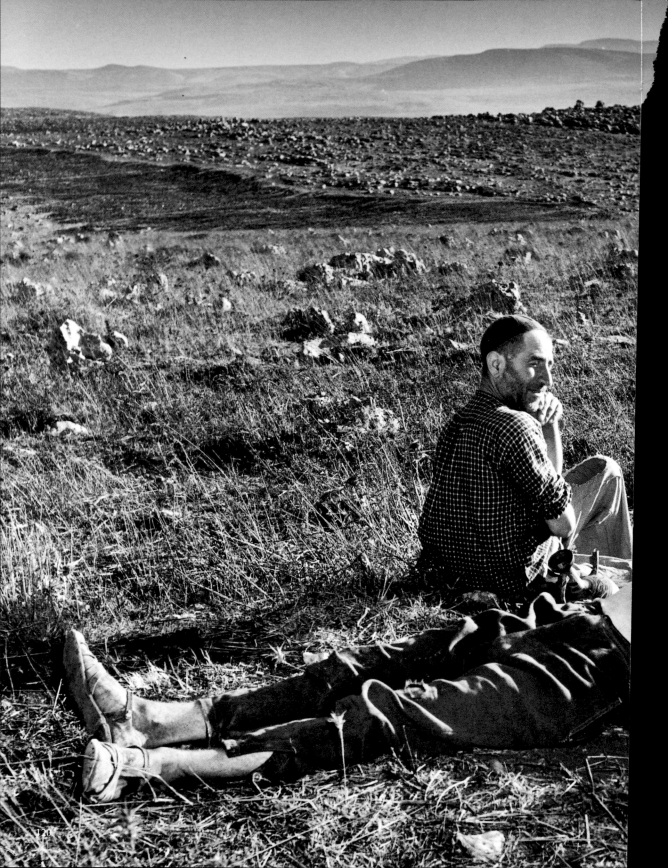

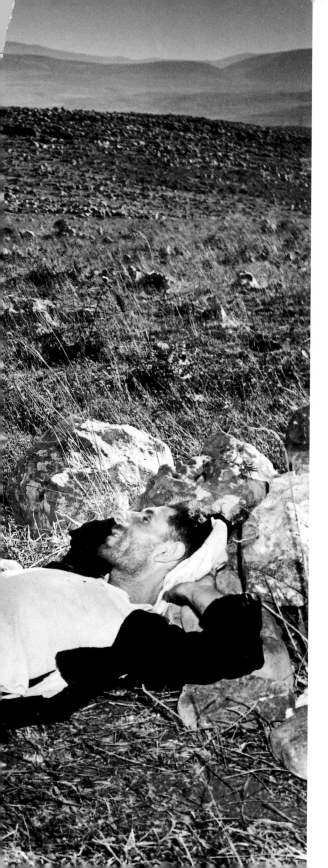

Palestine at Peace

1946

Hills and Valleys
and Dreams
of Today and Yesterday
In Galilee

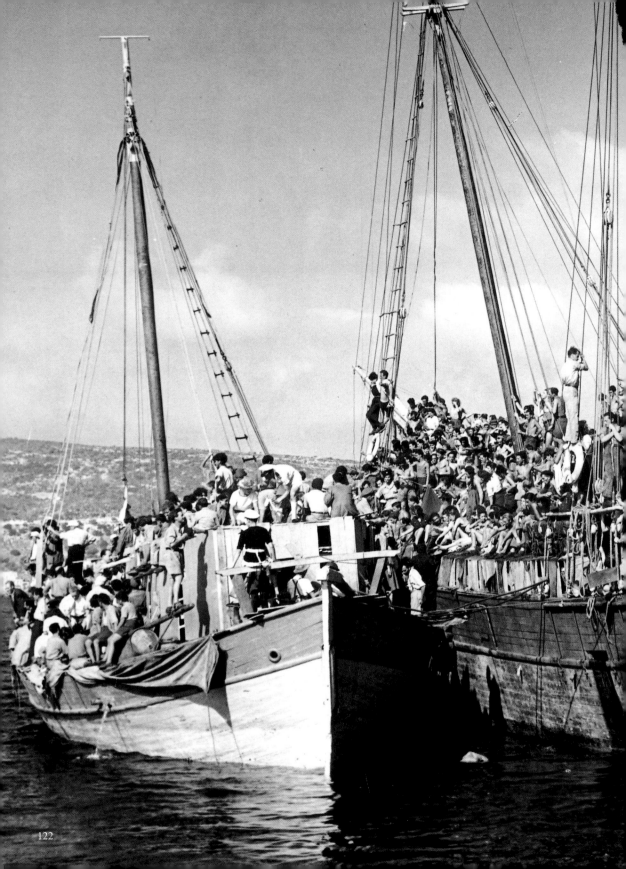

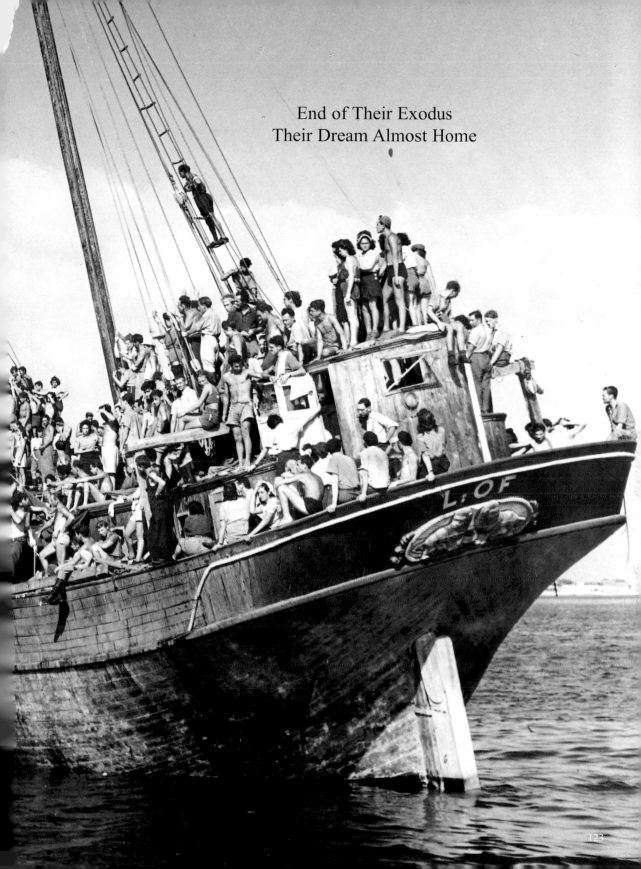

End of Their Exodus
Their Dream Almost Home

The Holy Land?
"The Bloody Holy Land!"

According to those Red-Beret paratroopers manning barbed-wire roadblocks around Jerusalem, getting shot and then trying to retrieve the booby-trapped bodies of their buddies hanging in olive groves baited for them to hit a trip-wire; or crushed under collapsing walls of King David Hotel – dynamited by Irgun "terrorists" (no quotes in my old LIFE stories of July '46) blown

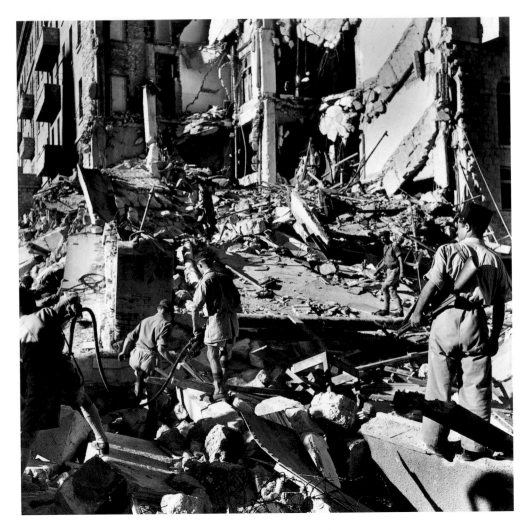

LIFE Magazine New York/Cable & Wireless / Jerusalem 13 Sept 1946
Hicks: Shipping film exclusive terrorist attack Jaffa Bank gunman backseat shot three Arabs

at noontime with Finance Director Thompson at his desk working overtime to go swimming. The Irgun Gang of a shadowy Menachem Beigin, whose Marine-style sharpshooting machinegunner had mistaken me for a young Sabra from a *kibbutz* (Qashqhai mahogany) dancing his fire around me when robbing the Ottoman Bank in Jaffa, just before I got a firstever interview with Beigin, whose guys made a map for me of their dream coming true.

So *sure* they forgot one word -- Israel.

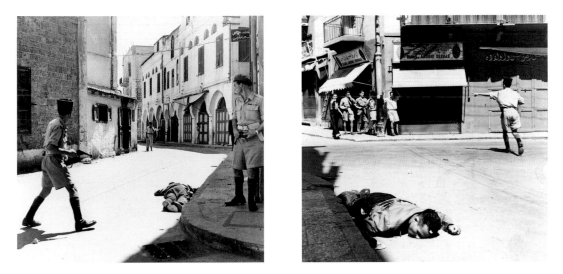

beside me capture of three terrorists whole show accurate report still missing you'll get it before pictures . . . what a beautiful day still to be alive. Dave

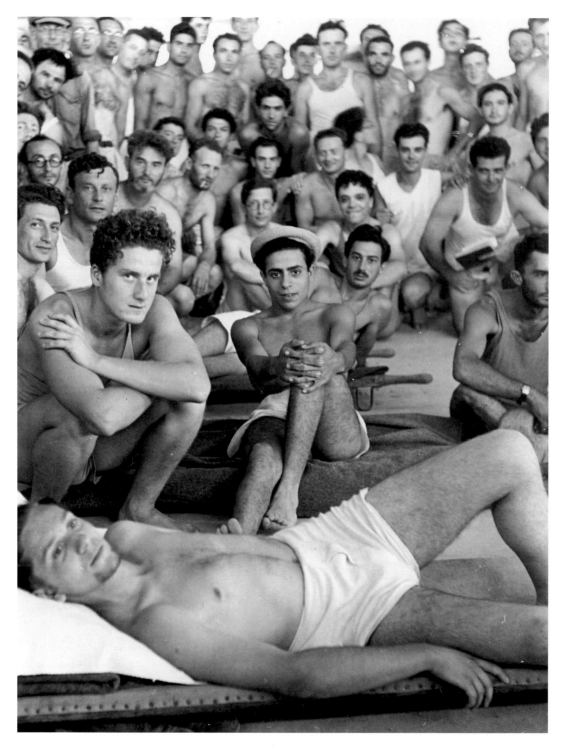

Jewish Refugees / British detention

German camps to Palestine camps

126

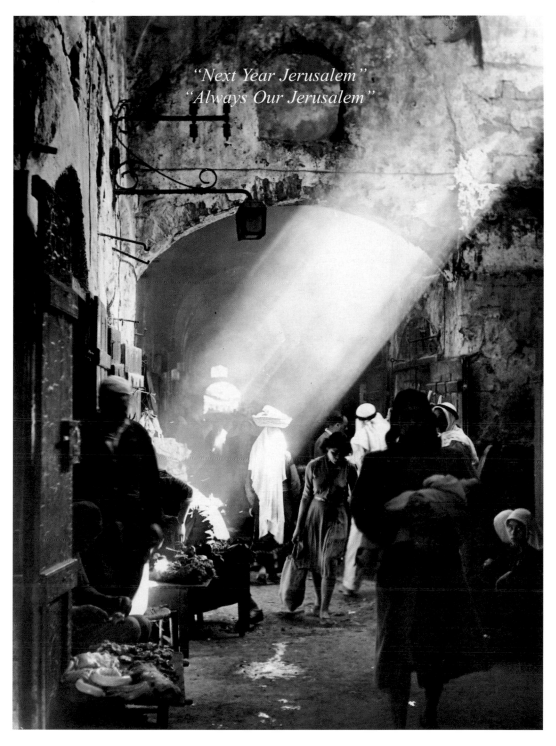

"Next Year Jerusalem"
"Always Our Jerusalem"

Old City of Jerusalem / Arab Residents. No photojournalist alive today will shoot the answer.

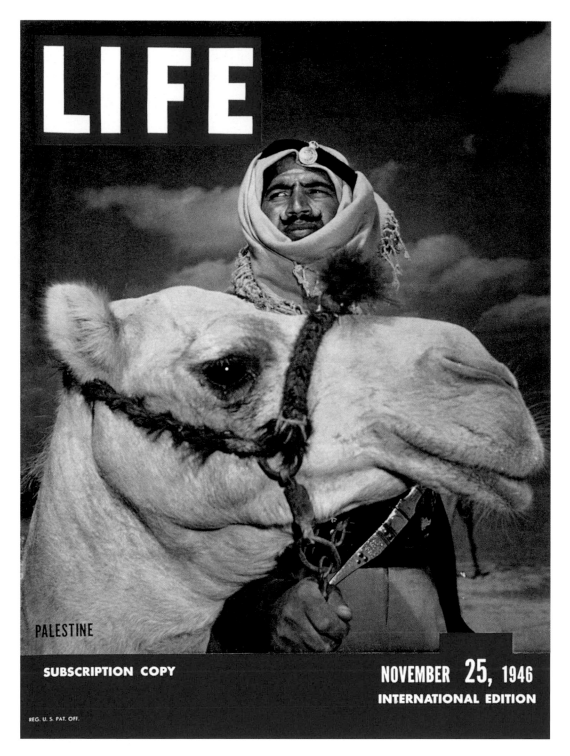

My first LIFE cover came as a surprise – atop Everest with Hillary
and Tenzing – the second of India/Pakistan's godfather; murdered.

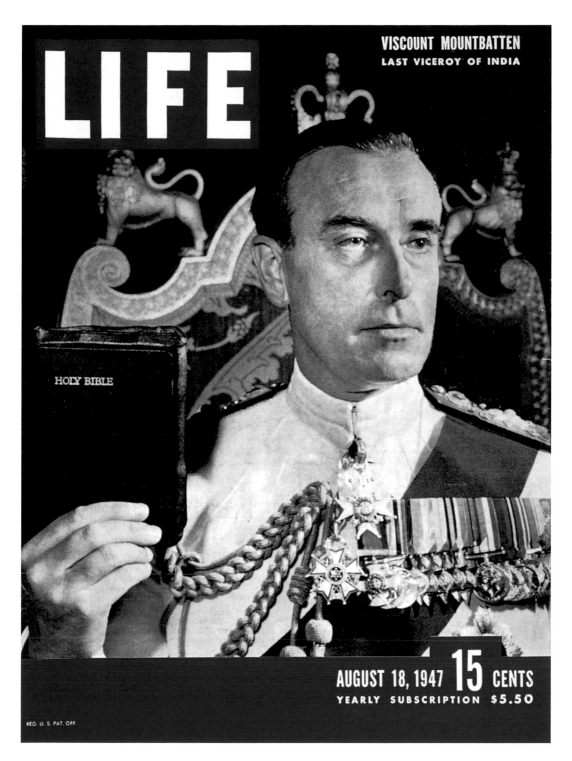

There was no armed conflict between Arabs and Jews when I arrived in Jerusalem from the Qashqai tents: both worlds' doors wide open.

Desert honeymoon
— Egypt and Arizona —

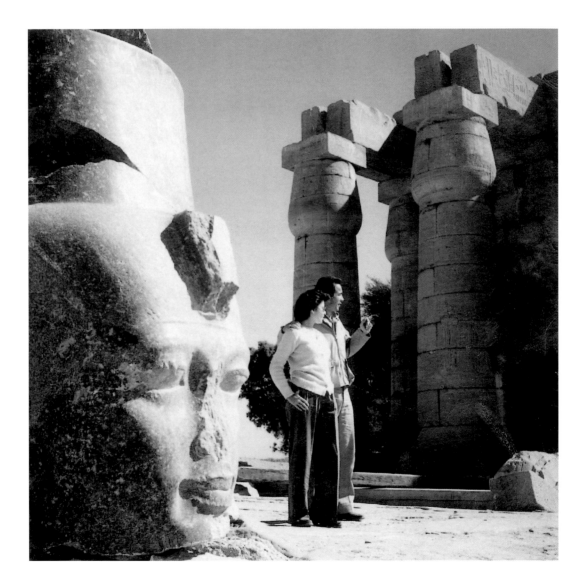

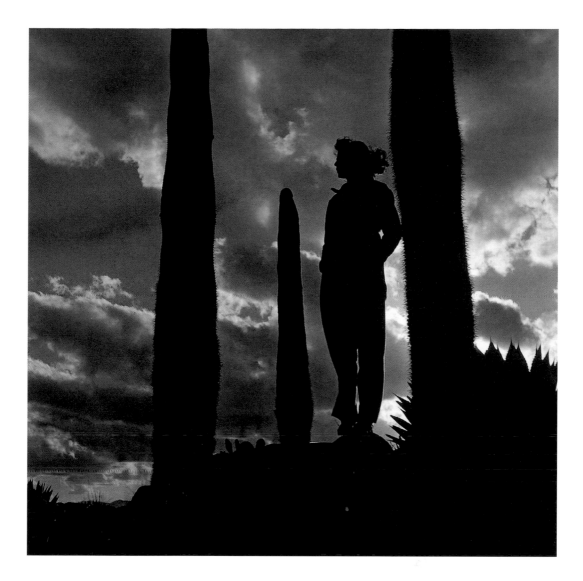

Karnak amid pharaohs' towering temples to their sublime afterlives -- then to those equally towering (for Nature) monoliths silhouetting a slender visitor from the Nile Valley itself: shared adventures into the other's world where everyday was a field expedition to the fragile dreams and hopes and expectations that life would continue as a honeymoon day-after-day . . . and it did indeed until many years later.

Auburn-haired, freckled, books-reverent, wren-curious yet secretly gazelle-shy, now American, multi-lingual Turk-Egyptian who in Kansas City bestowed her magic perhaps loving my family more than her own . . . thank you from all of us – Loussa.

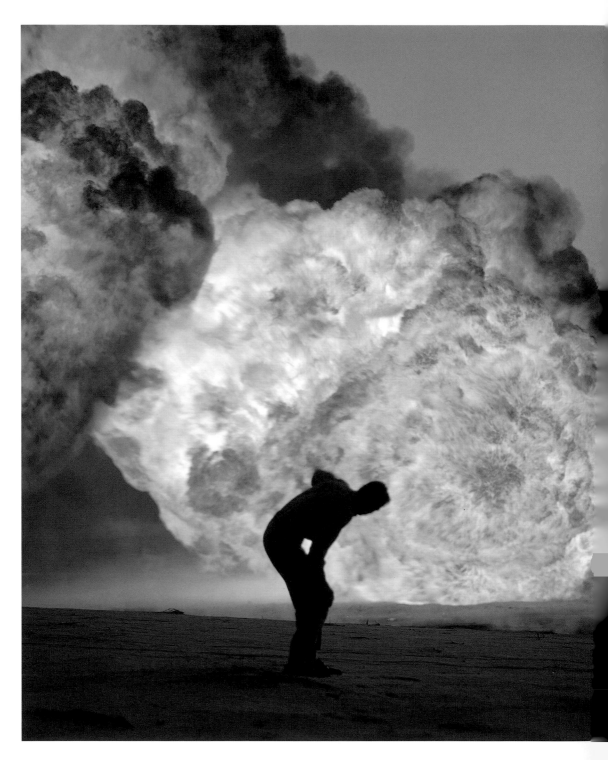

Geologists, cobalt-glass goggled, checking arrival of ready-for-production pure oil at Abqaiq well 44 – then cut "flaring" and well-head spigot closed.

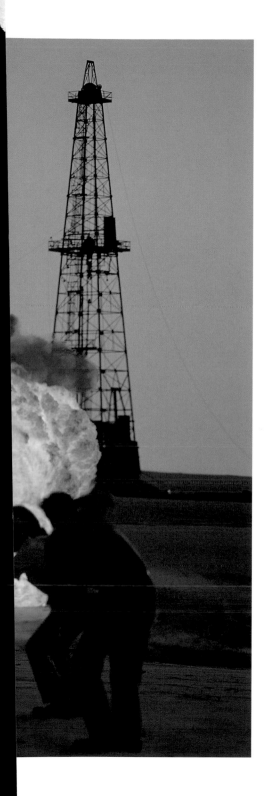

The Flaming Heart
of
World Power
and
Moslem Anguish

ARAMCO
Arabian American Oil Company
Dhahran
Saudi Arabia

on the
Persian Gulf
another world
from the birthplace
of
The Prophet of Mecca

133

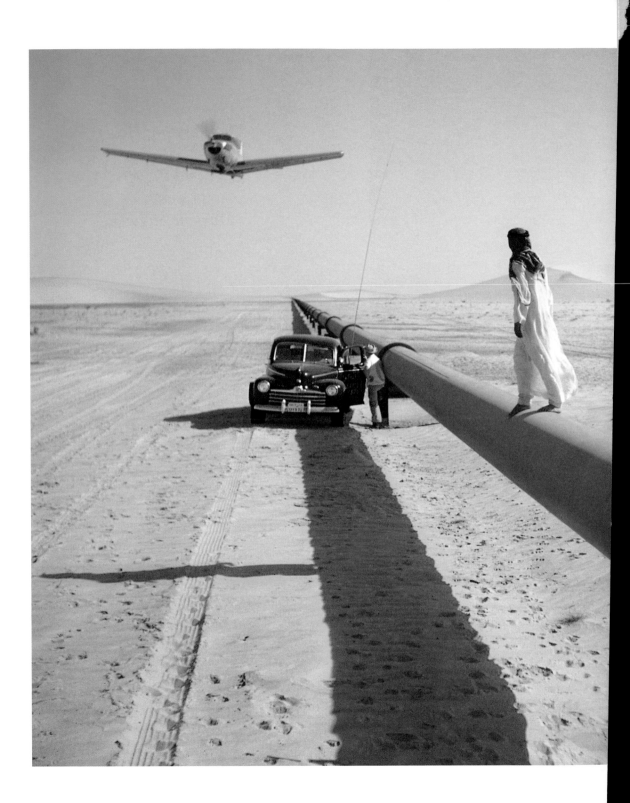

1948
Trans-Arabian-Pipeline
Dhahran ... Kuwait

TAP

air patrol – scout car – barefoot
preparing for its birthday
every steel mile checked daily.
140 F
noontime
normal tracker's stroll.

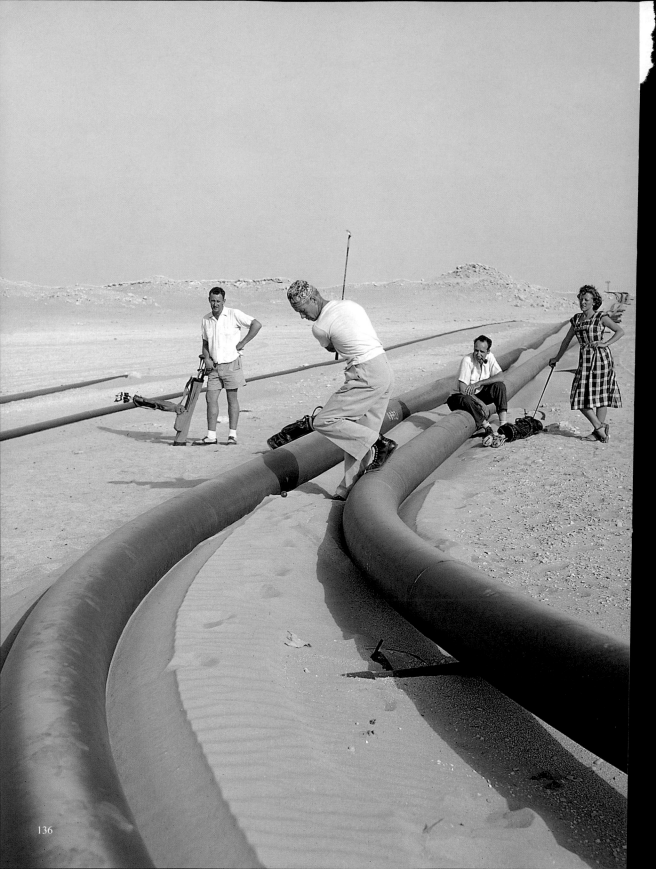

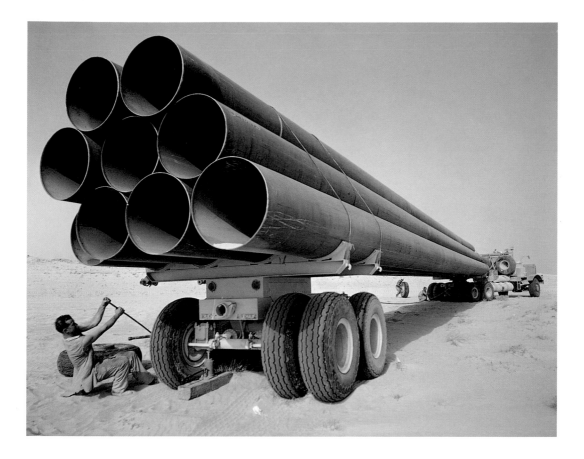

Talk about Sandtraps … All of Saudi Arabia!
And the rough? — you mean grass? — not a blade!

Really fun
after you'd changed a 200-pound super-reinforced tire
on a stuck Kenworth monster
in the
worst boondocks like no other except maybe

— Guadalcanal —

A bit too fast – broken weld – minor disaster
normally – 500,000 barrels a day – Dhahran-Kuwait

Lifeveins of mankind's world today
Once upon a time this was a tropical forest

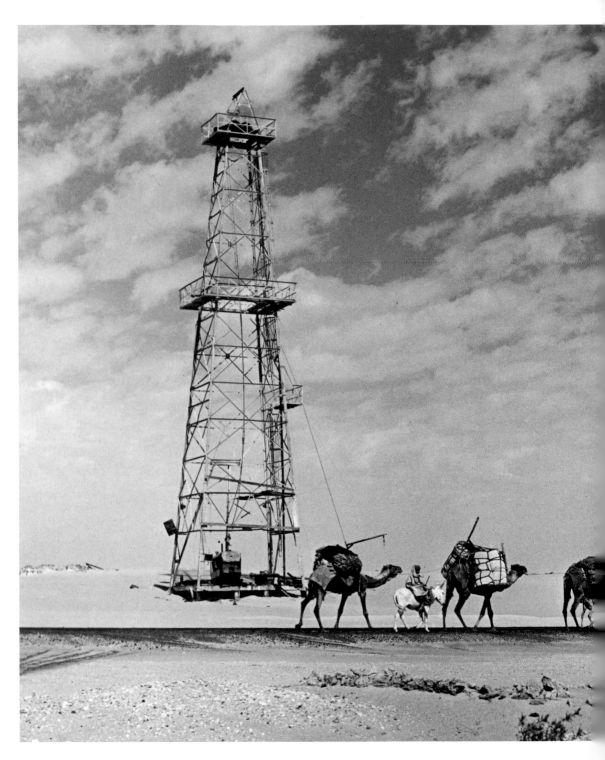

Battered mobile oil rig atop greatest oil ocean on earth

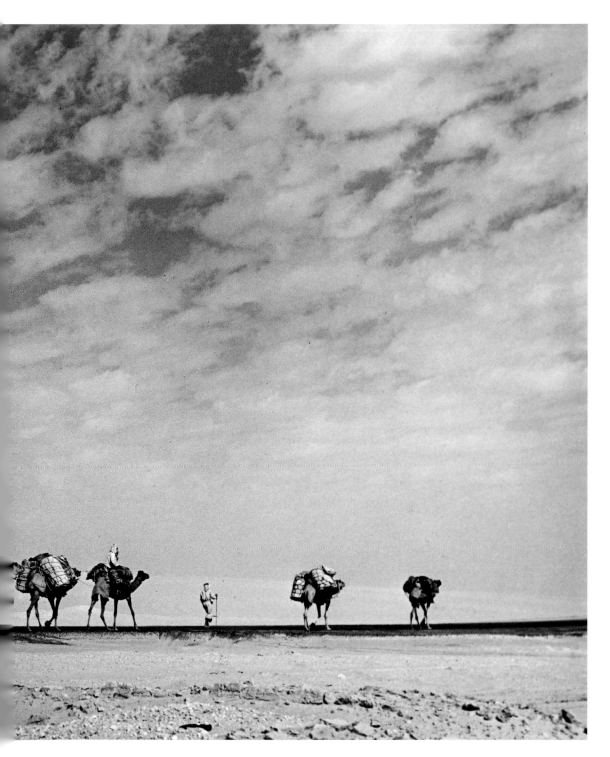

Saudi nomad family with all possessions soon in a Toyota pickup or Ferrari

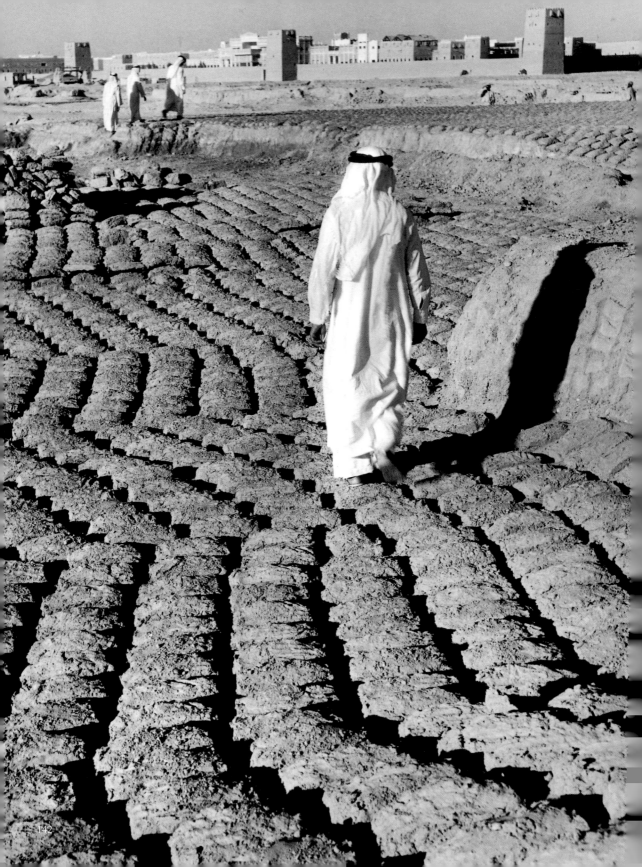

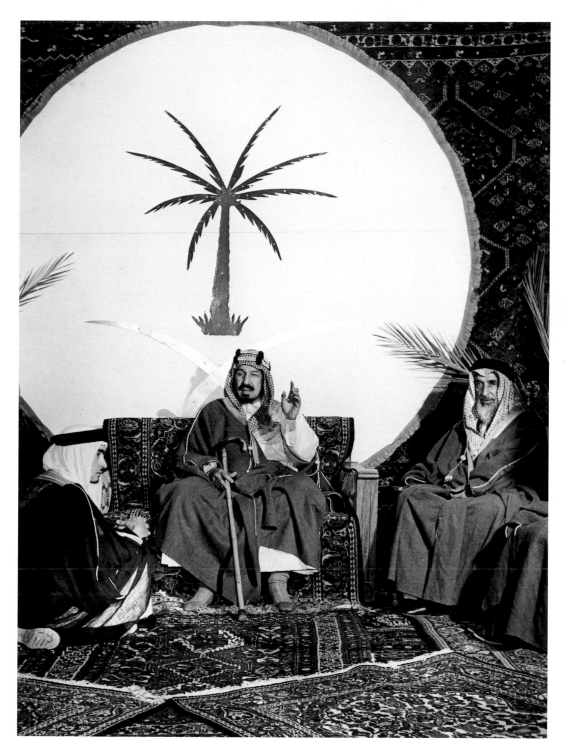

King Abdlaziz ibn Saud conquered this fearsome land almost alone.
Riyadh - Saudi Arabia - 1947 - adobe-turreted fortress - yesterday razed today.

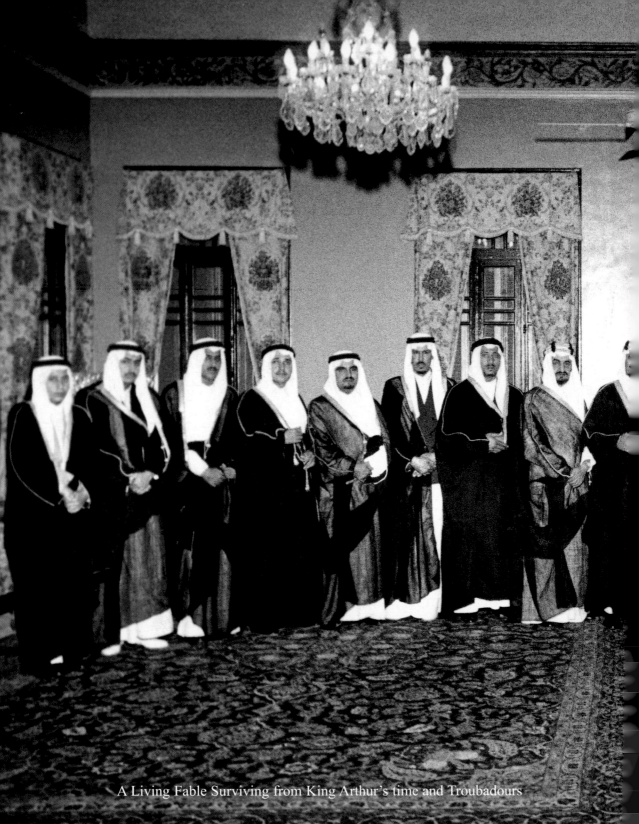

A Living Fable Surviving from King Arthur's time and Troubadours

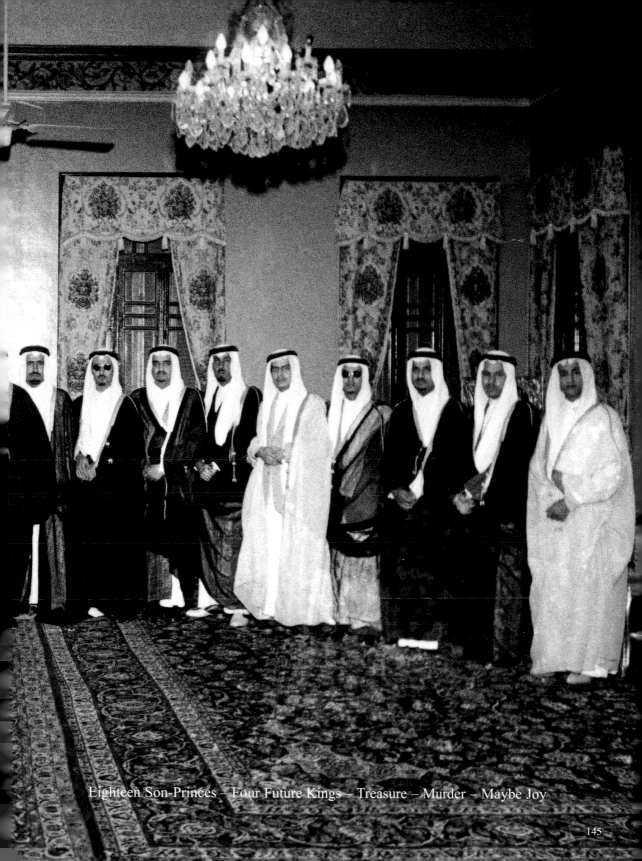

Eighteen Son-Princes – Four Future Kings – Treasure – Murder – Maybe Joy

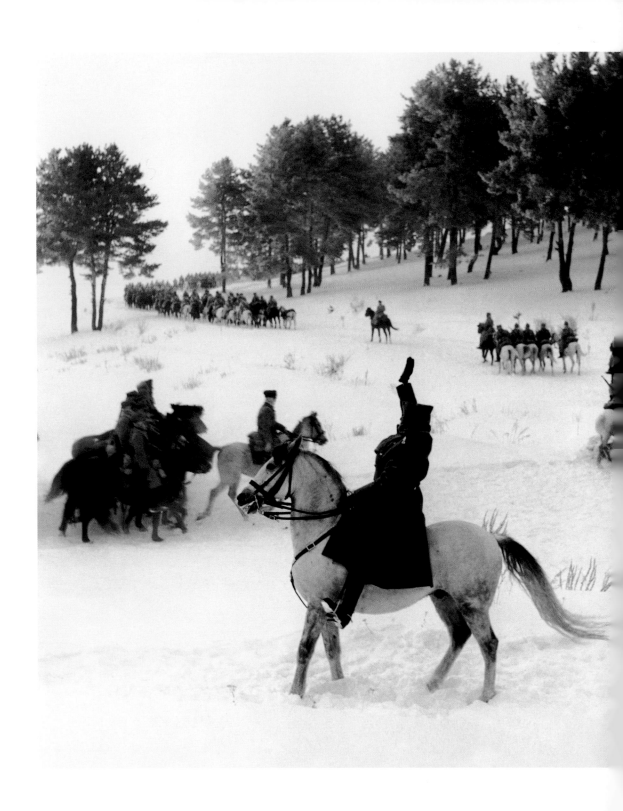

Turkish History

Russians called him *"Kara Avni"* Mizrak, Black Avni, because of the ferocity of his cavalry charges in the First World War. Later, high among the icy forests and rills of a land that had seen nine invasions come from the east, Black Avni's men rode out into blizzards which they welcomed. Each storm reassured them of an ally long considered vital to the country's defense.

President Truman probably wrecked plans of the Soviet Union to dominate all of Europe, when he launched the Marshall Aid Plan for Turkey and Greece. It surely gave all other war ravaged lands cause for hope, too.

In Turkey, Harry Truman was teamed with President Inonu who rebuffed Churchill and Roosevelt during World War II, with a refusal to declare war against Germany or to send troops to the eastern front. He was sure the Red Army would have moved, as in the Balkans to occupy both the Dardanelles and Bosphorus – historic dream of Russians for five hundred years.

That winter, as weapons of modern armies poured in, Black Avni's cavalry columns appeared headed toward the pages of history – where they would feel more at home.

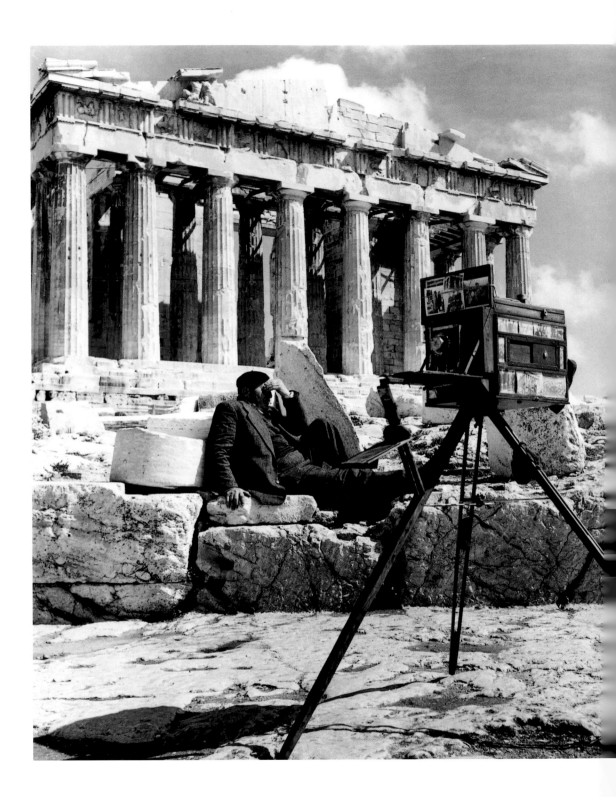

Athens
Ancient — Modern

1948

Acropolis - Civil War
Greek general / American general

andarte
guerrilla trench
filled with
blemished beauty
modern
Parthenon
every soldier a girl

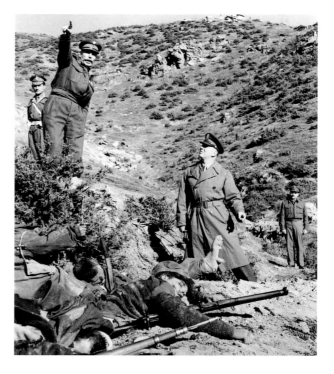

Tortured shepherd nearly blinded
for no reason at all by his neighbors

Shooting War Photographs?

Be close – Be fast – Be Lucky

Easy

always remember

be humane

never closeups of the dead
war is in the eyes

Florina Greece
1948

His Queen and King … Fredricka / Paul
hospital patients massacred by friends.

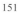

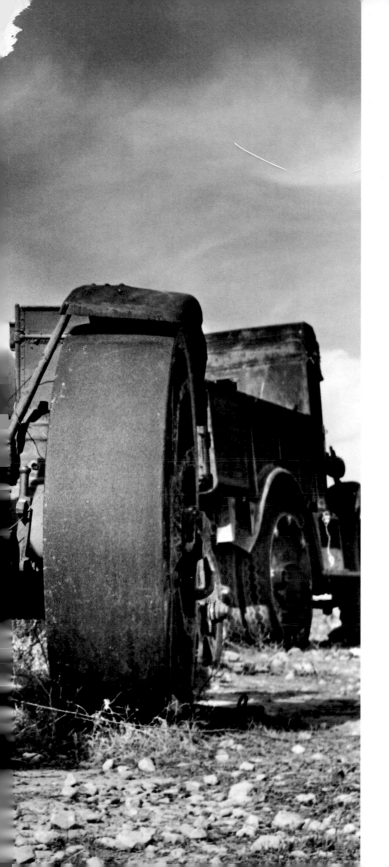

Shade for Goats
Mussolini's African
Dream

Libyan Desert

1949

Montgomery
Rommel

North Africa

Another War
Normandy – Stalingrad
Battle of Bulge
Iwo Jima
Ahead

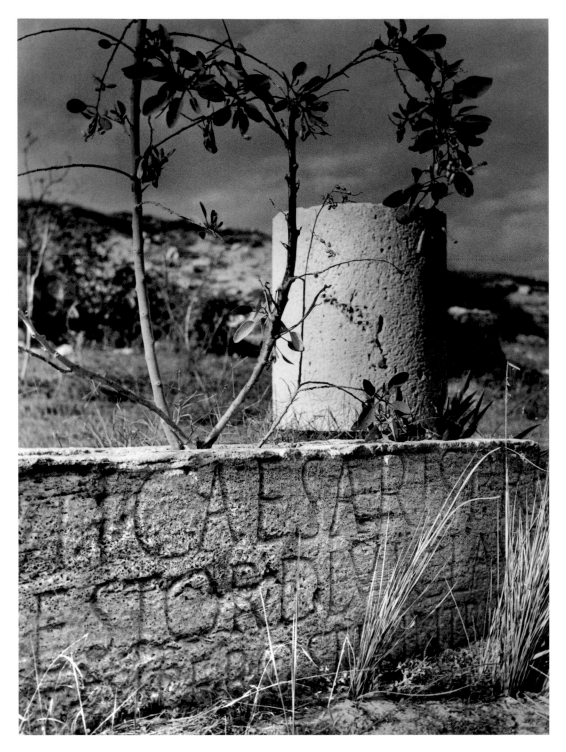

Julius Caesar's Aqueduct

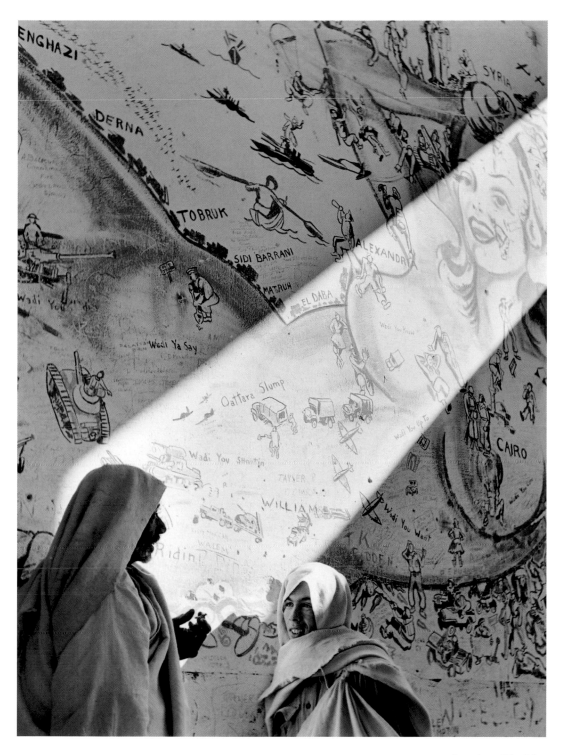

American War Map

Italian artillery - 1949 - Libyan desert

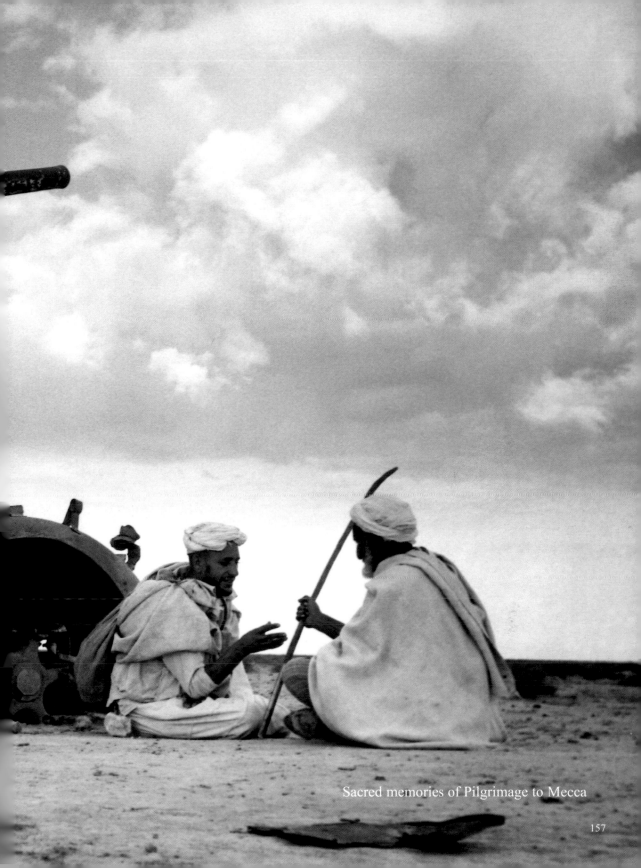

Sacred memories of Pilgrimage to Mecca

157

The Korean War
1950

General
Douglas MacArthur

"Caesar of the Pacific"

first three months

Marines - Navy - Air Force

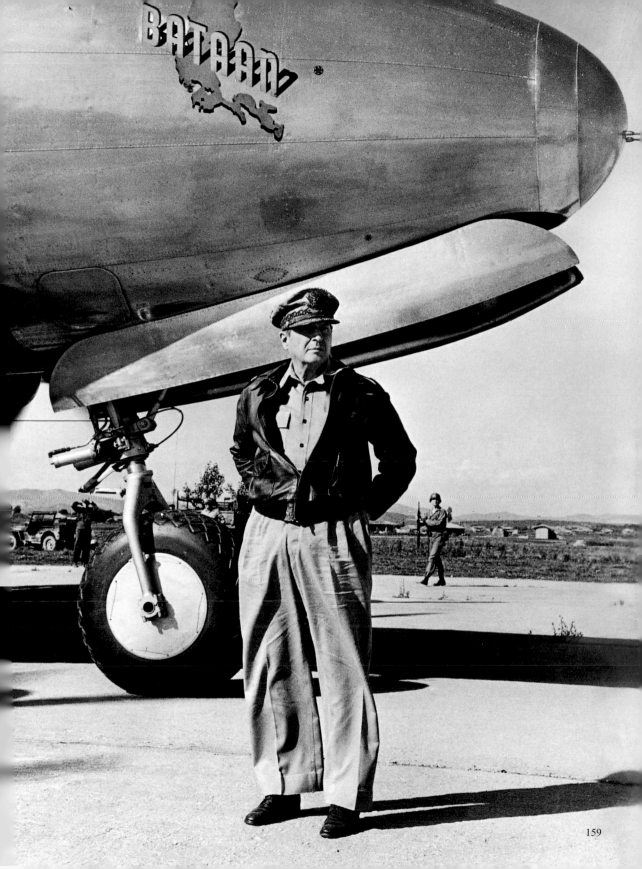

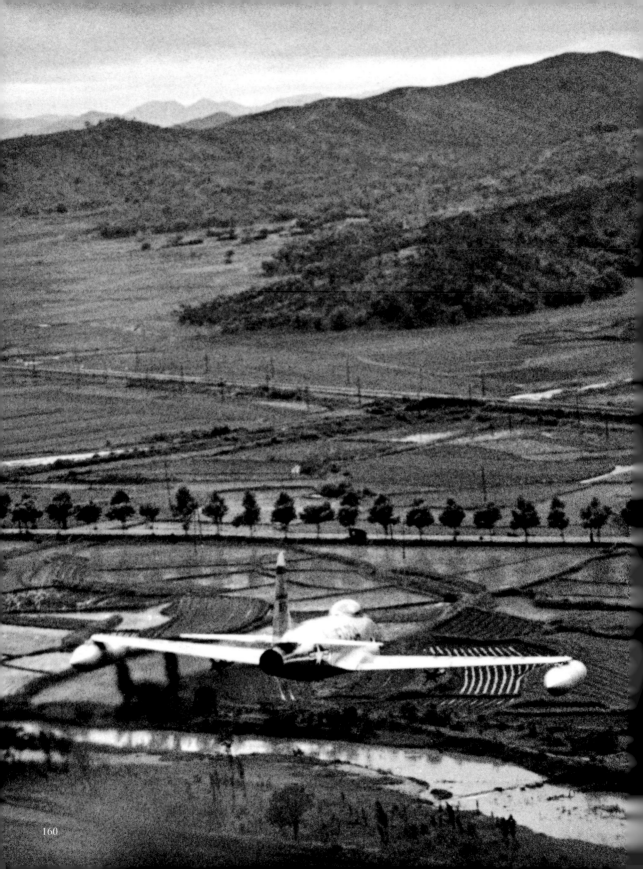

Grim days - Seoul gone - enemy tanks - jets fighting alone

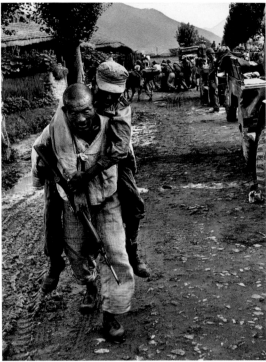

North South

Korea

South Africa? – South America?

War

Doomed to Oblivion
Before it Began

Except

for
Those Who Fought There

Wounded South Korean soldier
carried to rear after nearby
ambush by infiltrating enemy

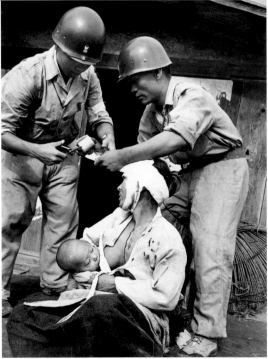

Local village mother nursing
son whose father just died in
same North Korean ambush

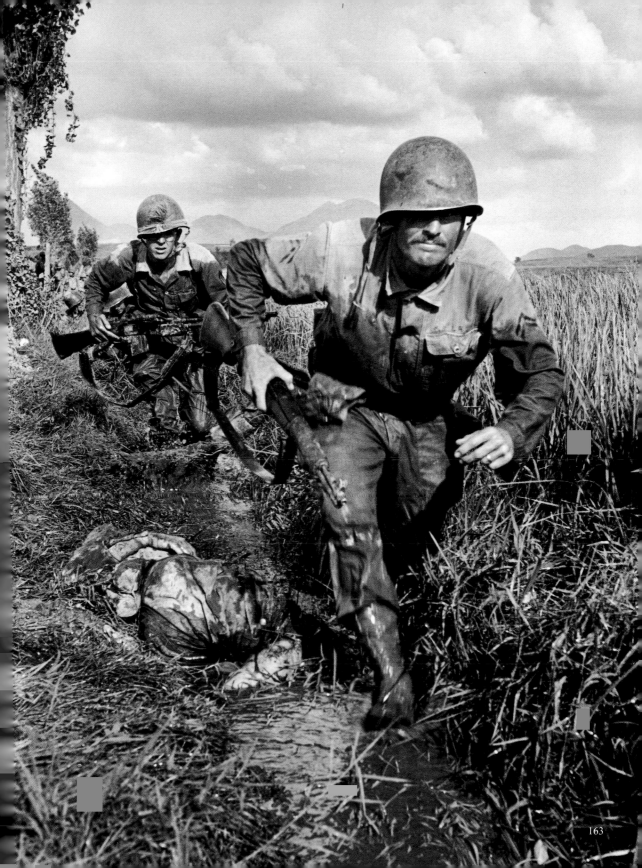

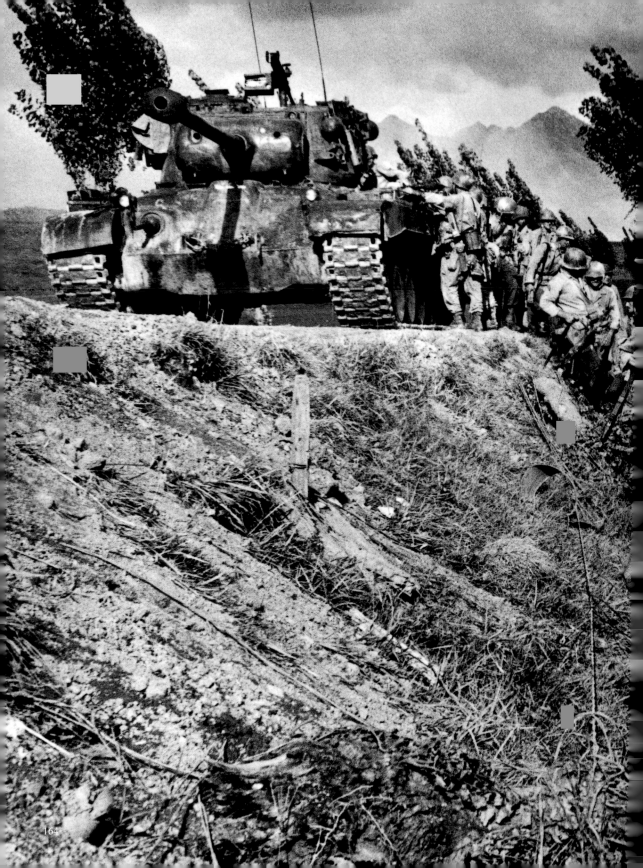

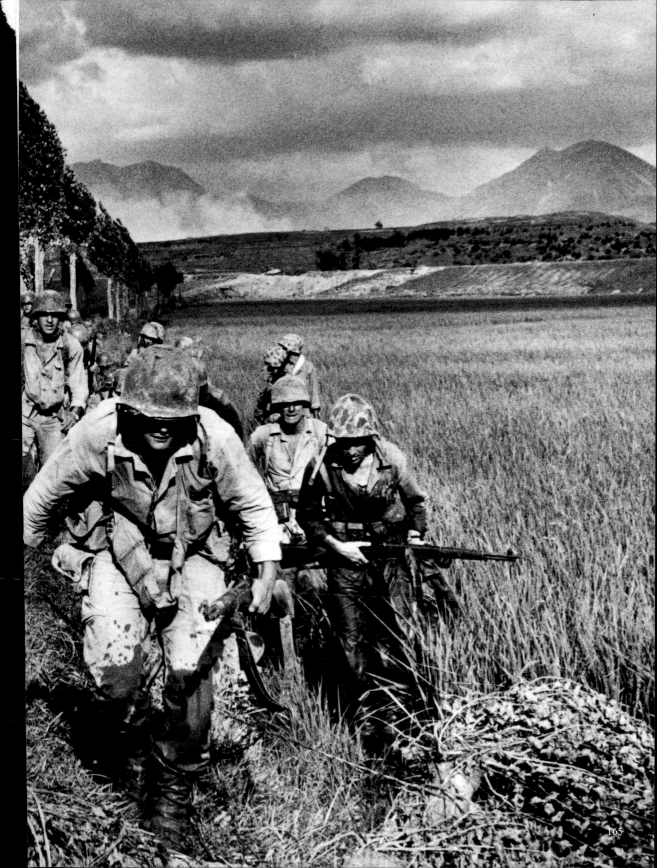

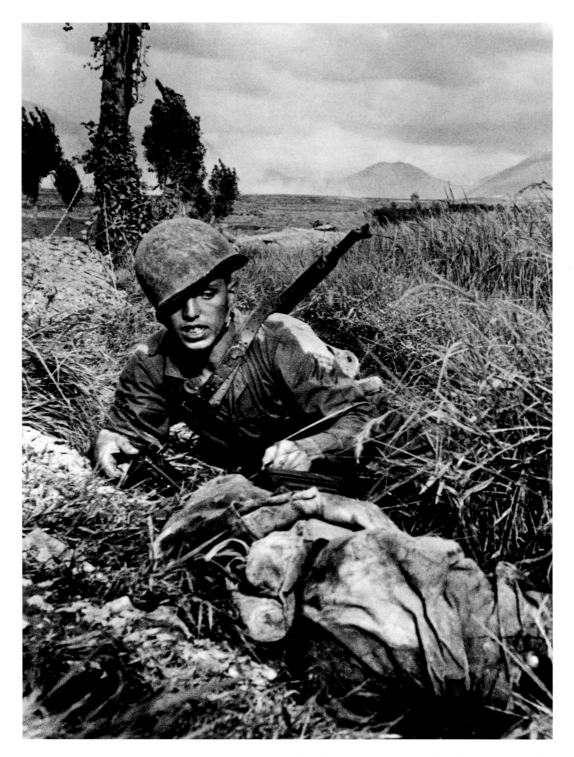

No place for a teenager -- even a brand-new U.S. Marine.
Jesus . . . Almighty God! -- boot camp wasn't like *this!*
Those guys pretended to look dead -- *almost no head!*

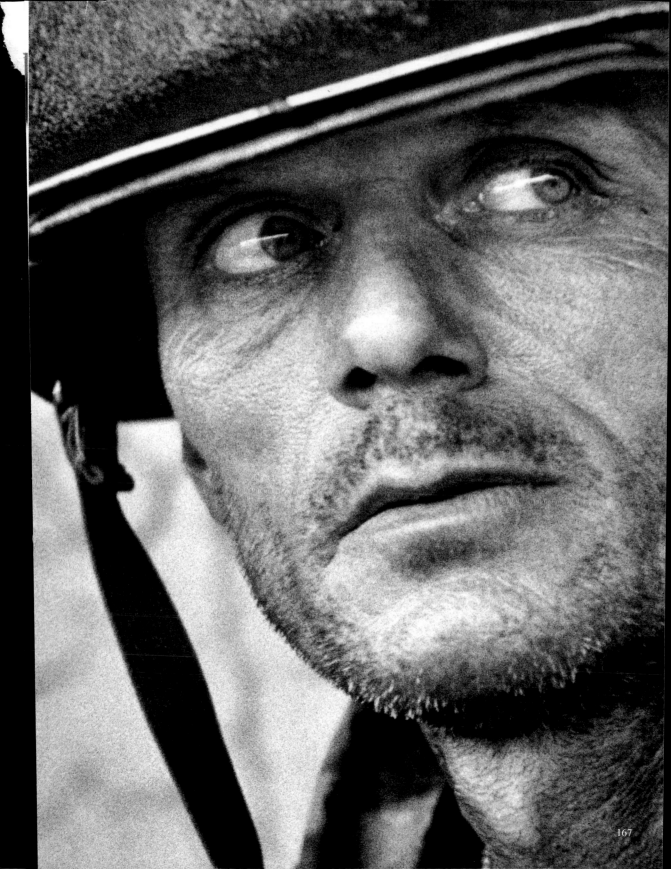

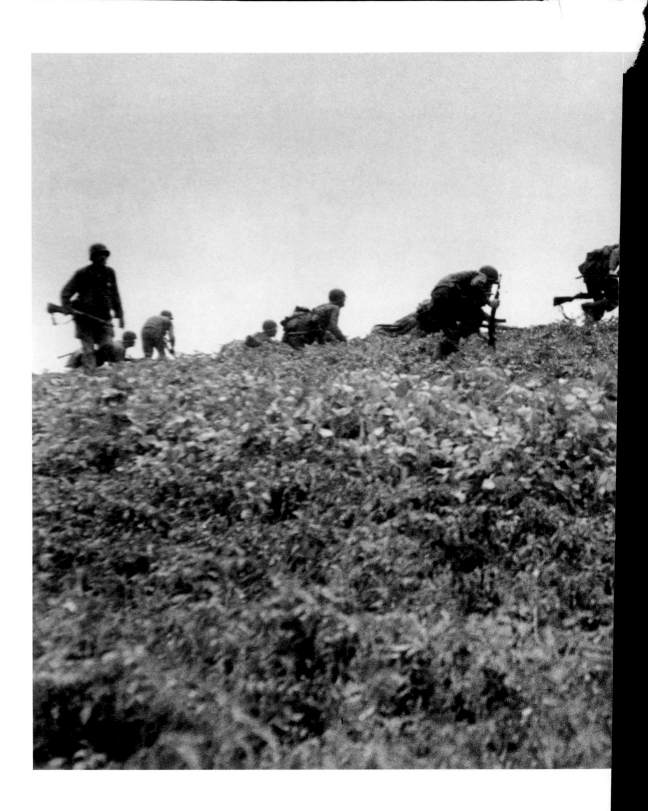

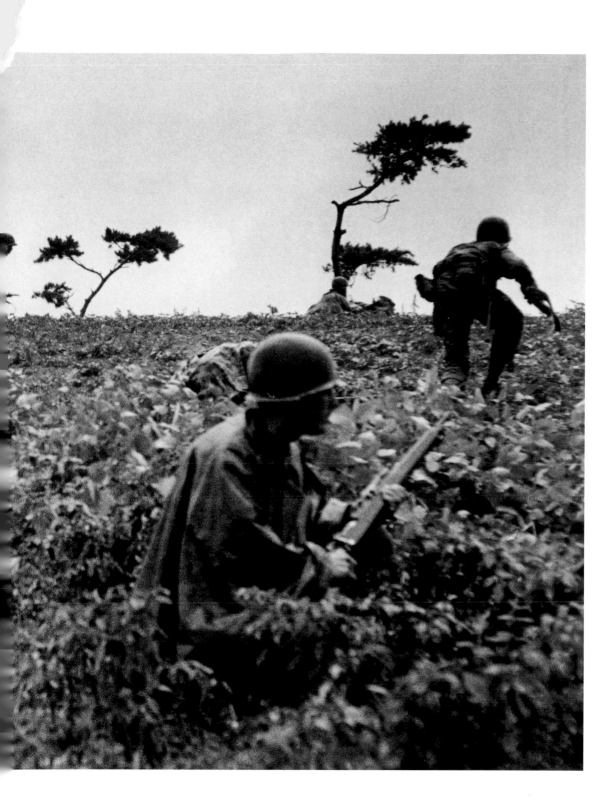

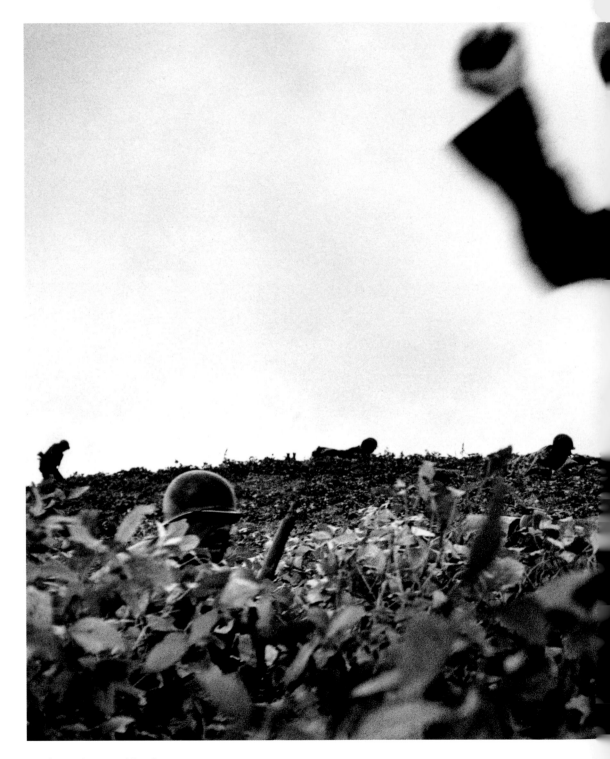

Hot in-coming -- sudden first monsoon
not faraway -- "medic . . . medic -- *Doc!*"

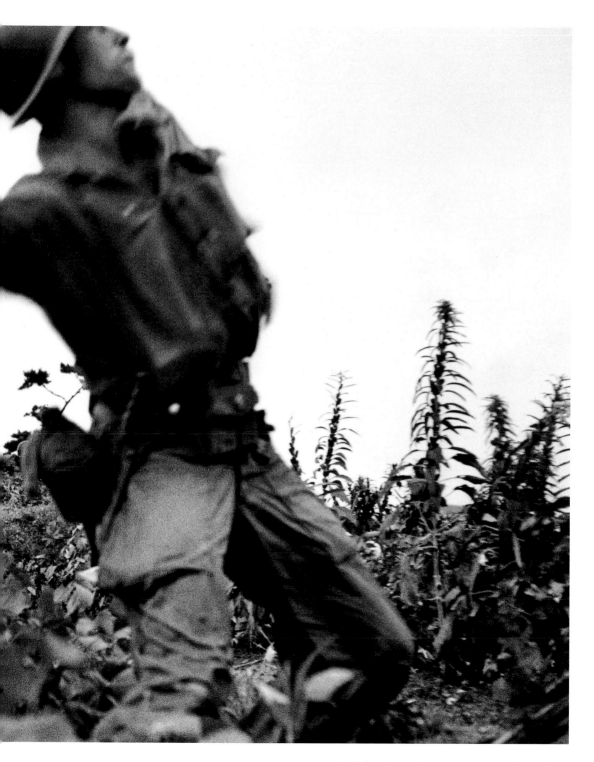

And then there they were again out of nowhere,
those South Koreans helping just like Marines.

The Price
of
One Worthless Hill

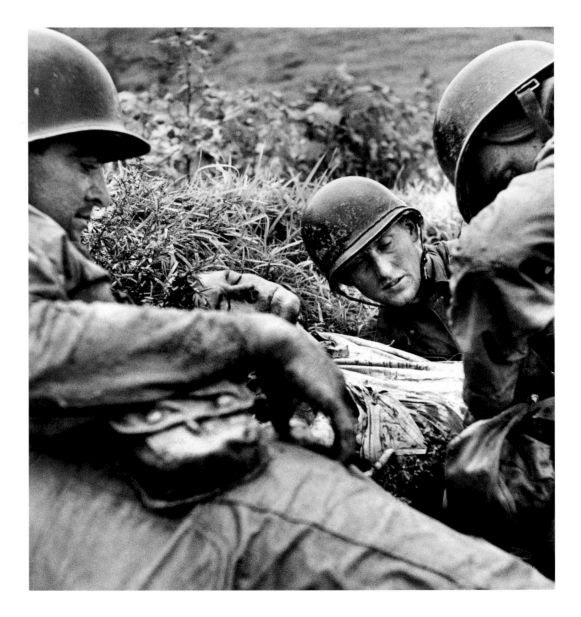

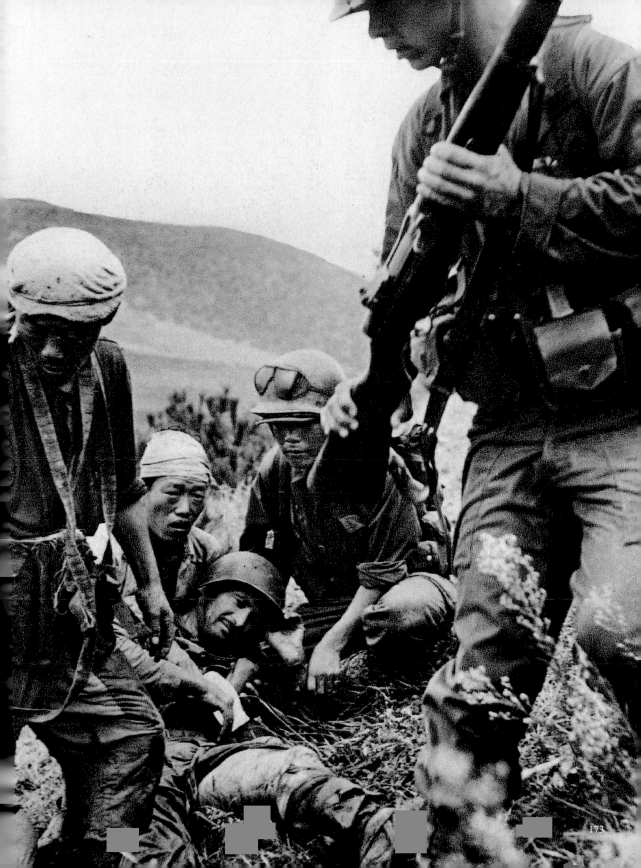

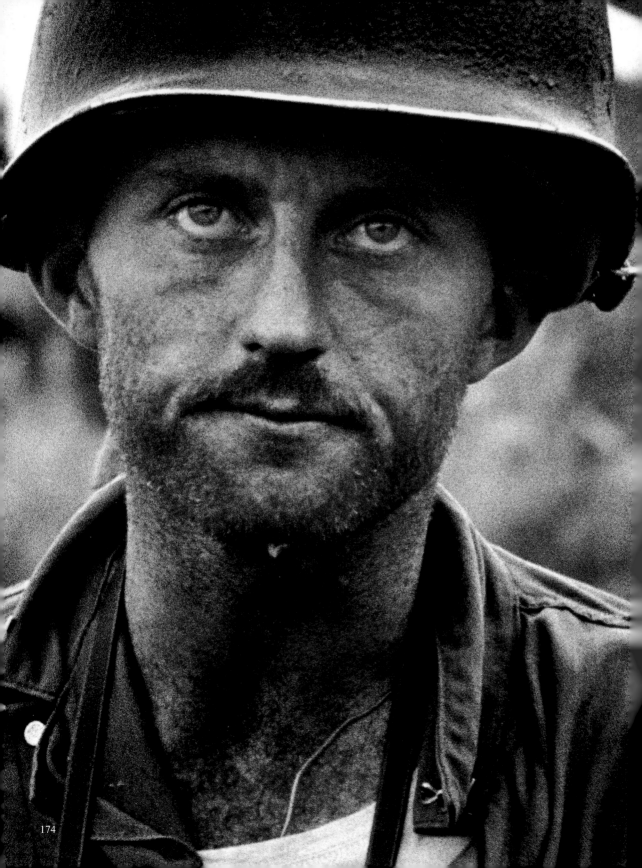

That Thousand Yard Stare

Captain Ike Fenton
U.S. Marine

1950
Naktong River
Perimeter

with some problems
no radio with anybody
mostly grenades
bayonets of course
no reinforcements
that's normal because
nobody back there knows
casualties
high still climbing
suppose
gook battalion
climbing
our little hill

Yeah . . . now to worry.

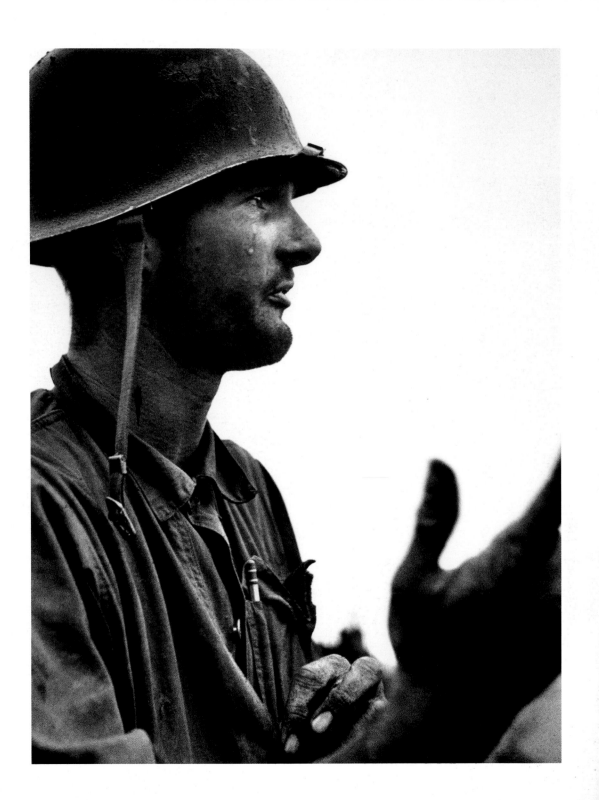

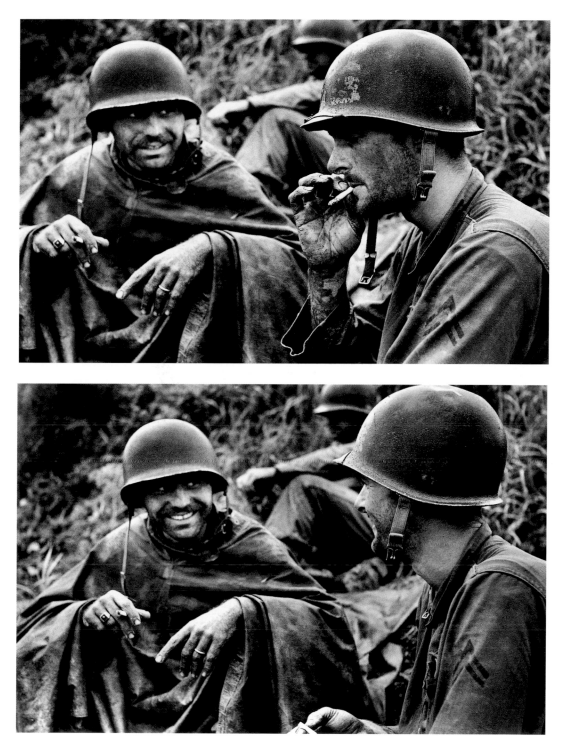

Corporal Leonard Hayworth machinegunner
without ammunition -- gun-mate killed
sought Captain Ike Fenton's help . . .

wept -- not fear -- helpless . . . hopeless until
another Marine speaking combat language
found a smile -- not lifting a finger.

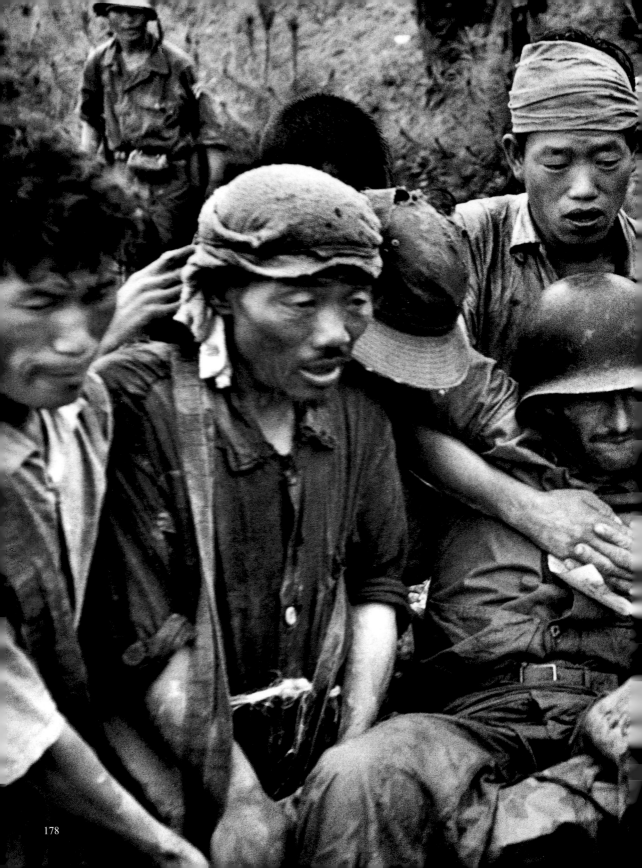

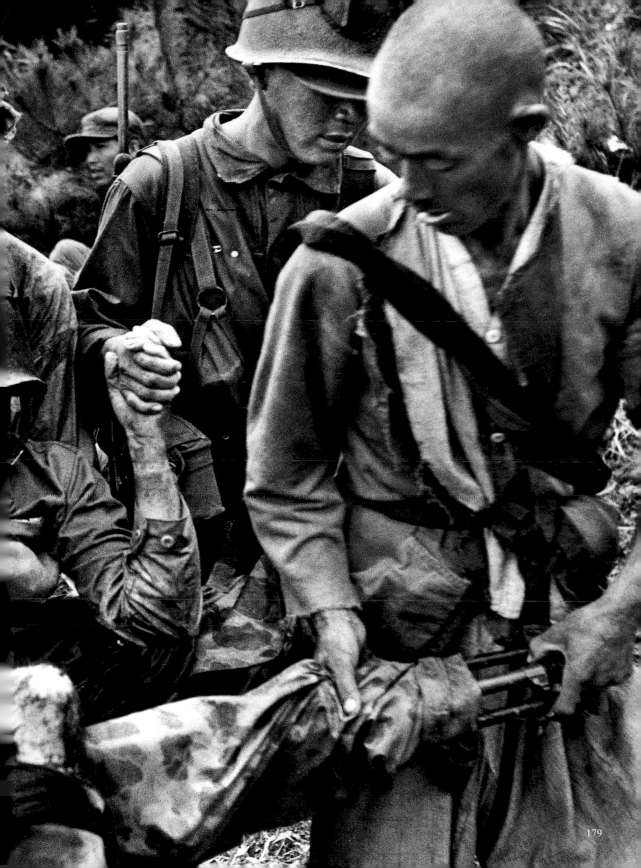

Two Marines — headed home
...a deep-mud road leading to forever for one.

25
September
1950

*Three Months
to
The Day*

McArthur

declared
Seoul
"Liberated"

Great!

— if not there —

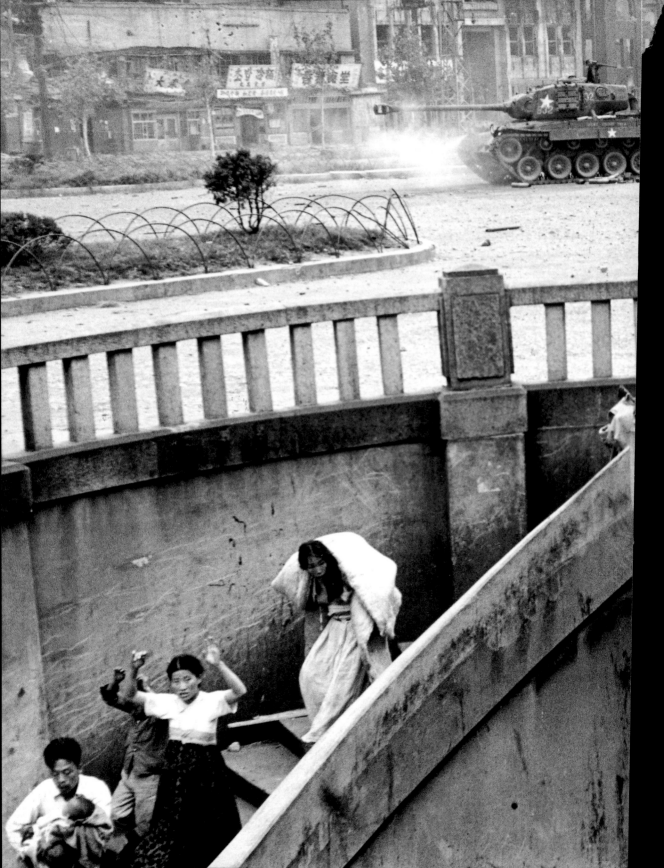

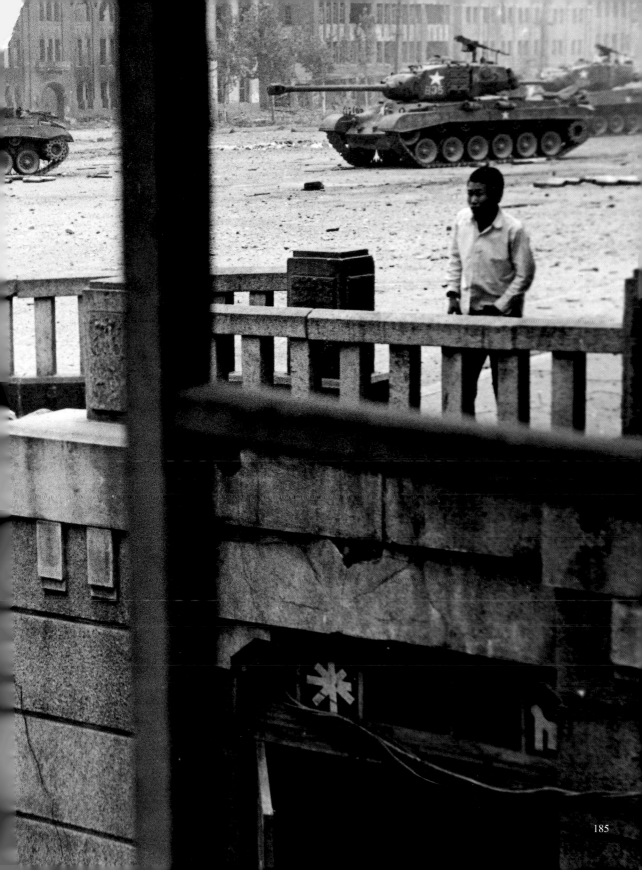

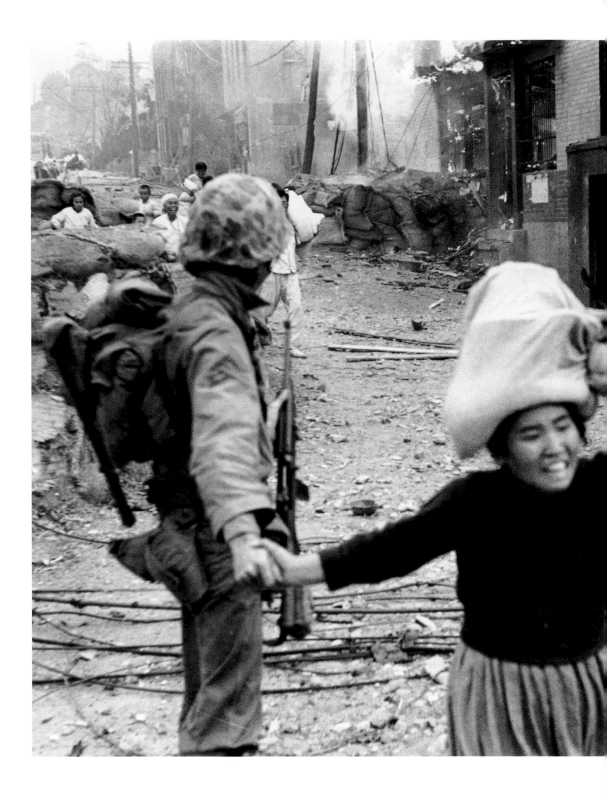

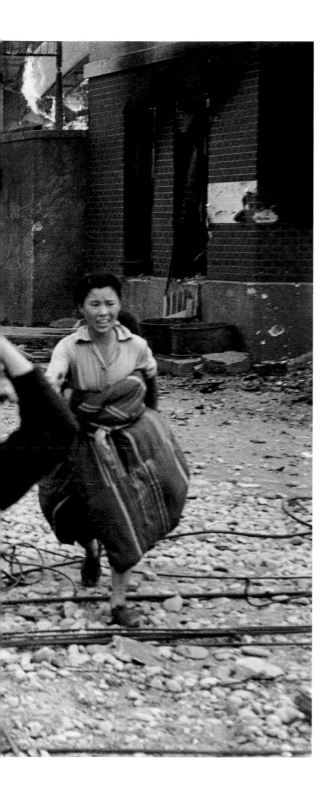

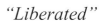

Those Hands
and
Smiles

Told the Story

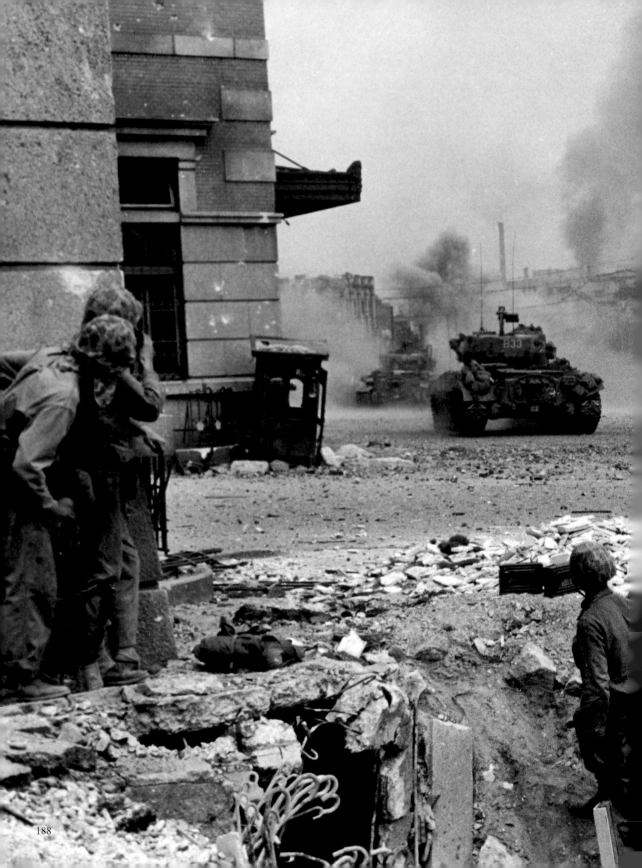

"The Greatest Show in Seoul"
for Marines who paid the price.

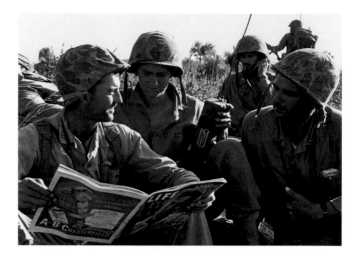

Captain Ike Fenton enjoyed

LIFE

Like at the drugstore back home, with a picture story about us way back on the Naktong River (LIFE had broken records sending it) with James Michener's "South Pacific" on its cover.

Wow!... What a show!

Over Ike's head another show was already their life.

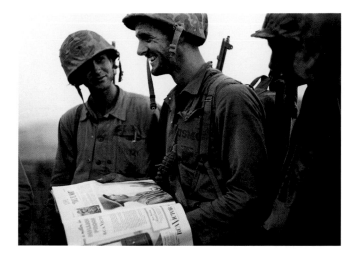

"This Is War!"

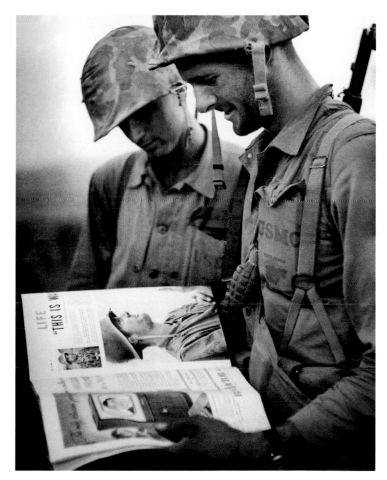

Quiet Leonard Hayworth,
an expert machinegunner
Deerpath, Indiana, tear-
on-cheek . . . handsome
as movie star Errol Flynn,
saw himself in the lead
story of the biggest photo
magazine in the world.
Silent a moment, smiled.
Never said a word.

Dawn . . . "Seoul liberated"

Sniper shot.

Between the eyes.

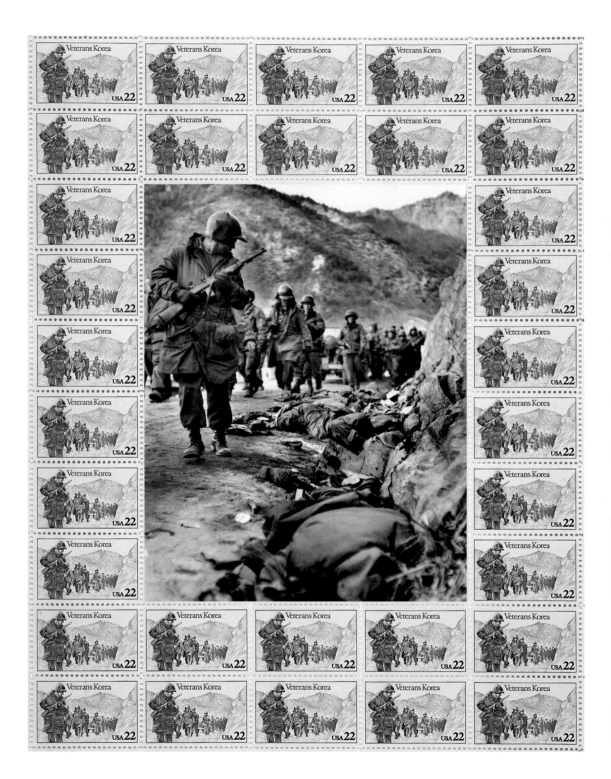

North Korea
1950
December
- 40 F

Years later a 22-cent stamp / bargain / censored / maybe "no casualty" wars were born.
Look under that trooper's feet. For about a quarter America was reminded of a war in Korea.

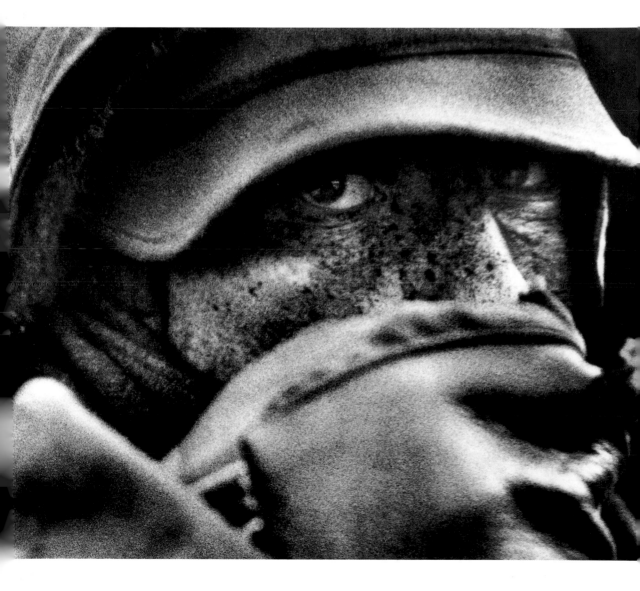

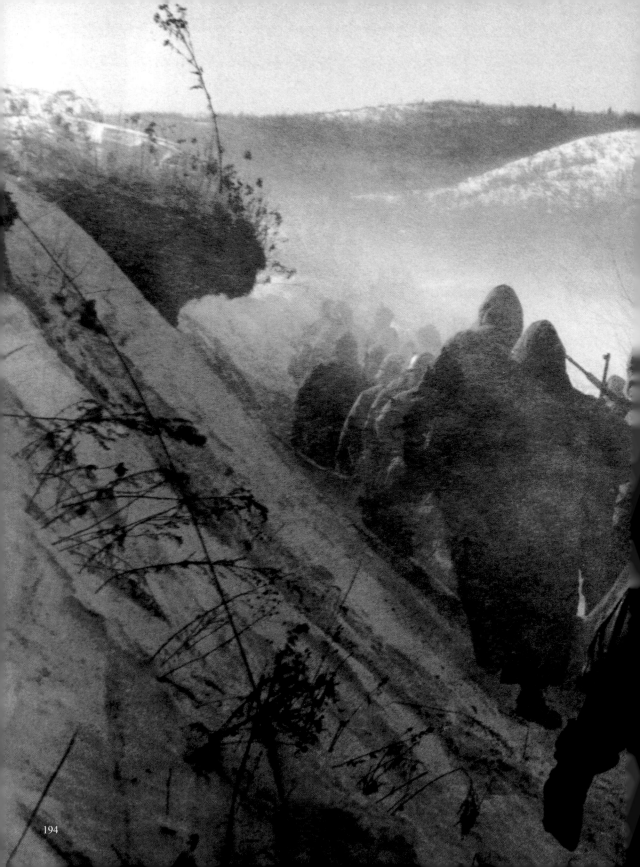

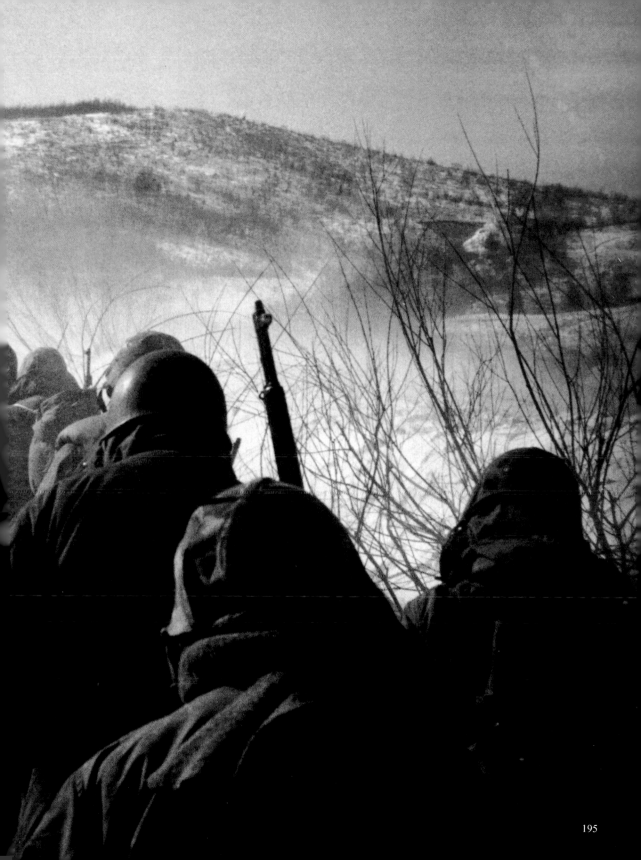

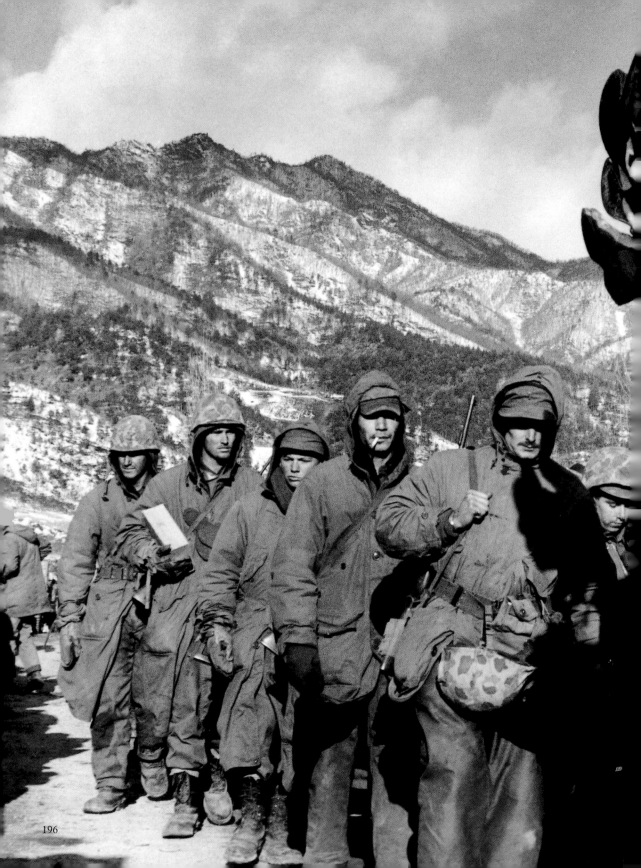

1950

Christmas Eve in North Korea

Hungnam Harbor

final moments — final maneuver

evacuation

United Nations Military Forces
of
General Douglas MacArthur

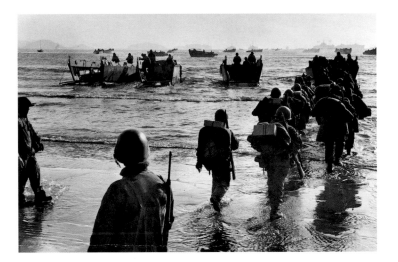

Navy frogmen had mined and wired tanks and trucks and all gear too heavy to hoist aboard waiting transports, swung their Higgins boat back in-shore to evacuate a wet-from-knees-down photographer -- last live American in North Korea . . . then slammed plungers into firing boxes. Hungnam Harbor headed sky high and beyond for *a very long time!*

I sailed away for Christmas among thankful Marines to a delayed story on classical Japan.

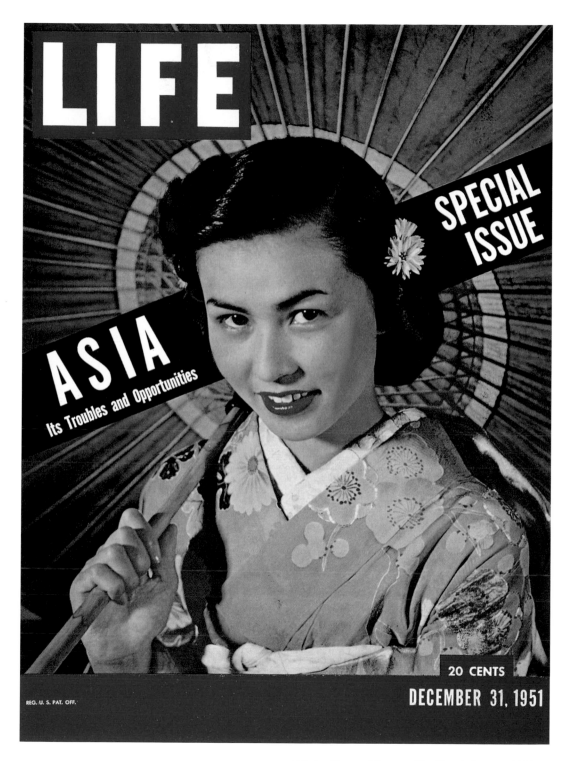

Mitsuko Kimura, 19 years old of bomb-devastated Tokyo.
Her first portrait – soared to Japanese movie (27) stardom.
Married and today is an American grandmother in California.

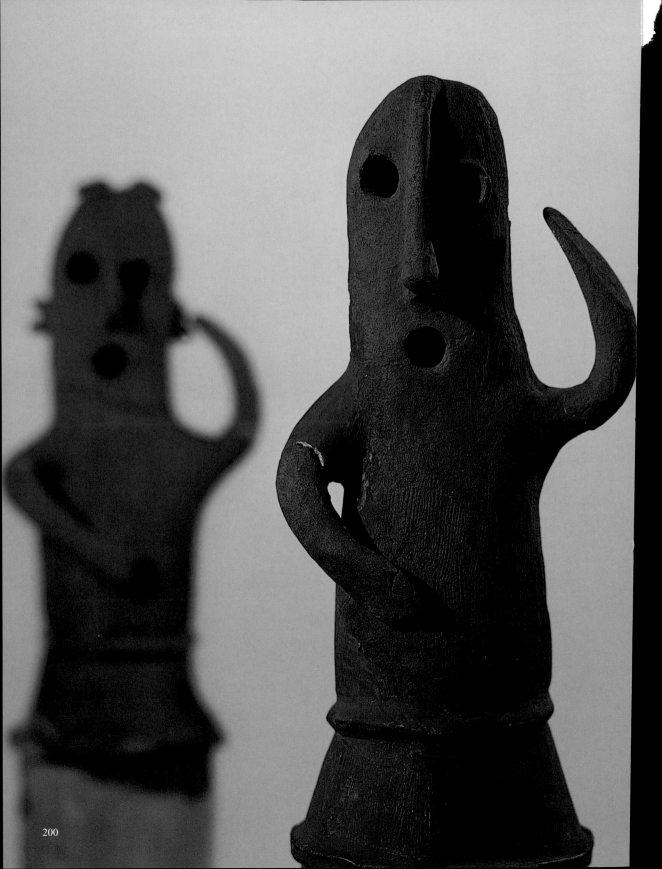

Japan
Hierinji Temple

1951

Living with Antiquity

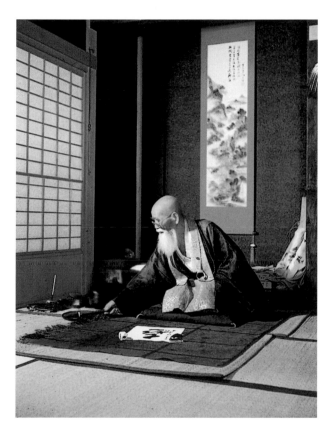

Earthen *haniwa* sentinals stood above prehistoric graves. A ninety-two year old Zen monk painted classical scrolls, wove his clothing, farmed his daily food . . . had chosen his future life's home in temple garden -- for seventy years never having walked through its gate.

Lifestyle of Yukichi Obata

owner of a noodle factory

beyond a millionaire's dreams
today

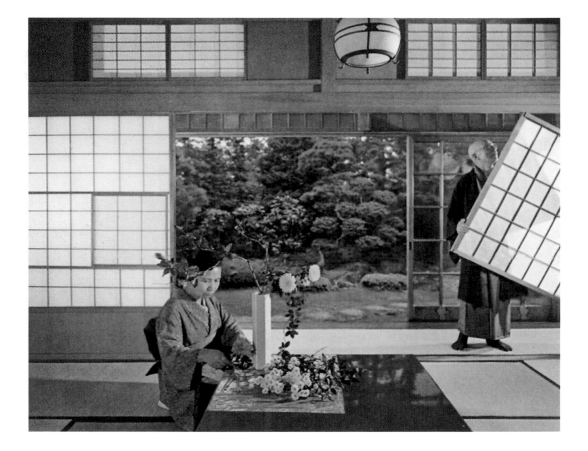

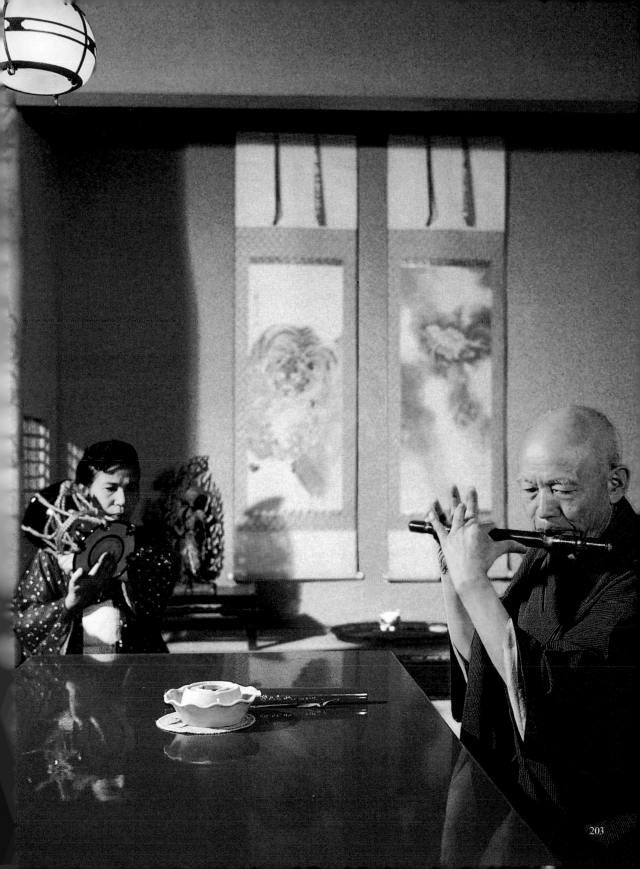

Ishinaka and baby sister Midori
may already be grandmothers themselves

Waiting for Grandfather to say "Good Night" . . .
after burning incense nearby.

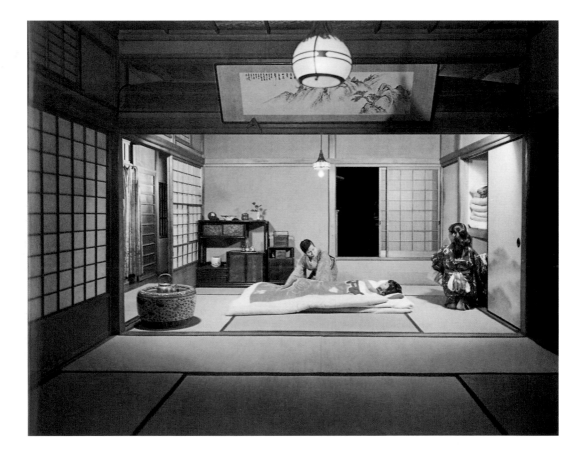

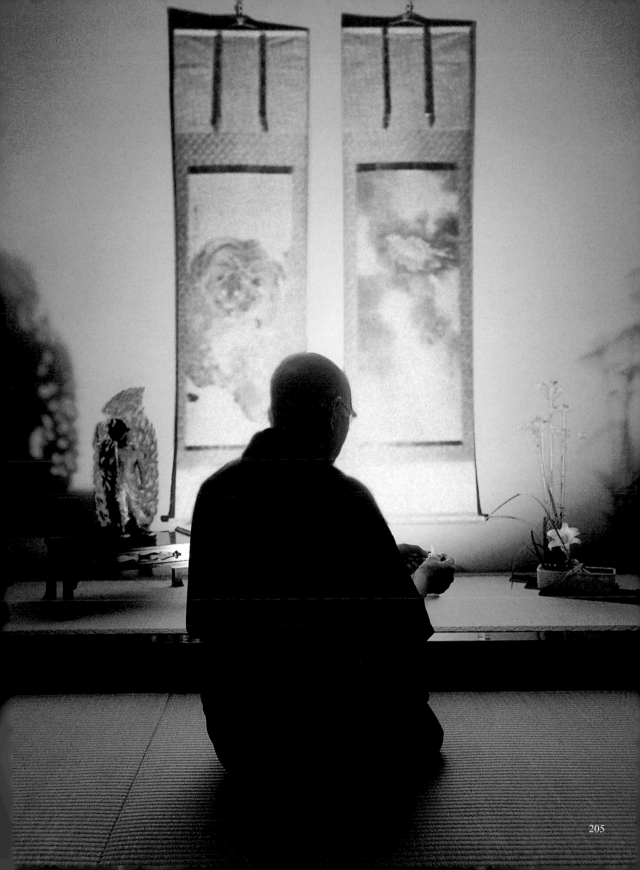

Karakayado

One of Buddhism's holiest shrines

Even Grass Is Divine

Ancient visitors to China brought a new faith home; where now pilgrims turn to the statueless cemetery on remote *Koya-san*, the holy mountain in forest-twilight and often rain . . . emerald moss cushions all sound: trails wind among austere tombs of emperor, *samurai* and pilgrim where a profound impression is pervasive . . . walking toward the horizon on another path.

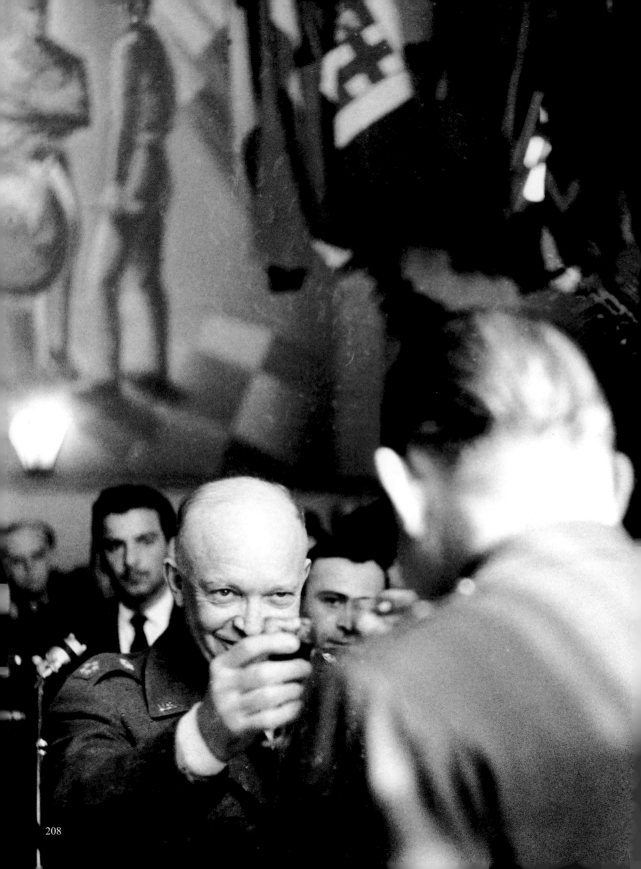

Ike

Athens — Istanbul

1952

Welcomed Greece
to
NATO

as
photographer
shouted
"-- it's easy!"

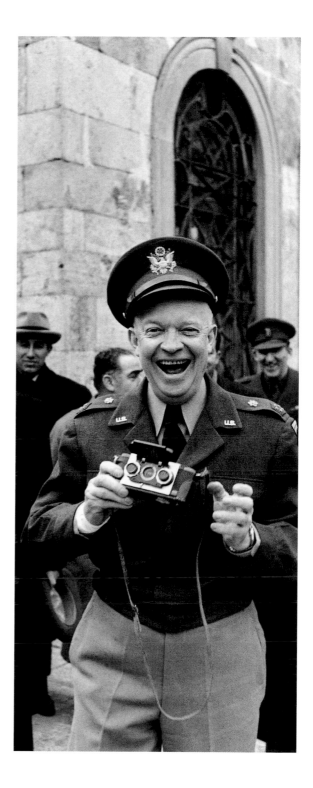

1952

Birth of the Iron Curtain

Germany

Volkspolizei

picnicking villagers
until
standing up

barbed-wire electrified fences
snipers and machinegunners and landmines
came later
half-a-century of murder

211

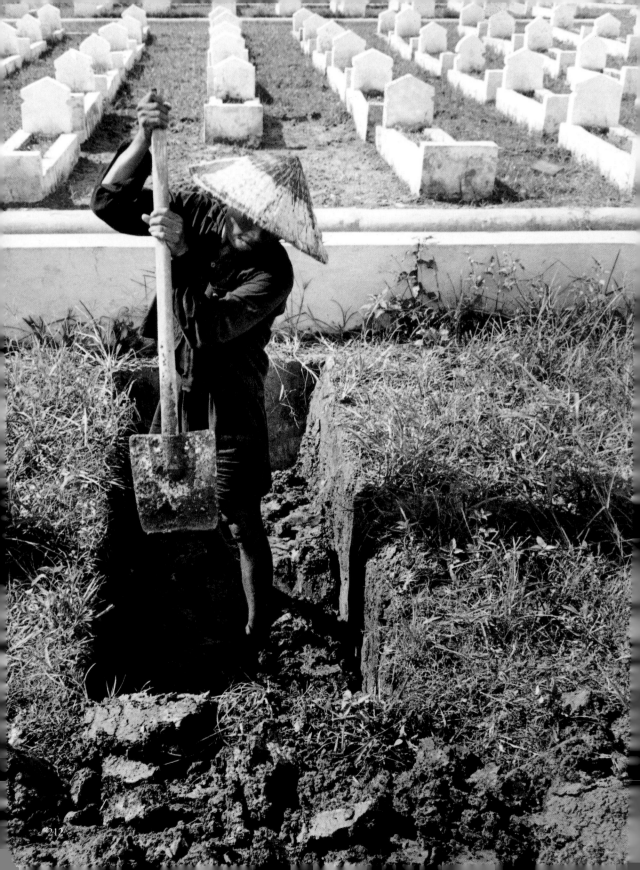

1953

Hanoi Military Cemetery

Died for France

Old tombstones

that jungle voice

spoke

"Die for Vietnam!"

Ho Chi Minh

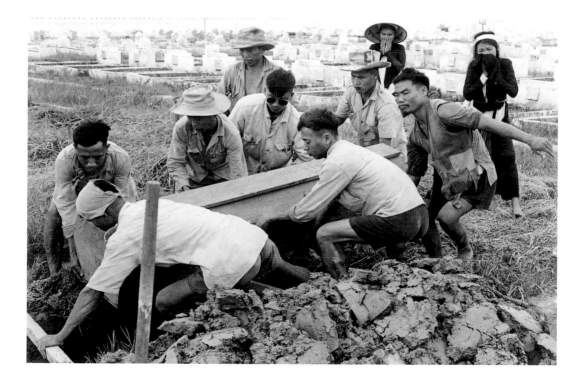

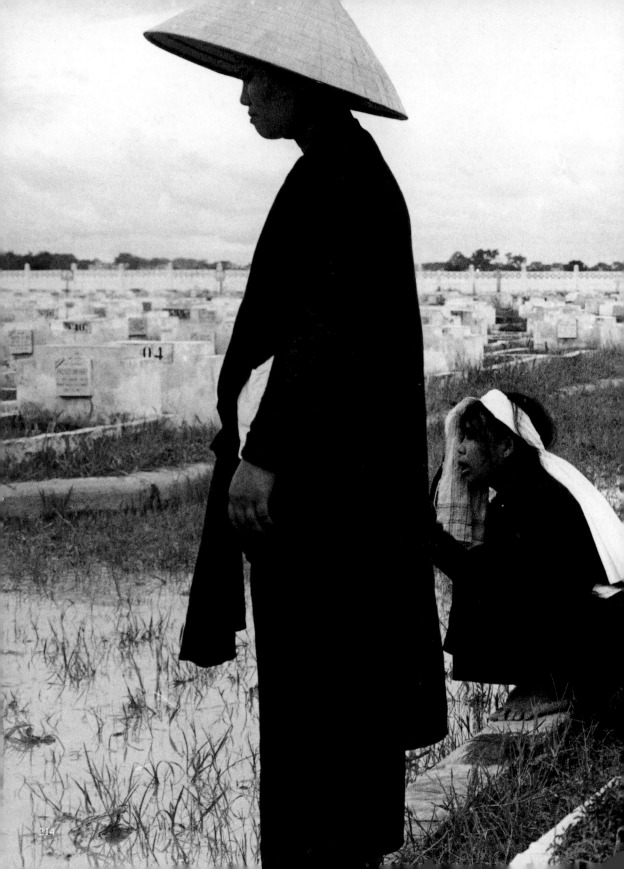

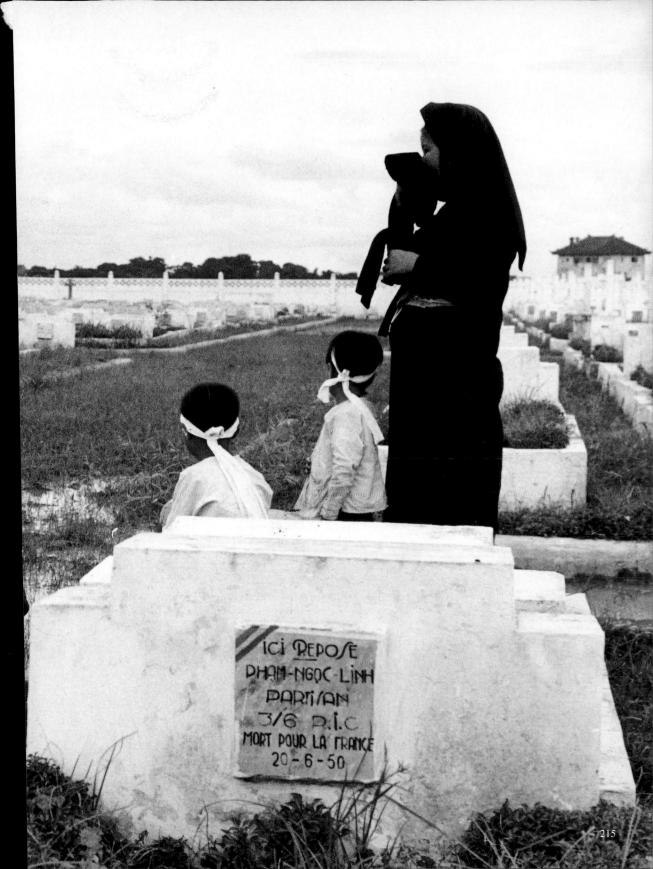

ICI REPOSE
PHAM-NGOC-LINH
PARTISAN
3/6 R.I.C
MORT POUR LA FRANCE
20-6-50

Prayers to Mecca across southern China atop his bunker
No Moslem-French soldier was ever shot facing Allah

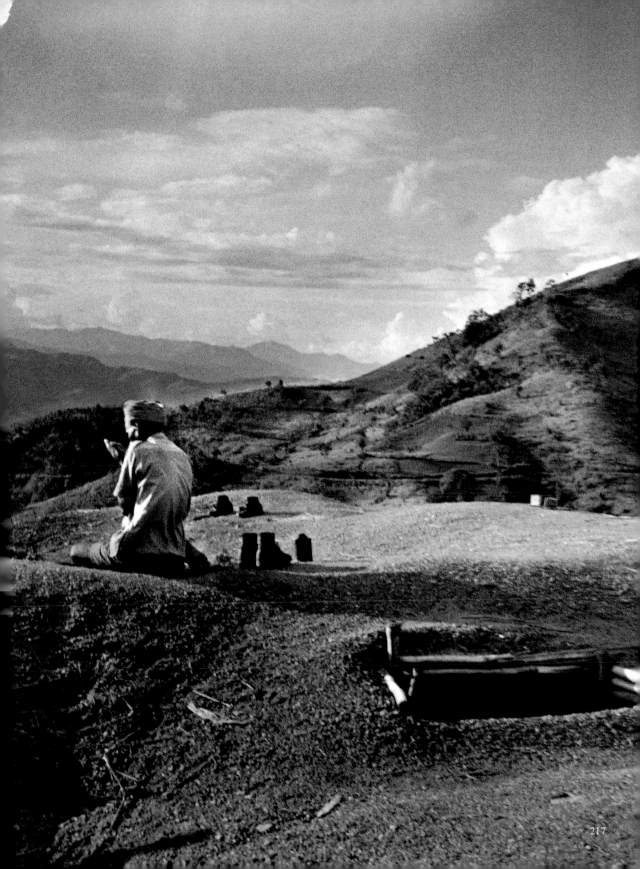

Lost in their toxic Dantean escape with opium
Men of Saigon shared dreams -- maybe Ho Chi Minh's

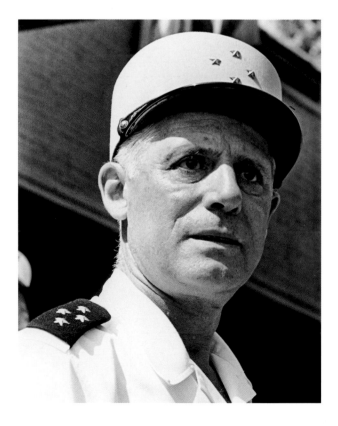

Hanoi
French Headquarters

1953

siesta

The Indochina War

shambles

Heartbreak and Dishonor

Fallen Commander
General Raoul Salan

Farewell

"Indochina All But Lost"
-- LIFE / 1953 --

Henry R. Luce Editor-in-Chief and Founder was in Paris assuring the French Government that Time Incorporated backed French Policy for Indochina 100% -- so where did this renegade David Douglas Duncan come from . . . ? I knew where he came from -- and said so. Suddenly "persona non grata" in Indochina but not fired by Luce -- in fact he sent Ed Thompson a cable -- "Duncan didn't fire me." Humor invisible a night before in the Embassy garden: Claire Booth Luce -- Ambassador.

Mr. Edward K. Thompson
Managing Editor
Life Magazine Rome, Italy
New York, N.Y. 3 September, 1953

Dear Ed:

Last night, I had quite a conversation with Editor-in-Chief Henry Luce. It revolved around the Indochina story. Since the conversation also involved you I'd like to take this opportunity to write to you so you will know my feelings when he brings up the subject. The meeting lasted nearly two hours; I shall try to cover the highlights.

Mr Luce was of the immediate opinion that my story was "defeatist" and therefore wrong. When I turned to pick up the magazine which I had brought with me, and started to say that there were some solid, constructive opinions about how the situation might be improved, he became quite indignant and said that I apparently had no desire to hear what he thought, as I, apparently had no concern for any opinion other than my own. I told him I had the deepest interest in his opinions, and what he was saying about Indochina . . . but that as for the story being an irresponsible story based solely upon my personal opinion I could not agree with him. I said that that story reflected the attitude of the majority of Americans in Indochina, under the level of aid administrator and ambassador to Saigon.

Mr Luce asked me whether I thought Jack Dowling (Time-Life correspondent based in Southeast Asia) would agree that the story was worthwhile and whether he would agree with me. I said "Yes." Thereupon he handed me a cable from Jack, which said that the layout was fine, pictures fine and text accurate as far as it went, however it suffered by not telling all of the story . . . meaning, I presume, that we didn't say, again, as we did last year in Sochurek's picture story, that it is a dirty war and good Frenchmen are getting killed. I mentioned Howard's story, saying that that could be taken as incomplete, too, for it did not tell anything of what the Indochinese thought, or that the theater was being lost due to inertia. I did say that I felt fully qualified to judge, and report upon, the dirty side of the war, and that what I saw and reported from Indochina was weighed against all of the war experience I had ever had . . . and that I still didn't see how they will successfully win the war as long as present day methods and stubborn mentalities are tolerated, even cultivated.

Mr. Luce felt that great changes have been made in Indochina, and that my story told of a situation now dead. I did not agree, and said so. While discussing other features of the story I pointed out that I had contacted every possible source in Indochina, and that our story reflected the opinion of the bulk of U.S. Mission personnel. He replied, saying that Acheson had been surrounded by defeatists, at the time China was lost. I answered that his suggestion that such was true today in Indochina did not seem to be the case, for most of the Americans I met were hopeful that some aggressive new strength might be injected into the French effort so that their war might be won. However, at the time I was there, most of them felt that no such energy was in sight, France had on again-off government, and that the Viet-Minh were winning by default more than any other reason. I again repeated that my sources were the most qualified men I could find, and I felt that the story was absolutely accurate.

Mr. Luce then pointed out that an entirely true story can be a wrong and malicious story… and drew a comparison between France's plight now and Britain's during 1940. He pointed out that it would have been wrong to point to the shortcomings of British colonialism at a time when the only country trying to stand against the Nazis was nearly on her knees. I did not say that I thought that the British effort under Churchill, at that time, was quite foreign to the French effort under migratory governments, today.

We then turned to discussion of how the story came into being in the first place. I referred to my Hong Kong cable to you, outlining the story, plus the comment that Hanoi odds were running 10-to-1 against our publishing such a story. I also told him you had replied that I had a hell of a nerve predicting what you would run until you saw it. Mr Luce mentioned that that appeared to be one of my techniques…and I agreed, for then I was sure that you were well aware of the story in question, and followed it through the mill with even more that personal attention. I also added that I have really enjoyed tangling with you, and felt that you have too, for then each of us, in my opinion, got the maximum from the other's efforts. He then asked what I meant by that reference to the betting odds against Life's publishing the story, and wanted to know whether I questioned your ability as a managing editor, or your desire to report stories fully. I answered that I never questioned your ability or intentions or methods as an editor. Mr. Luce then added that I must then have been referring to the policy of the magazine. I agreed. He then added that I must referring to him. I answered "Yes." I added that it was the opinion of many reporters, myself included, that a bare-knuckle story on Indochina would not be tolerated because of France's role as our ally, with all of its related problems. Mr. Luce leaned back into his garden chair, took off his glasses and didn't say much for several minutes.

Mr. Luce handed me a translation from Paris Match, which said that we had claimed that America was taking credit for paying for the war. I turned to the section on U.S. military aid, where it clearly stated that our contribution was now climbing past 30% and that in the future we may be called upon to carry more of the burden.

It was getting late, so we headed for the door. But just before getting up from the garden chairs Mr. Luce stated that I posed a real problem for you. I waited for clarification. None came by the time we got to the front driveway, so I asked him what he had meant. He answered that A must be in step with B, and that C must be in step with B.

He said that you, as B must answer to him as A . . . and that I, as C, must answer to B, you. So I said that if my presence on the magazine was distasteful to him, and in any way made your job awkward, then the logical thing for him to do was to fire me. He said "No," that was not what he meant . . . that it all revolved around my getting along with you, and you finding a place for me. I left, but repeated that if I had become a source of trouble and embarrassment to you then the answer was really quite simple. I should be fired, and that would be that. He said again that that was not the answer, but that if only C (myself) is out of step then it poses a great problem for you, and your relationship with the staff.

This morning, I received a call from Mr. Luce's office asking that I be there at noon. He opened our new conversation by saying that nothing much had been settled in the garden last night, and that he had had time to review much of what had been said. He wanted to make two points clear. The first was that my story was untimely. I added "true, but untimely?" and, I believe, his was an affirmative nod. The second was that I must get along with you. I replied that my prime responsibility was to report each story as I saw it, balanced against experience and knowledge and research . . . that preservation of magazine policy was the concern of the editors . . . that it was an every-man-for-himself fight until that particular issue closed and we all began planning for the next week's magazine . . . but until that final deadline had passed, my every effort would be spent fighting for that particular story being published exactly as I had seen and photographed it. He mentioned that it was, of course, the editor's problem, his problem, to establish and maintain top policy . . . such as during the Presidential election, despite deep feelings and efforts of those others within the magazine who clearly were supporting Adlai Stevenson and the Democrats.

At the beginning of this conversation Mr. Luce referred, again, to a chewing-out he got, four years ago, from the Premier and Foreign Minister of France, all within one hour. I told him that I had wanted to ask him what he had done. He wanted to know what I meant. I said that I meant just that . . . "What did you do . . . with your understanding of what was right and wrong . . . with your dignity and pride in being Henry Luce . . . "What did you do?" He replied that he listened . . . something that most correspondents have a difficult time doing, for we are usually talk, talk, talking. I asked him, again, what he had done . . . after listening. He answered that he had told them that they did not understand the problems or the role of journalism in America.

This second meeting soon ended. It did so, I believe, with fuller understanding having been reached between the two of us. He said that it is most difficult to measure the results of a story, and he still would not hazard a guess whether a "shock-treatment" story such as this might actually result in benefits.

In re-reading these pages, Ed, I realize that they might be taken as having been written in a light, almost trite frame of mind. Such is not the case. I simply want you to know how I view the entire episode, and that I mean what I told him . . . if I have fouled-up your operations at that end so as to make future operations difficult, where I am concerned, then drop me a line saying so. I'll fully understand, believe me, and shall write it off as the end of a great period of my activities, then turn to other things I've long had in mind -- expecially, returning to Jerusalem and the Arab World.

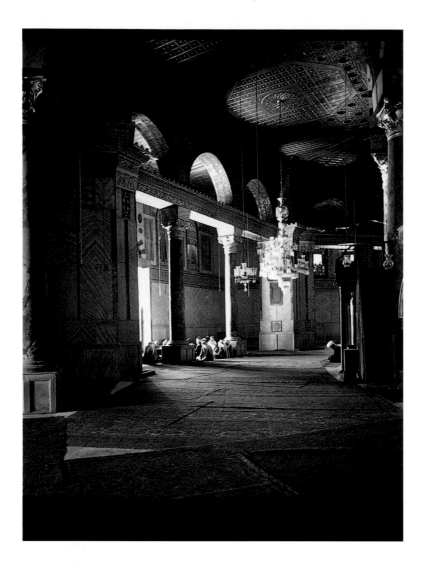

Jerusalem

Dome of the Rock

8th-Century Mosque above grotto where God stayed the hand of Abraham
bent on the worst for his son, where centuries later the Prophet Mohammed astride
Barak departed for Heaven and Eternal Life.

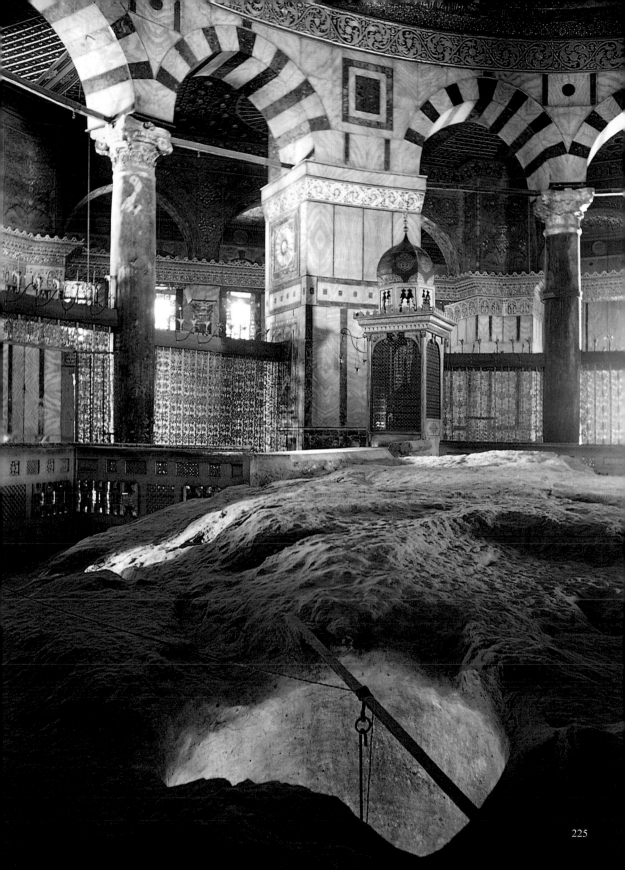

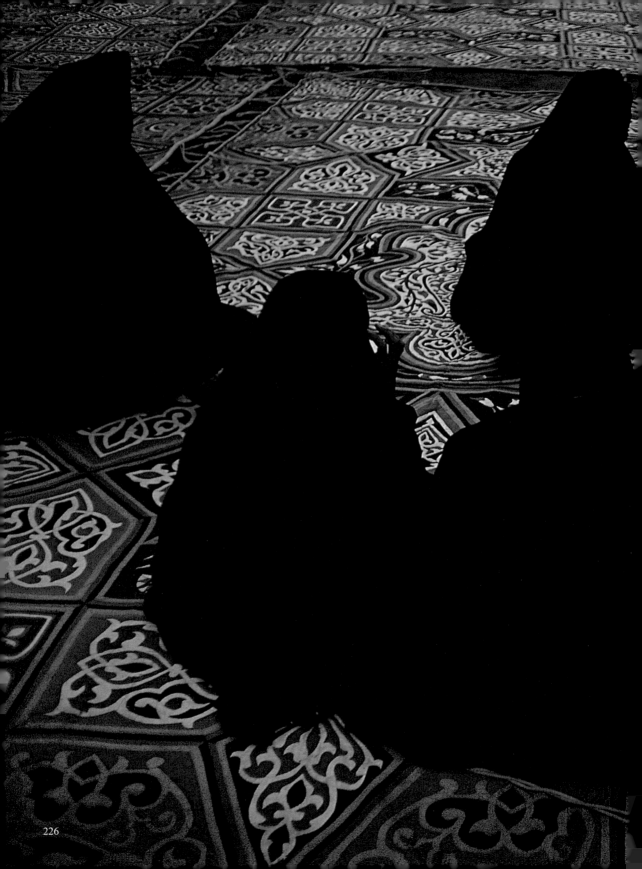

Cairo's first dawn of Ramadan Sacred Month of Fast for all Moslems.

1955

Peaceful Afghanistan

today a minefield

Dawn at Band-e-Amir Lake in the Hindu Kush

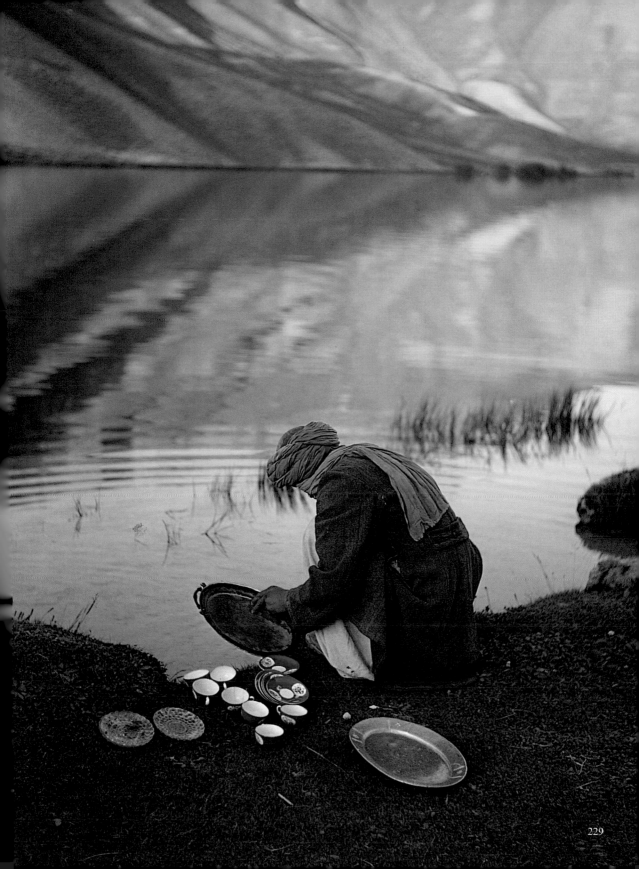

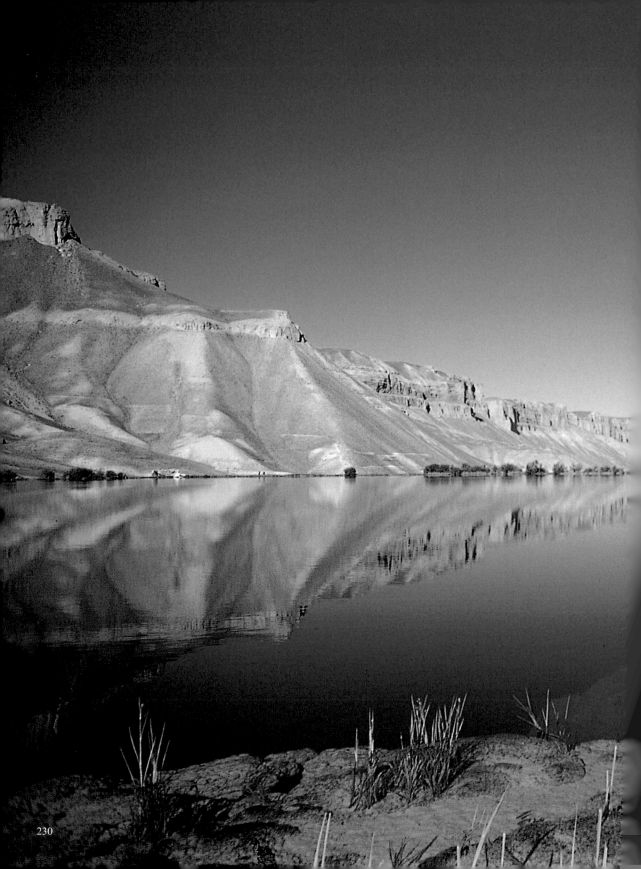

Noon on Band-e-Amir Lake once a Mirage Shangri-la

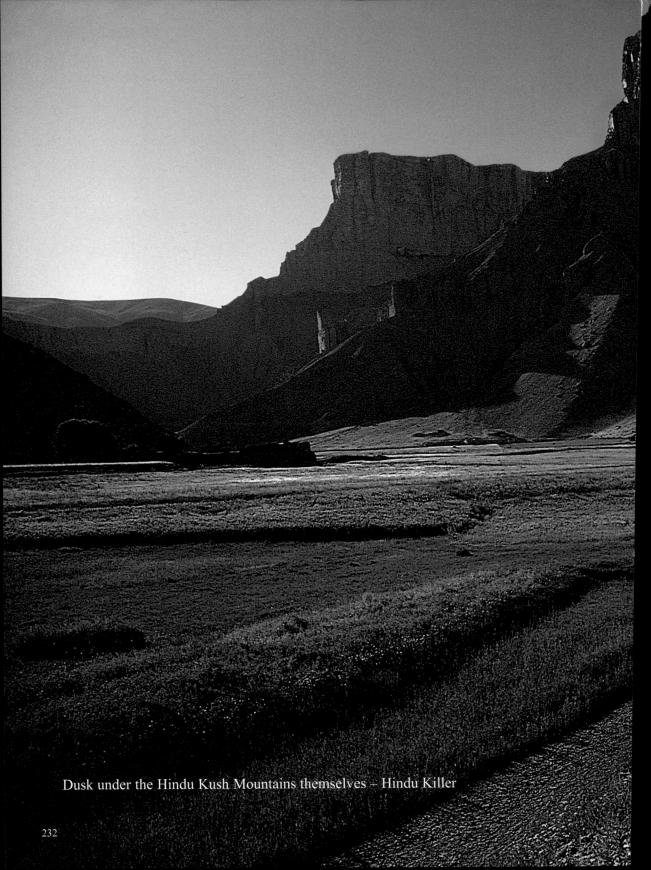

Dusk under the Hindu Kush Mountains themselves – Hindu Killer

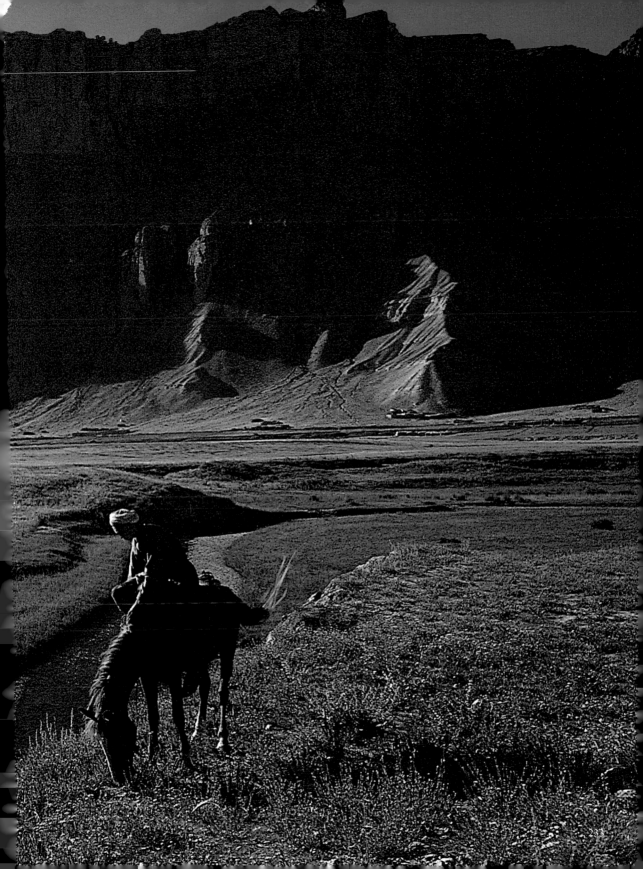

Berbers

1954

The High Atlas Mountains
of
Morocco

Bronze Age Man

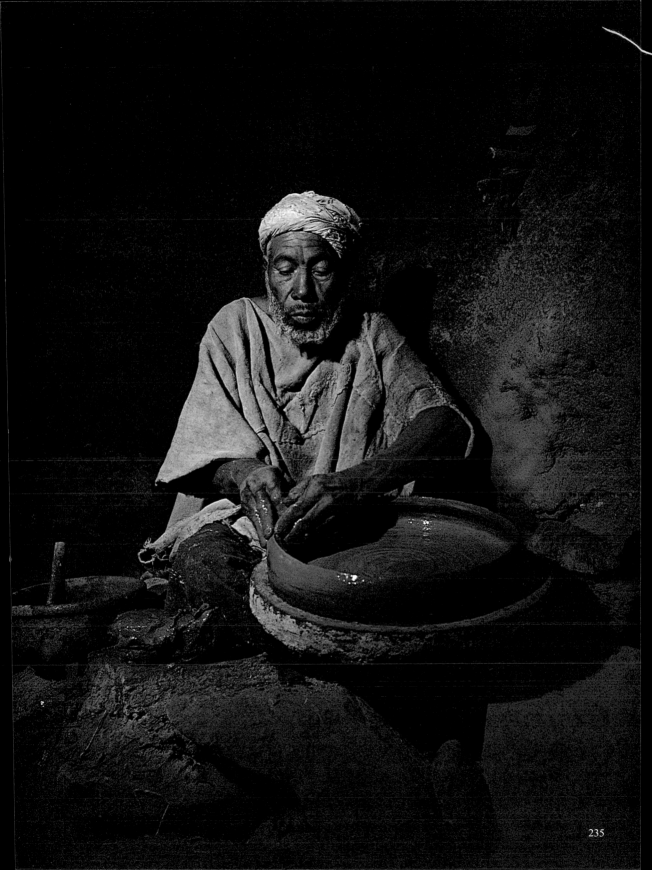

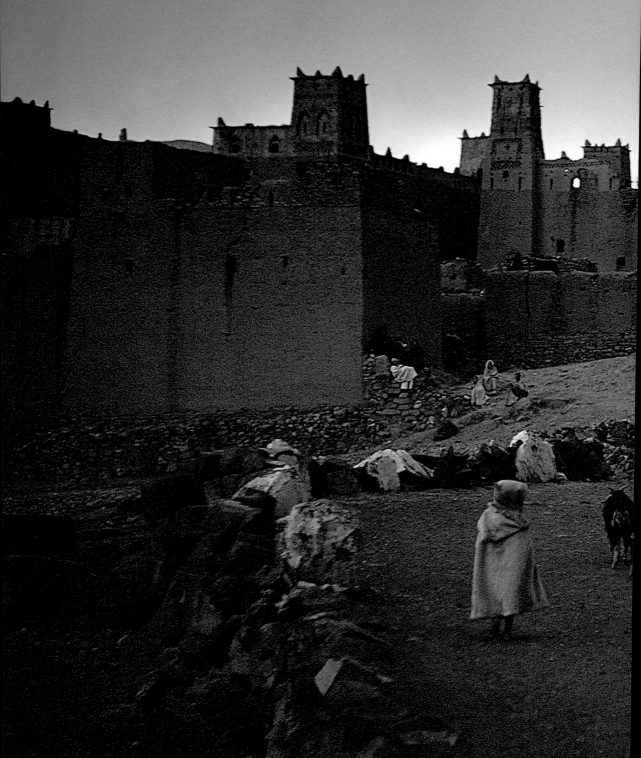

Idir and son and flock of Ait M'Hand built of adobe bricks centuries ago.

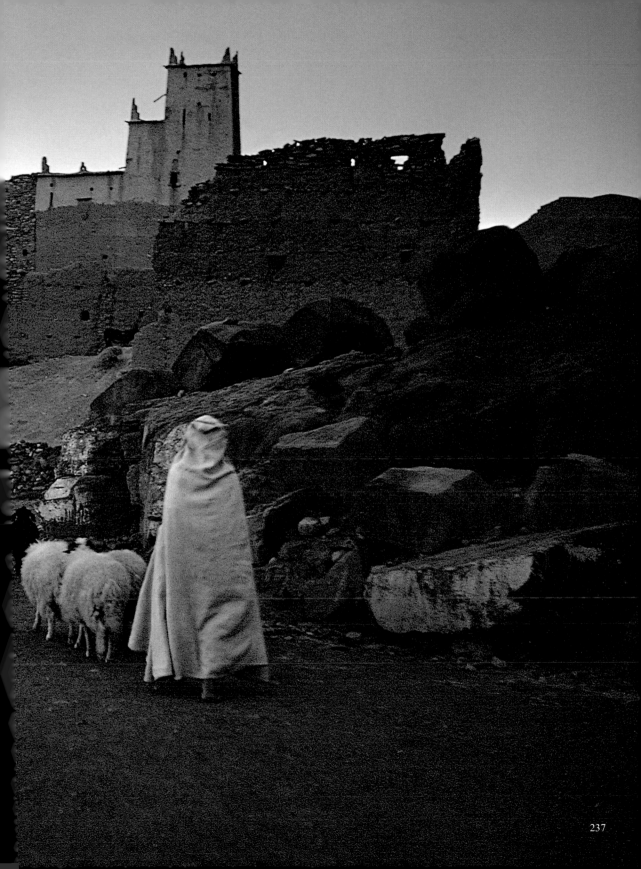

Masterpiece-home of some unheralded Herculian architect-artist – maybe his wife.

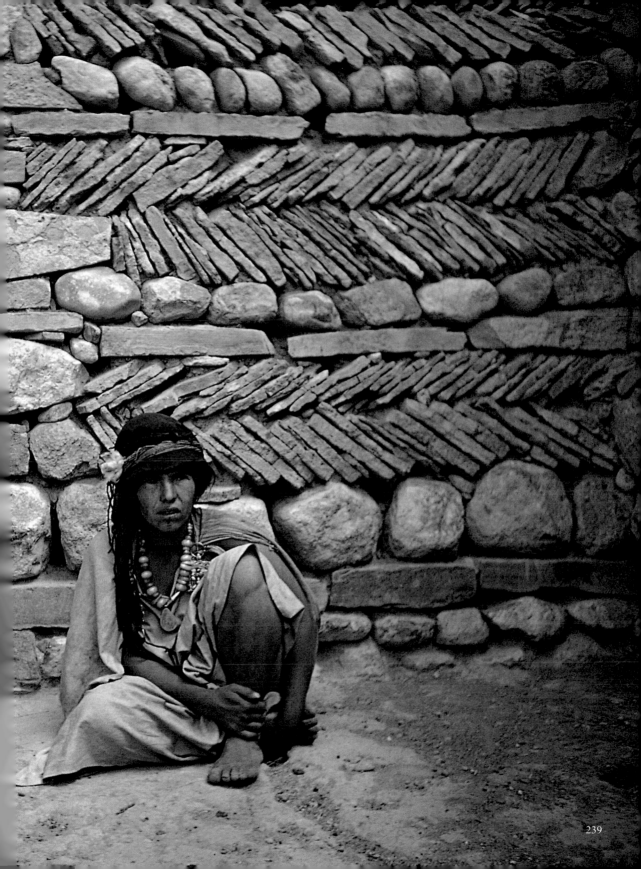

Ait Tfqirt Village

Perhaps that Bethlehem home was like this
long before a Searing Light slanted down.

Mid-day darkness 16-year old Aicha M'Bark
milling grain – beauty tatooed upon wary feminine steel.

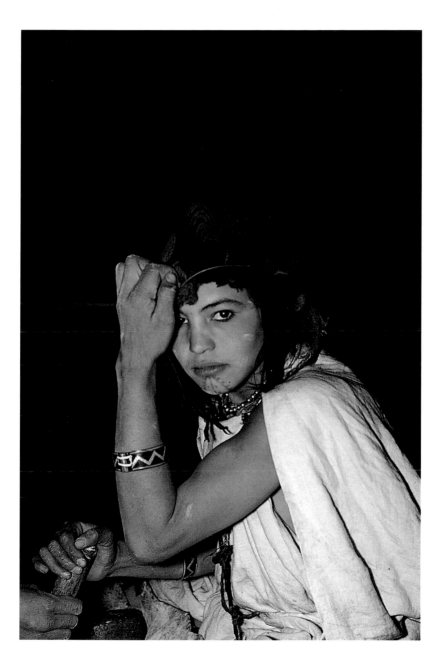

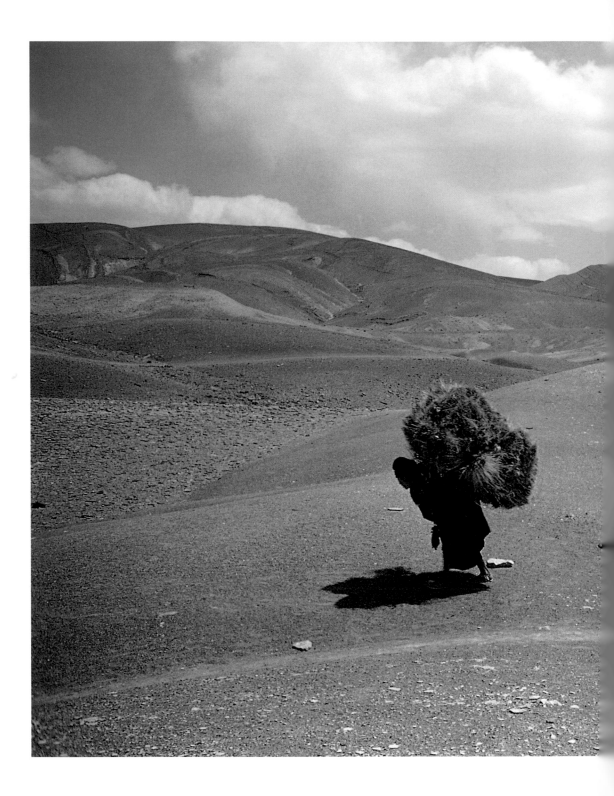

... only centuries-battered-stone-into gravel under sandaled feet
village children bent near-double with fire-brush loads – coming from where

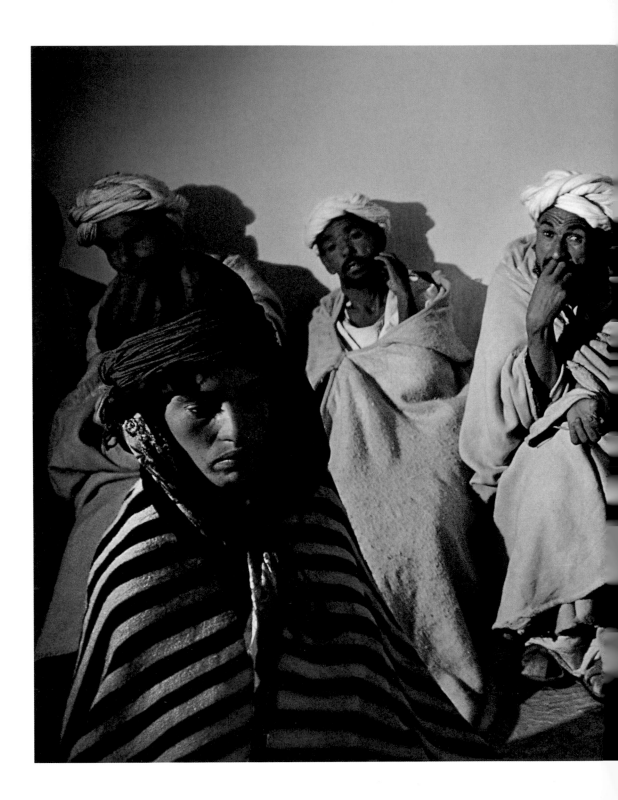

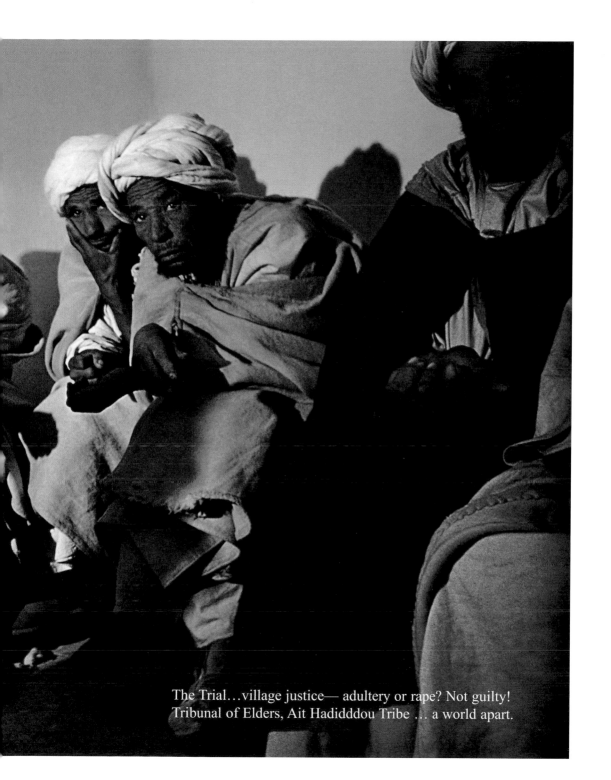

The Trial...village justice— adultery or rape? Not guilty!
Tribunal of Elders, Ait Hadidddou Tribe ... a world apart.

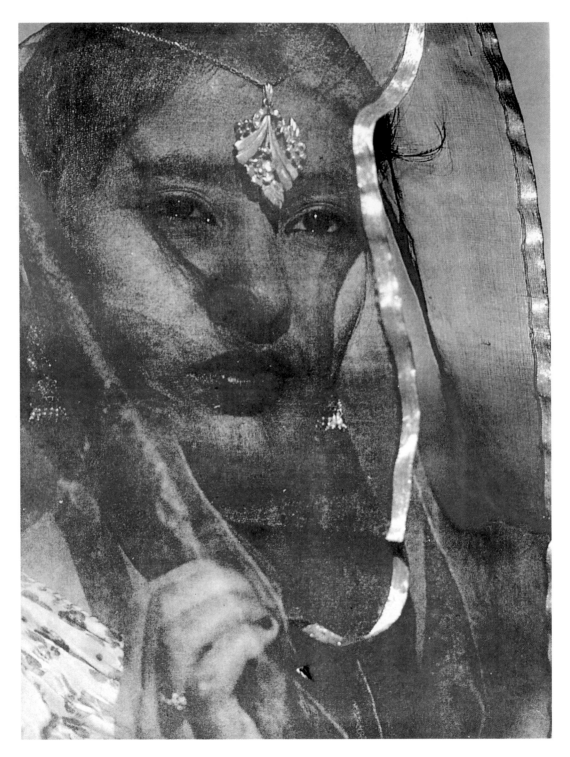

Raiza Khanum in bridal veil/not *purdah*
Riflewoman Pakistan National Guard.

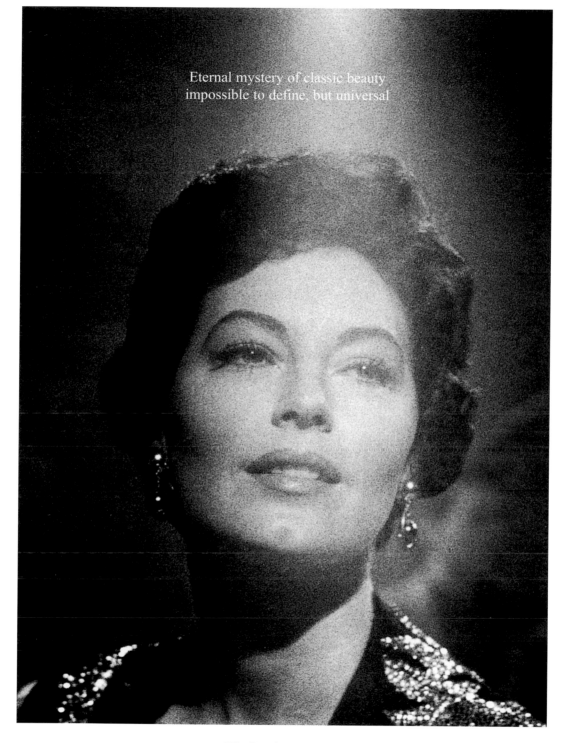

Eternal mystery of classic beauty
impossible to define, but universal

"The Barefoot Contessa"
Ava - 1954 - Rome

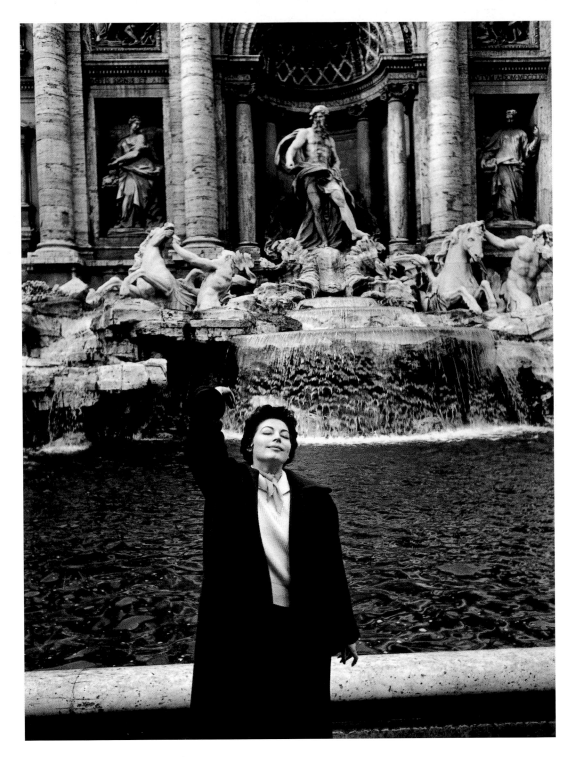

Wishing for Everything.
Award-winning superstar and olive-picking peasant.

From the movie set Ava's eyes saw only Luis Miguel
— Arles' bullfight arena … Dominguin/Cordobés —

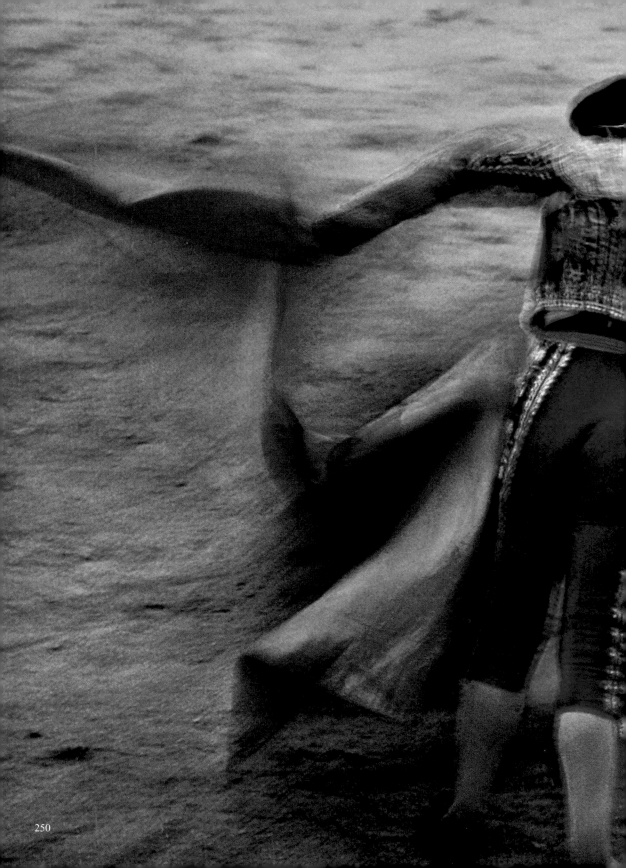

We called them
Ghosts of Sindelfingen
Stuttgart - Germany

1955

Artur Keser thought I was quite mad. I just strolled into his press office at the giant Daimler-Benz autoworks and casually told him I wanted their fastest car – painted Mercedes red – with their finest racing test-driver, and the police to block the streets of Sindelfingen while I shot pictures to show *not* the car – but its spirit!

I also needed an engineer to calculate the speed necessary for the driver to flash across one hundred feet during a one-second exposure, (he assigned Wilfert, who designed the 300 SL); a mechanic, (he assigned Hitzelberger, who hand-makes the prototypes of all their sportscars); and an interpreter in case the cops worried, (he assigned his colleague, the Prince Albrecht von Urach, who handled cops, photographers and nine languages with casual ease). And off we went to the heart of Sindelfingen, a nearby, sleepy village (past tense).

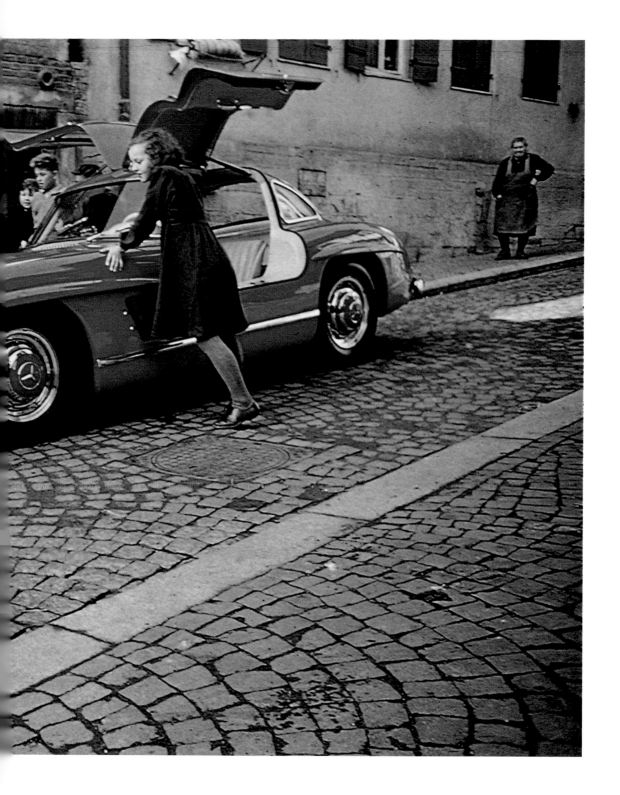

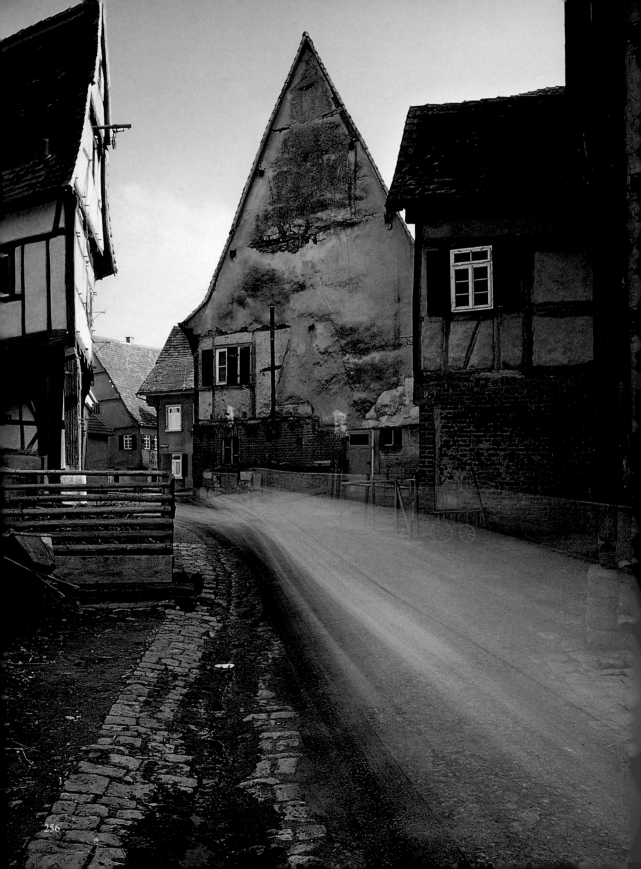

Rolf

Chief Guardian
of
Secret

1956

New

Mercedes Models

Took His Job

Seriously!

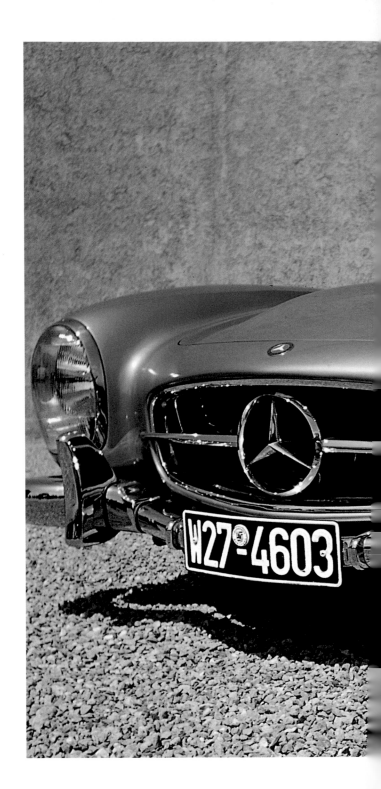

Grand Prix-class driver-engineer Rudolf Uhlenhaut dominated mountains,
Italian Dolomites … any road always slouched sideways fractions of a second slower
than Juan Manuel Fangio — fastest in the world.

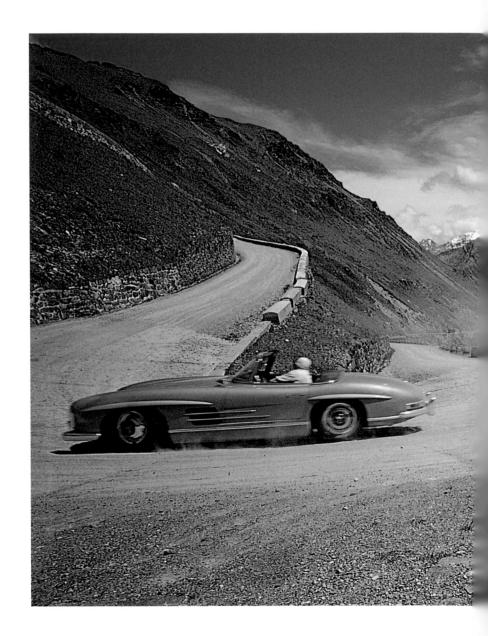

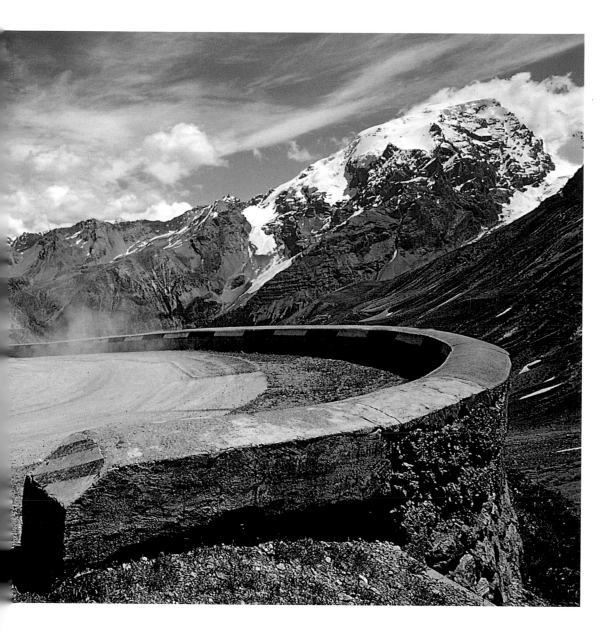

Connemara 1956 Ireland
Shattered home / tumbled walls

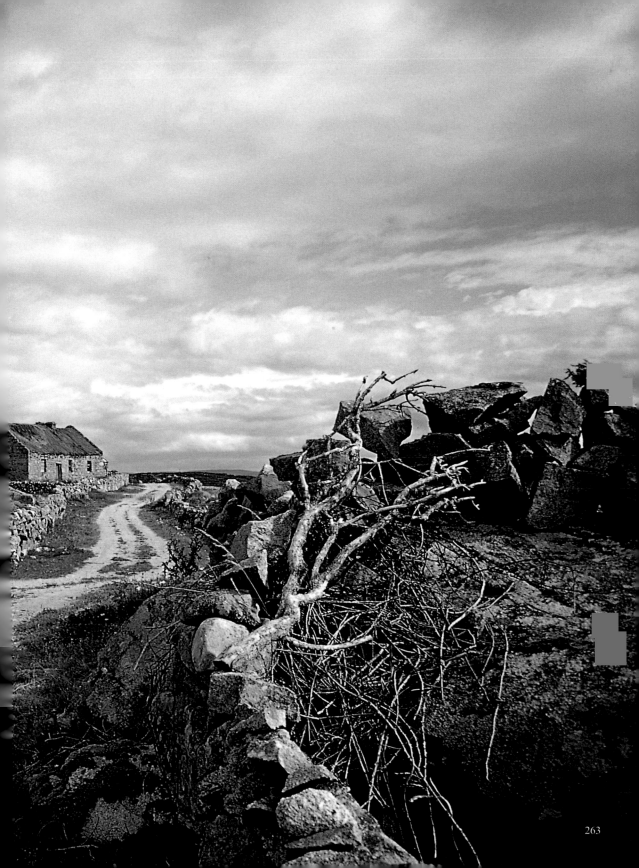

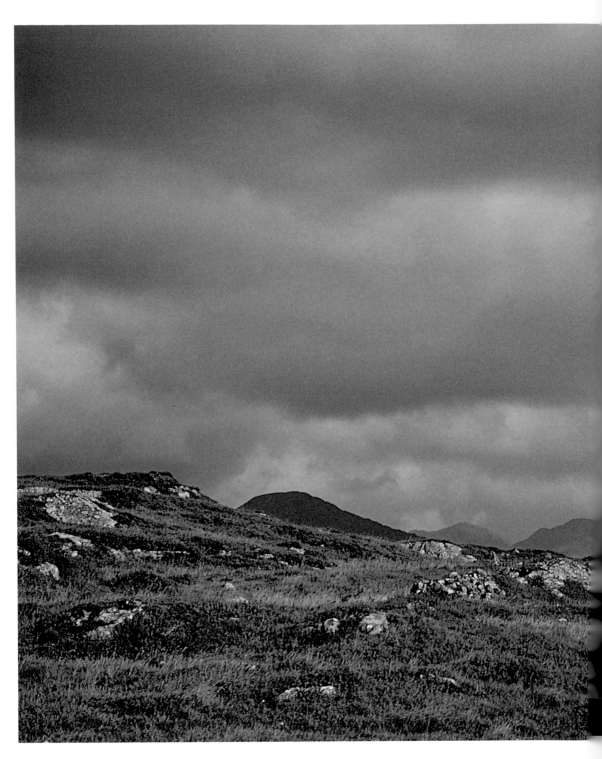

Ivory stallion carved by wind roamed as the Lord of the Sky.

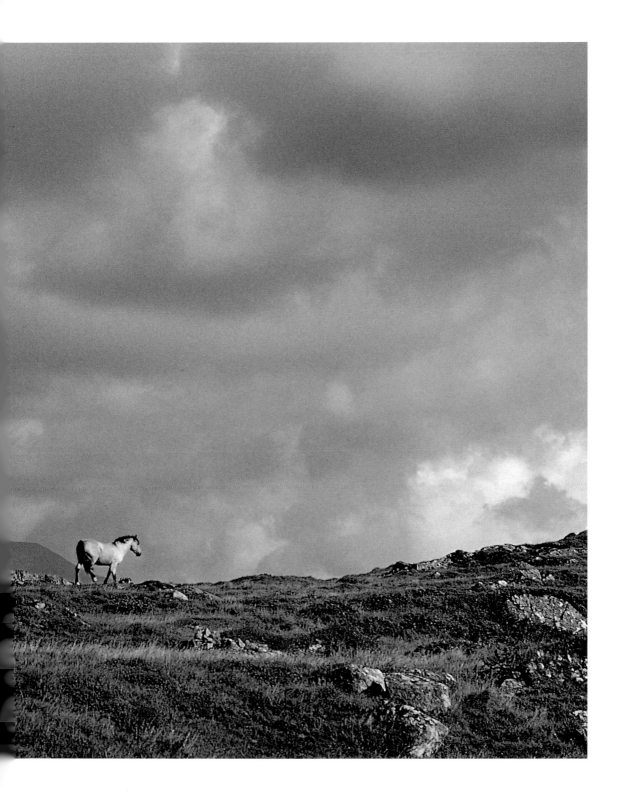

Exotic anemones floated across the endless sea.

Men had fled
Nature was victorious

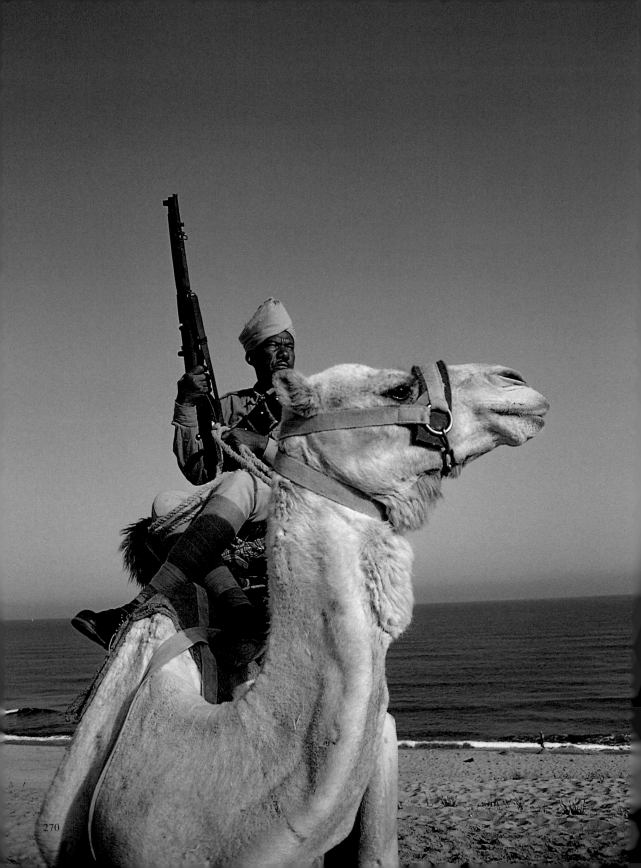

1956

The Gaza Strip Palestine

Desert tracker camel-mounted squadrons from yesterday patrolled this pristine sand-and -sky-world with its monumental Mediterranean Rothko-painted opera curtain stretching horizon-to-eternity . . . back as far as every recorded civilization's voyagers piloted sail vessels along that shore, those earlier craft loaded: dyes-spices-oils-salted sardines in giant amphoras now salvaged by treasure divers, today in museums worldwide whose curators are astonished by the purity of design with contents still well preserved inside -- all of this and more -- history's ageless always changing drama performed by ever-different casts playing roles long-forgotten or never forgotten . . . Phoenician searches-of-discovery; Alexander the Great's squadrons of vast conquest; cross-bearing probably seasick land-lubber Crusaders paying another price for freeing Jerusalem just up the coast; plundering Barbary pirates and probably unrecorded, also savage horn-helmeted Norsemen who preceded by perhaps a millennium the sinister-silent-single-periscope horn of also arctic steel-skinned narwhals lifting one-eye, probing, reed-thin horns above usually calm water soon to erupt into horrific geysers of just-fragmented ships and men when the U-boats' torpedos found their quarry -- not all that long before the 6000-man-crew-atomic-powered aircraft carrier *Abraham Lincoln's* jets catapulted tons of its unwanted gifts to Saddam Hussein and then sailed through these very waters for California with every sailor then on deck to welcome an unlikely visitor who tail-fork-landed aboard --

their Commander-in-Chief.

The President of the United States

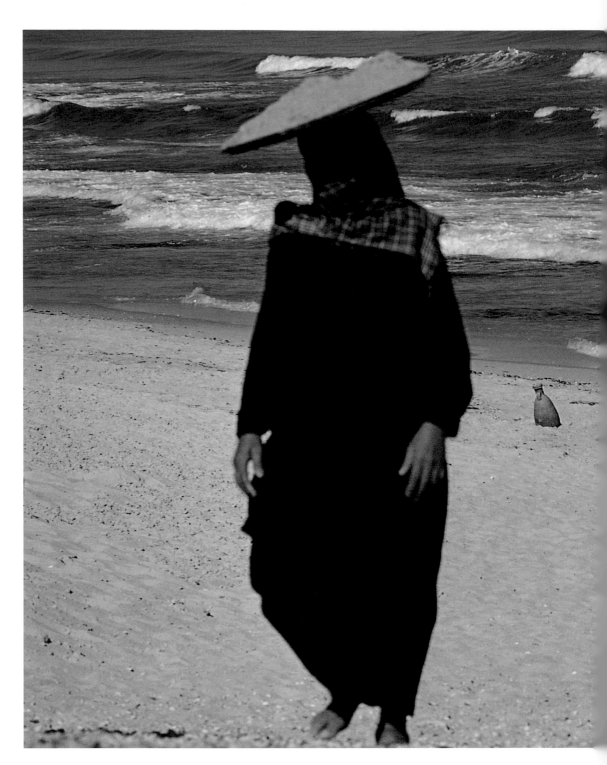

Refugee camp Palestinians head-lifting sand for concrete-block and scrap-tin huts.
Half-a-century -- two generations -- later their grandchildren still call them homes.

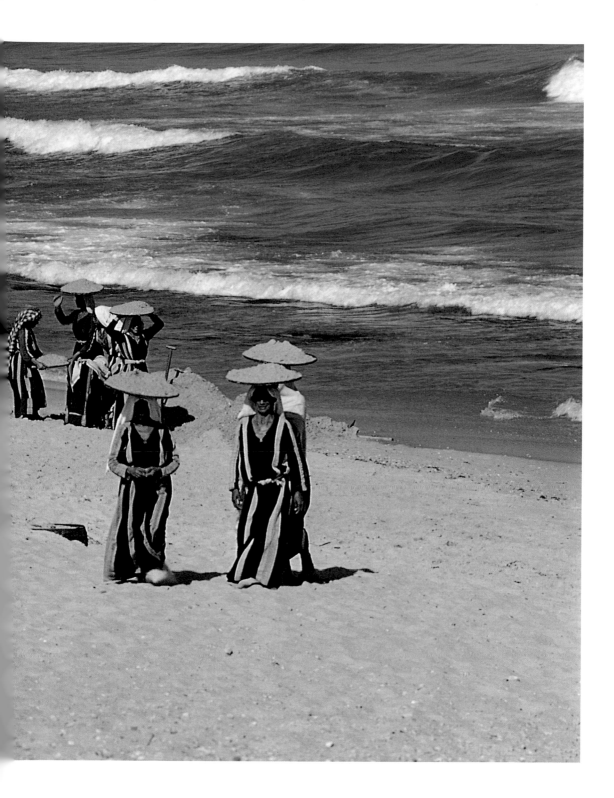

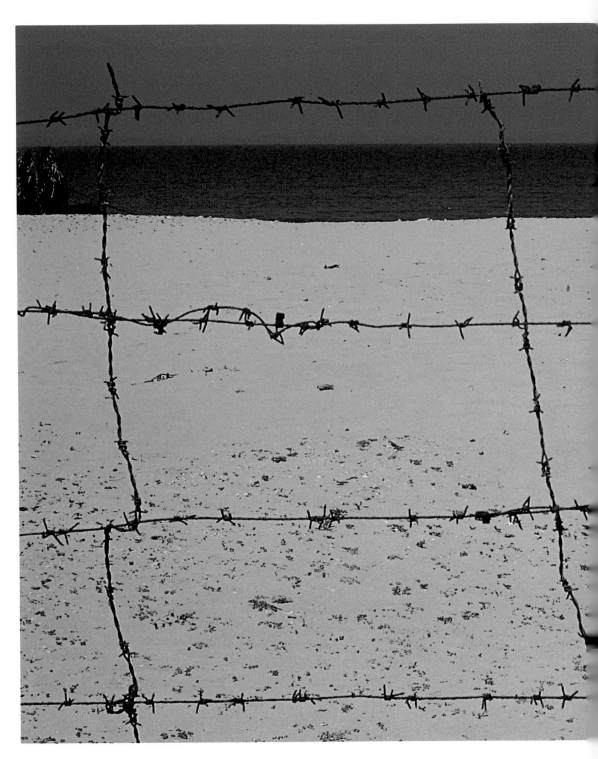

On Gaza Strip everything collided and still does . . . barbed-wire and holiday umbrellas.

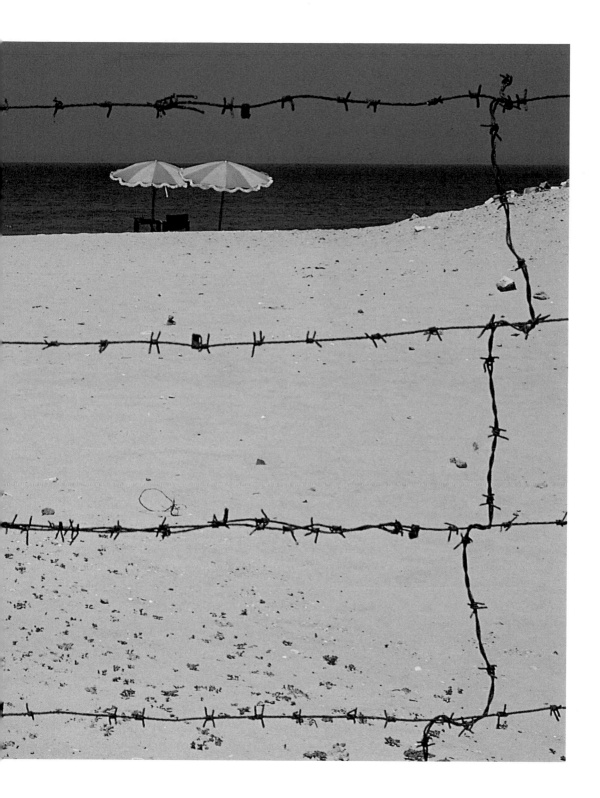

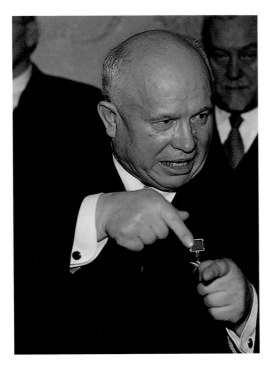 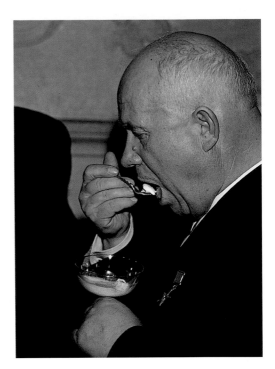

Khruschev
and
The Kremlin

1956

That peasant-framed-handed boss of Soviet eleven-time-zone military threat had slammed his fist "We will bury the West!" -- somewhat awkward to hear for the Moscow diplomatic corps brass who left the Polish Embassy *en masse* while Nikita baby really enjoyed his ice cream and I said (fearless interpreter) since you run this place ("Not always") and the Volga frozen where I'd dreamed of translating Russian history into a photo-essay -- how about the Kremlin Treasures? -- in color! . . . Out shot that fist: "Start tomorrow."

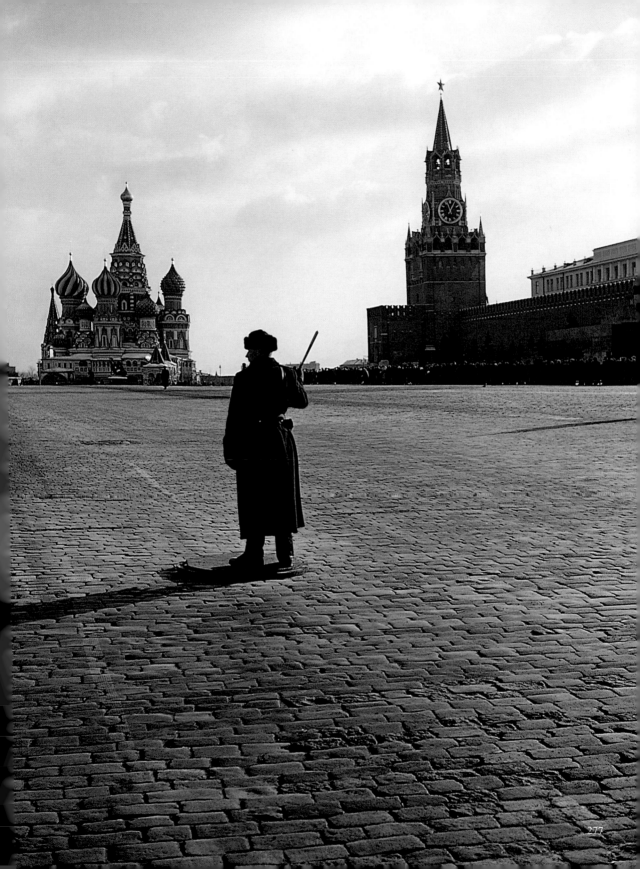

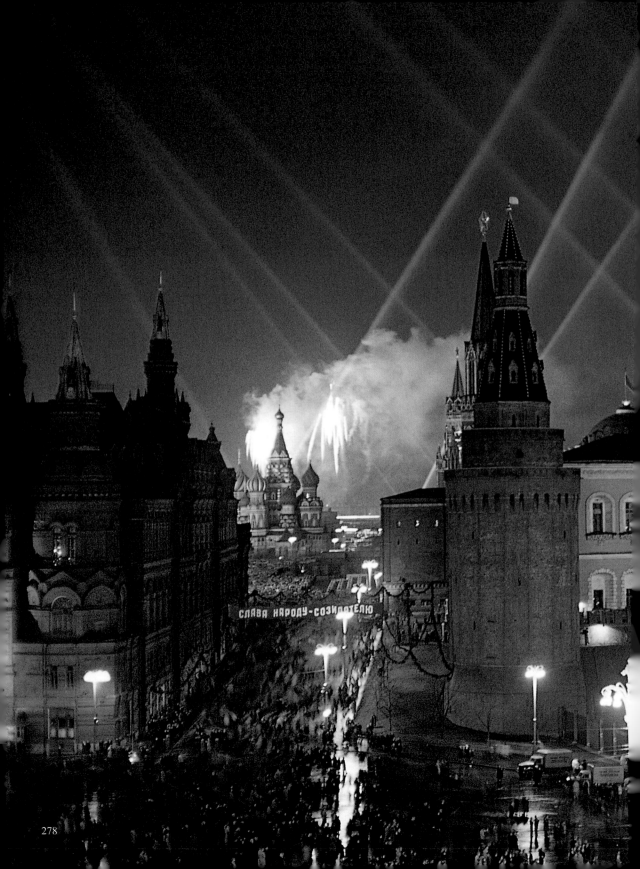

The Kremlin 7 November 1956 Red Square
Almost-War-Again Birthday Party for Mother Russia

Once Upon a Time in Russia

Ivan the Terrible was a despot of soaring dreams
when he took time off to command two masterpieces
of architecture and gald-and-jewel art

St. Basil's Cathedral and the Crown of Kazan . . . each mirroring the other

Tzars of All Russia celebrated in their Palace of Facets

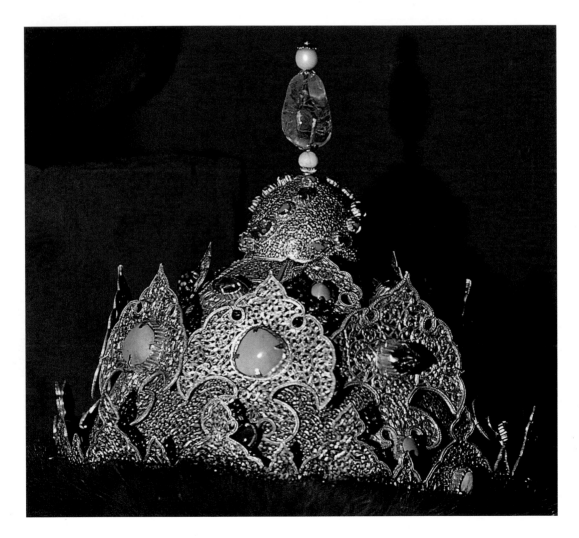

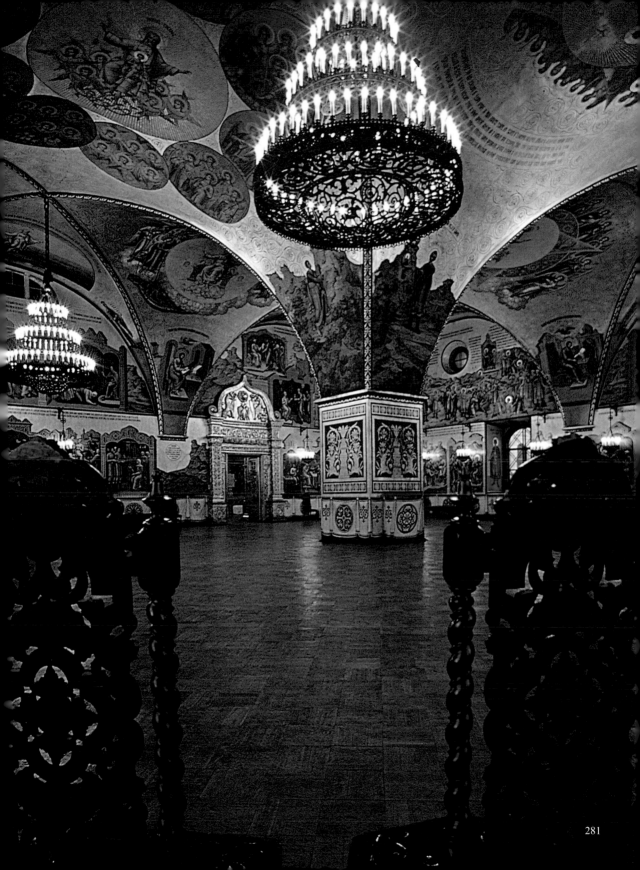

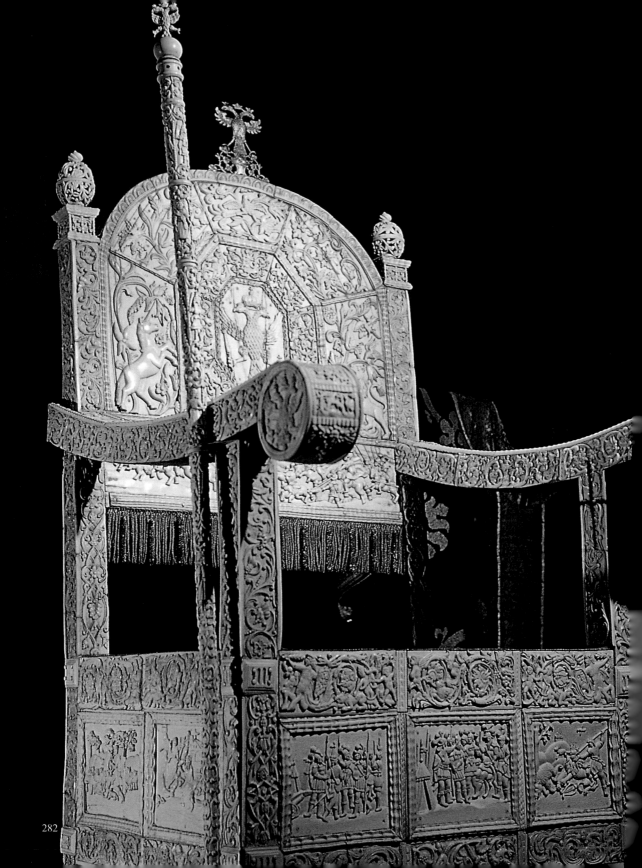

Tzar	*Caesar*
Ivan the Terrible's Ivory Throne Forever Remembered	Alexei's Jewelled Orb Now Forgotten.

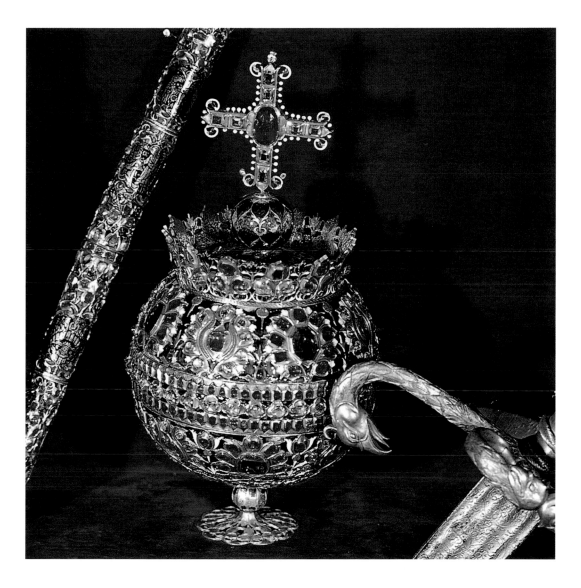

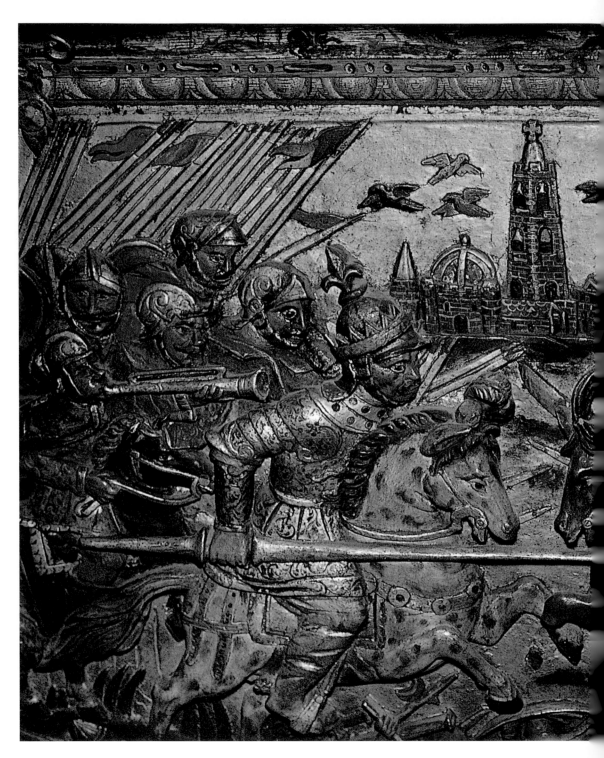

A gift to Boris from Elisabeth
Tartar Tzar of Russia / Virgin Queen of England.

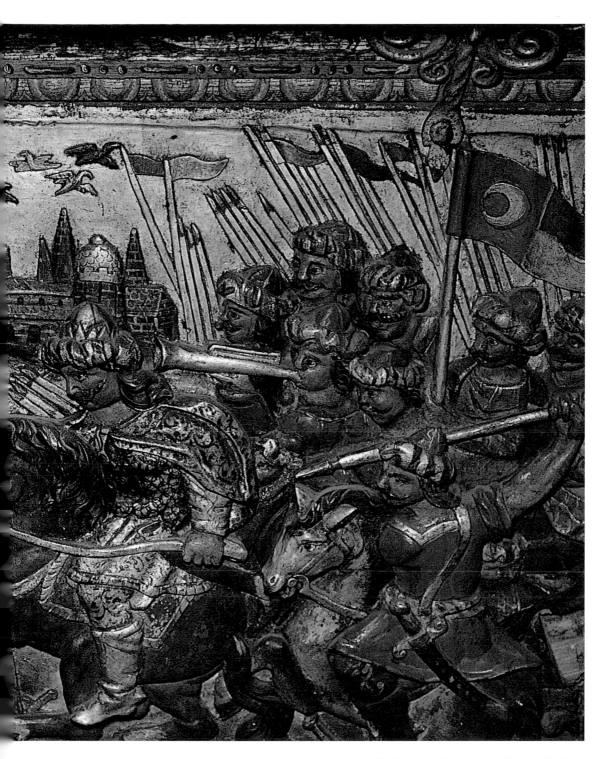

Christian Russians fought Moslem Turks --
imaginary 1612 bas-relief epic under carriage door.

Sultan Selim III of Turkey Surrendered with Style
celebrating the honor and generosity of his country even in defeat.

Catherine the Great in 1791 Treaty of Jassy won the Crimea --
pure gold-diamonds-rubies-enormous emerald . . . for her horse.

Metropolitan Photius of Russia Prayed in a Cassock of Pearls in the
Kremlin's Assumption Cathedral -- Jesus' Life embracing his shoulders.

One hundred years before Christopher Columbus sailed westward --
a most uncertain voyage of discovery with nothing but Faith his Cloak.

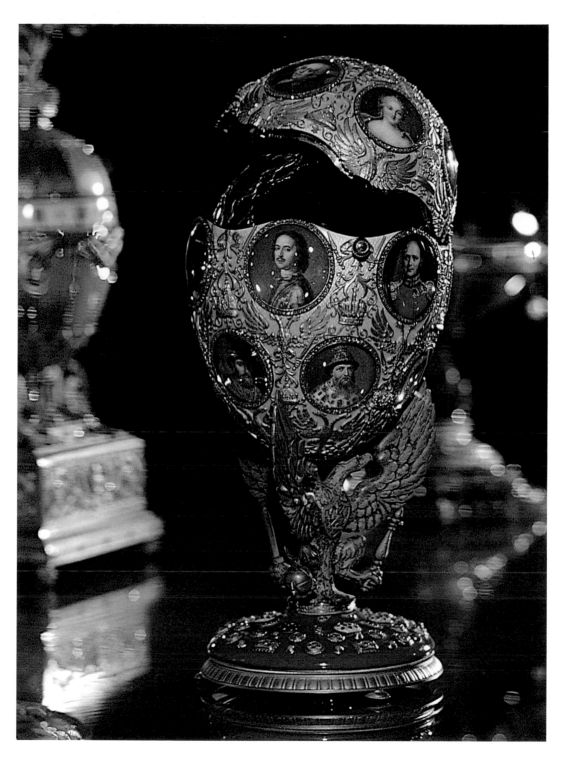

Icons for Tzars
Ivan the Great's Annunciation Cathedral

Fabergé a la Romanovs
three centuries on a jewelled Easter egg

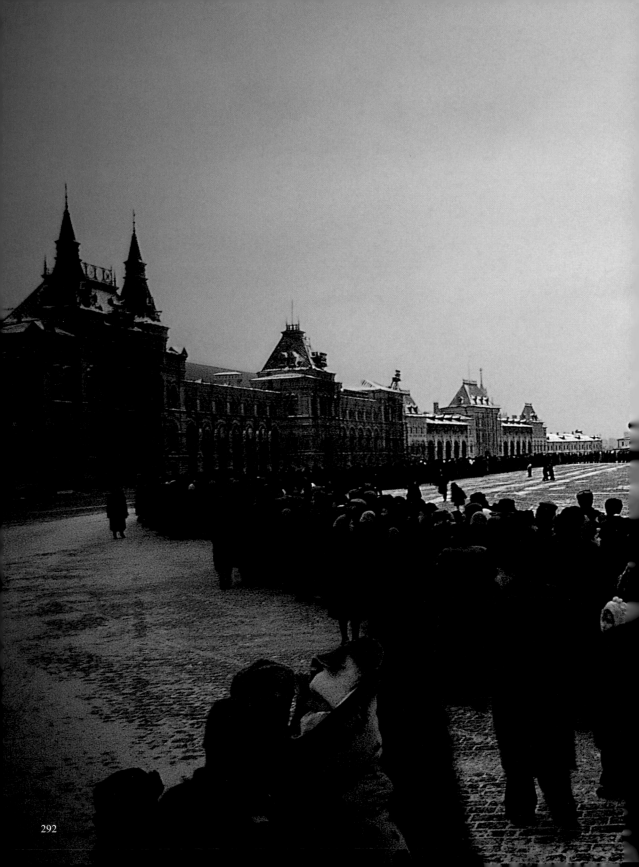

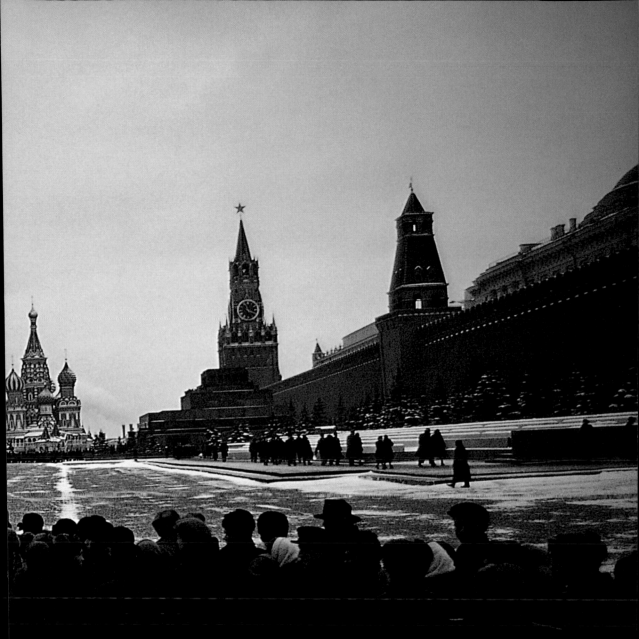

Red Square at Dusk

1956

Lenin Stalin

The Soviet Union Itself Buried There

Today

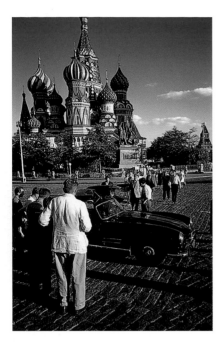

First Moscow's Kremlin: then to Leningrad-Helsinki-north-north-Midnight Sun-north-still-north-over the Arctic Circle sometimes even slower than those grazing reindeer in 300 SL Mercedes Benz capable of effortless 170 mph -- then south-south-south to beyond Stockolm-Copenaghen-Hamburg now flat out on their speed-unlimited *autobahns* -- idled in Switzerland and took the French Maritime Alps on a golden full moon almost coasting; arrived home at dawn, warm fresh *croissants* lavander-honey breakfast: reloaded cameras, braked down to Cannes -- tapped my horn, watched the gates open; went to "work" shooting Picasso's private world. Had phoned three days earlier.

If they wanted caviar before lunch.

Red Square to Côte d'Azur in a 1956 Black Torpedo

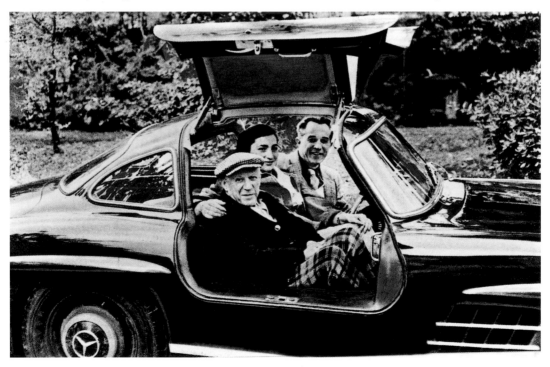

Picasso-Jacqueline / DDD / 300 SL.
photo: Gérald-Ynes Cramer / 1957.

Picasso / 1962 / *Château de Vauvenargues.*

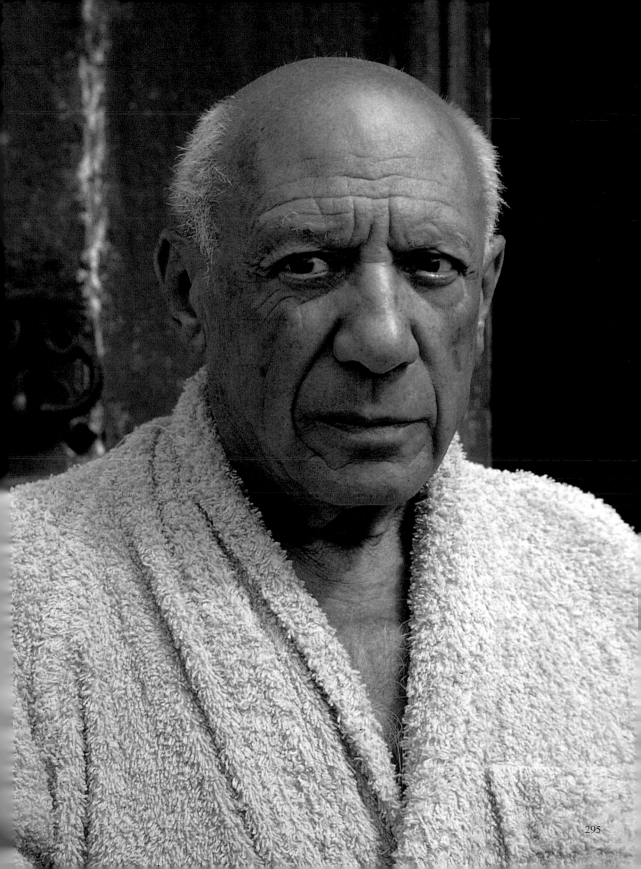

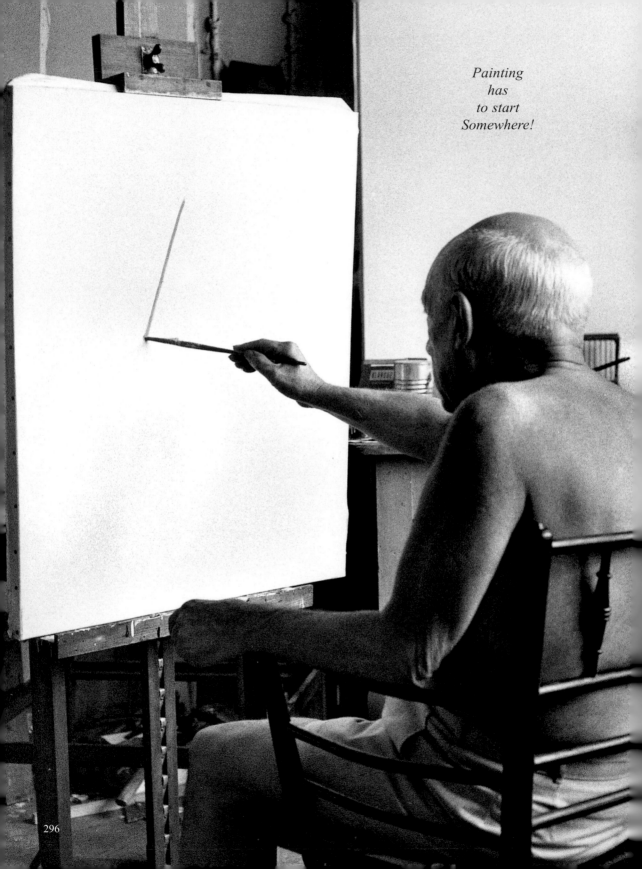

*Painting
has
to start
Somewhere!*

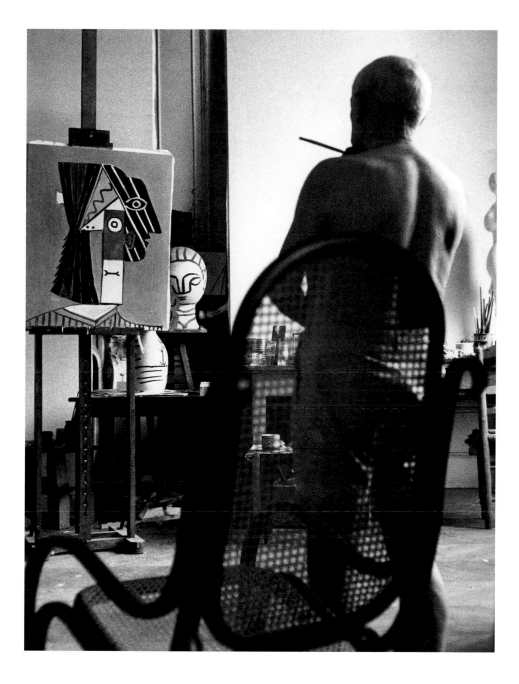

Cézanne - Matisse - Modigliani
... masterpiece upon masterpiece ...
for Pablo Picasso the masterwork was Jacqueline!

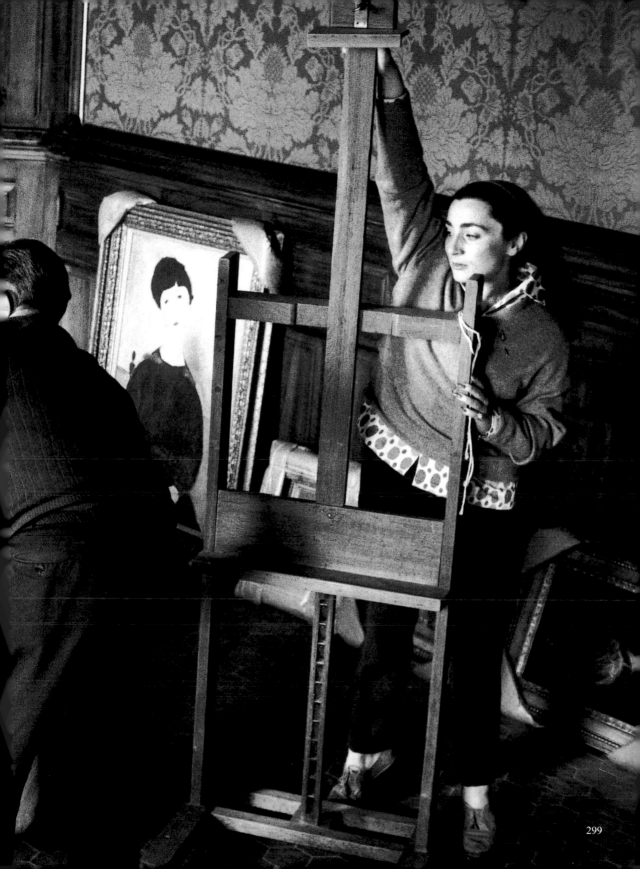

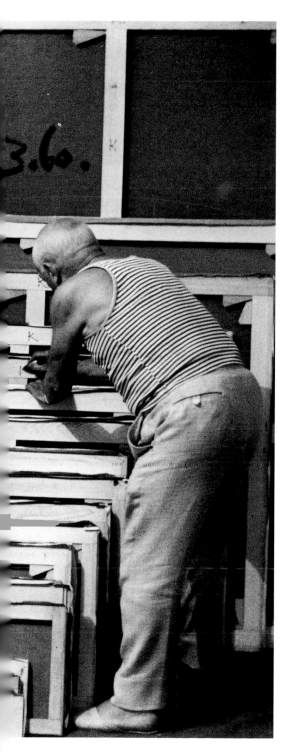

*One Year
of
Work*

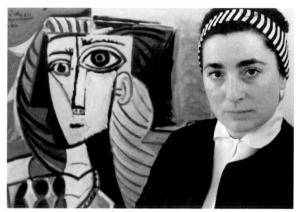

All a mystery -- before he taught me a language without words. He gave me that portrait of Jacqueline *"Para mi amigo Duncan"* yet he never called me Duncan. I was "Ishmael" or *"Gitano"*/Gypsy -- Great! . . . they adored him.

Her *portrait?*

Look at their matching features.

Share my language lesson.

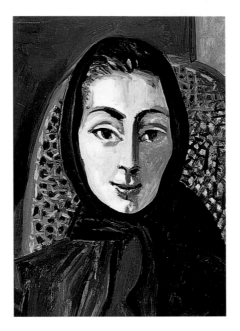

Jacqueline as Jacqueline

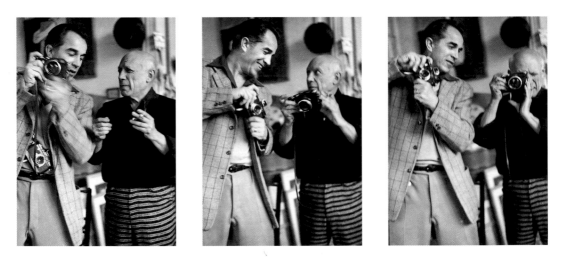

Sometimes he pretended to fire my Leicas / never did I touch a brush — pretend to paint.

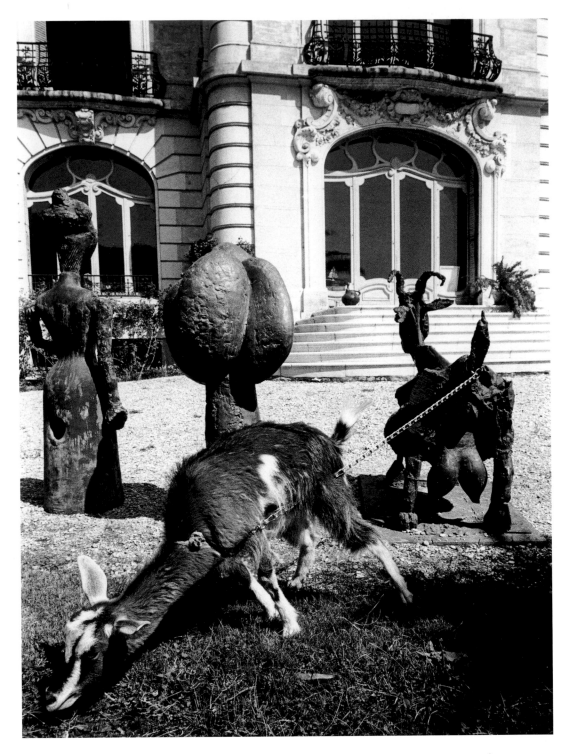

goat-to-goat
Picasso -- Picasso

those eyes . . .
shoulders-doorway-windows

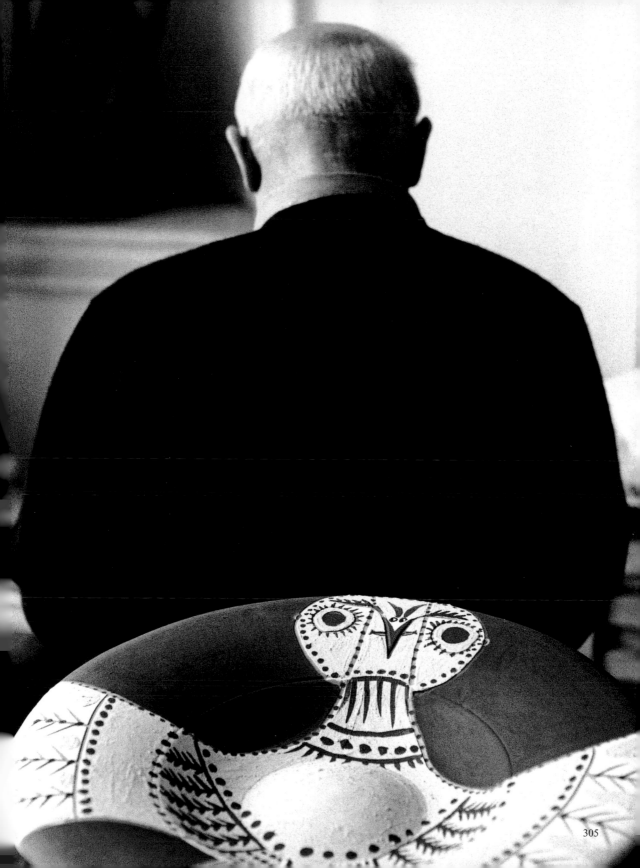

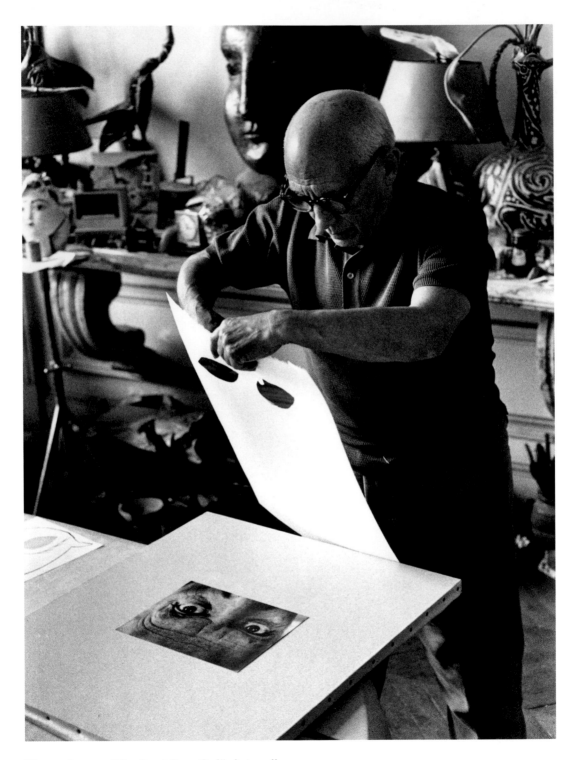

His eyes became *"The Great Snow Owl"* photo-collage
his work/my work combined . . . which he gave me.

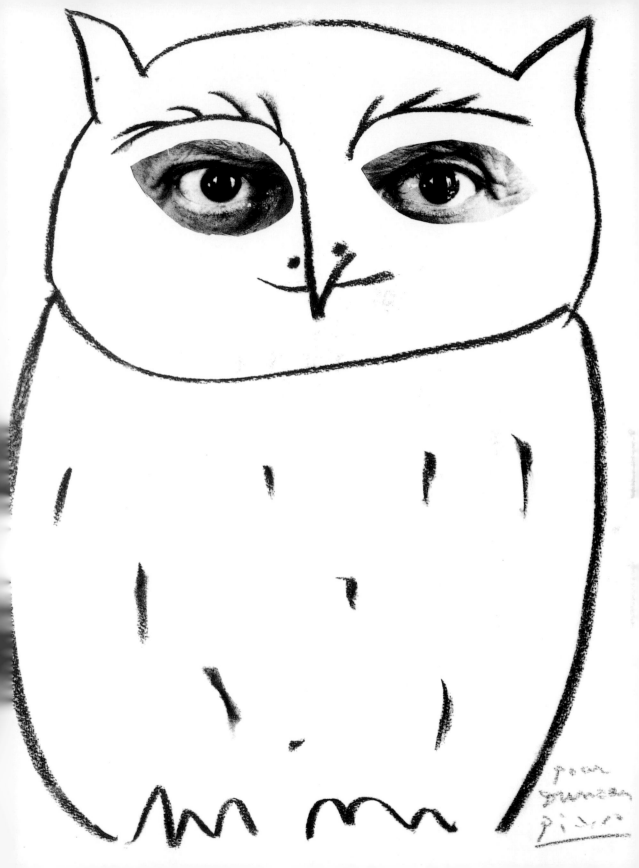

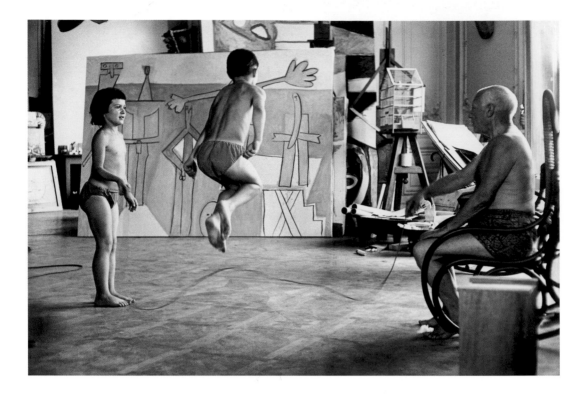

1957

Villa La Californie

The Happiest Summer of Their Lives

Daughter Paloma -- always "Paloma"
Son Claude -- "Octavio"
never
explained.

he was seventy-six
it seemed that He wasn't counting.

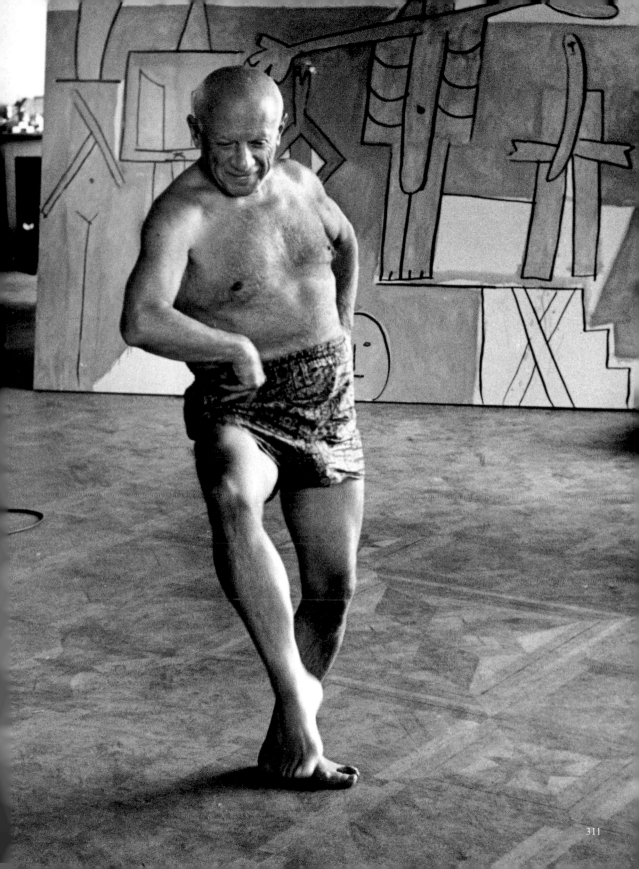

Creativity

A few slashes of crayon
transformed
his
oldest Catalan friend
Manuel Pallarés
into
Roman senator
joining him
in
their Bacchanalian fiesta.

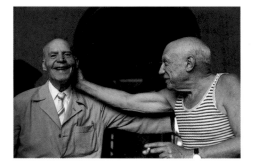

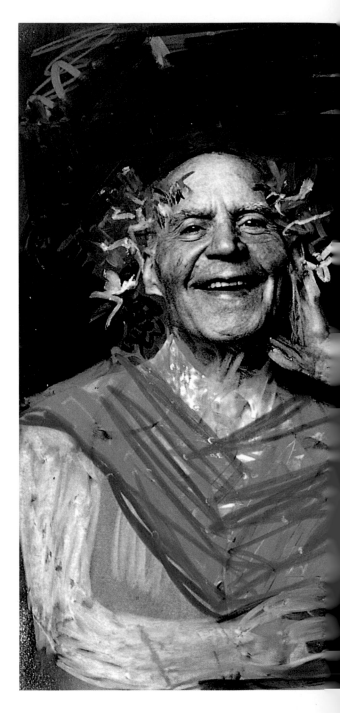

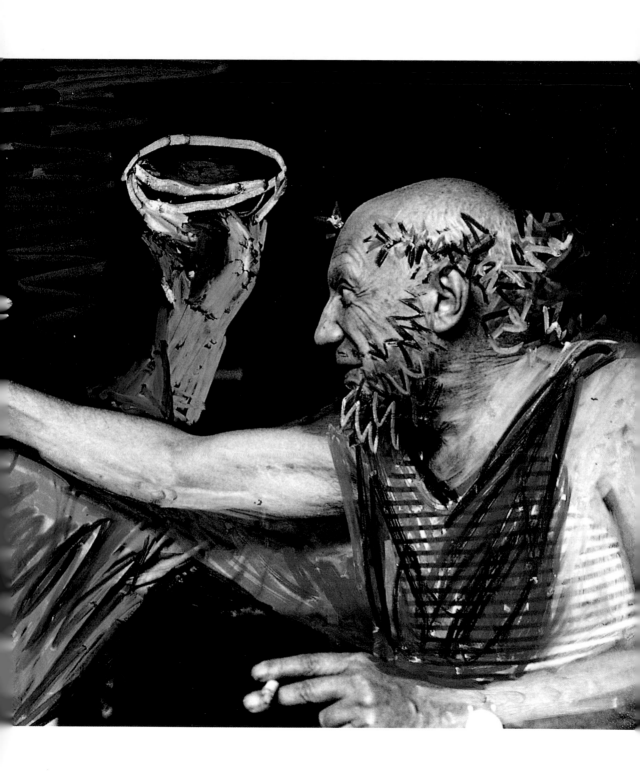

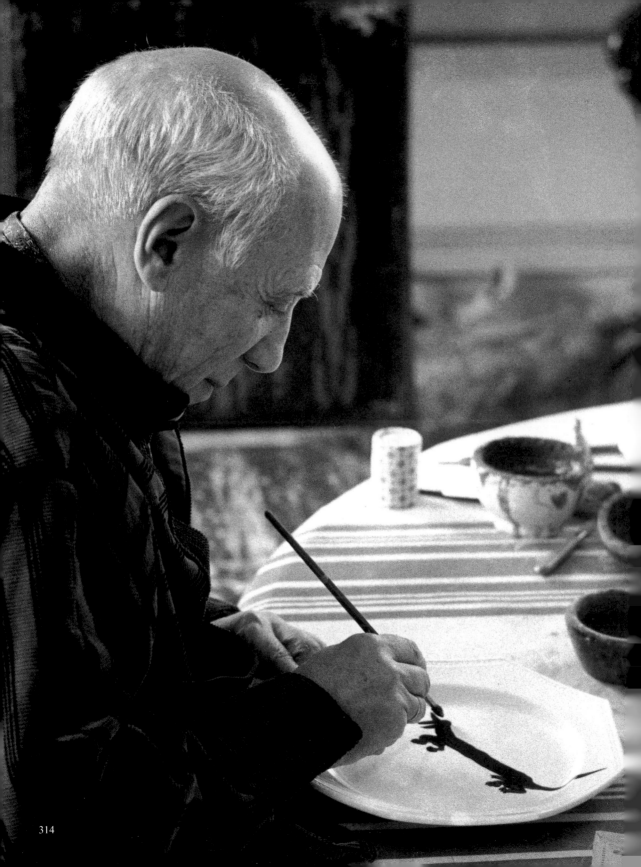

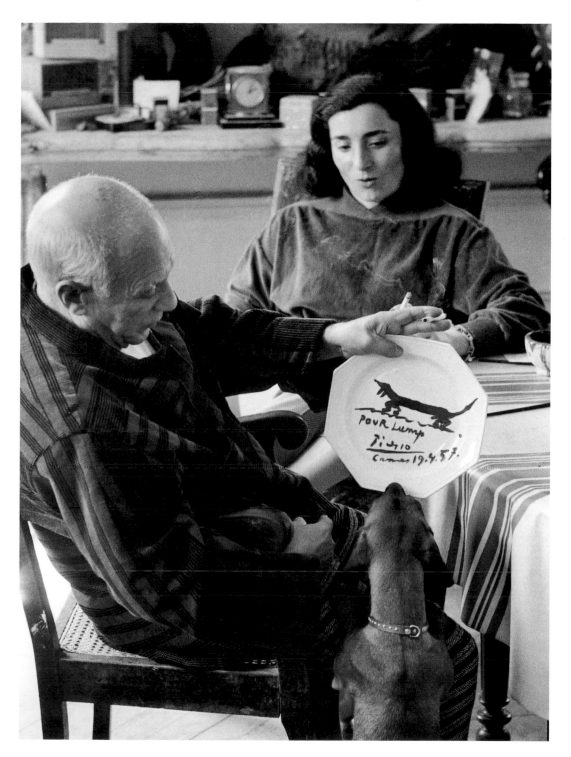

He ate from a Picasso plate with his dedicated portrait.
Lump my wily dachshund came visiting from Rome, stole Picasso's
La Californie and heart. "Lump has the best and the worst in us!" She asked him what he wanted for lunch.

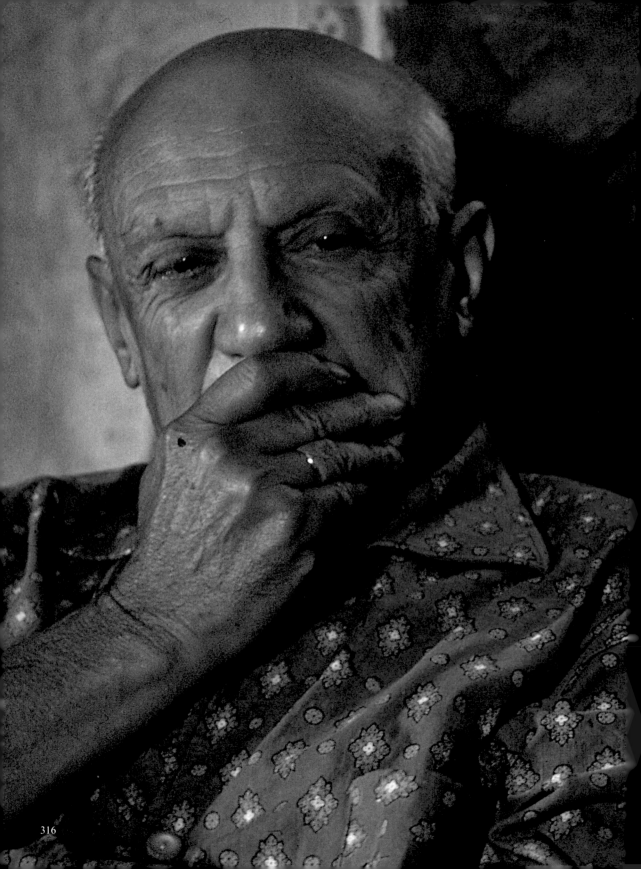

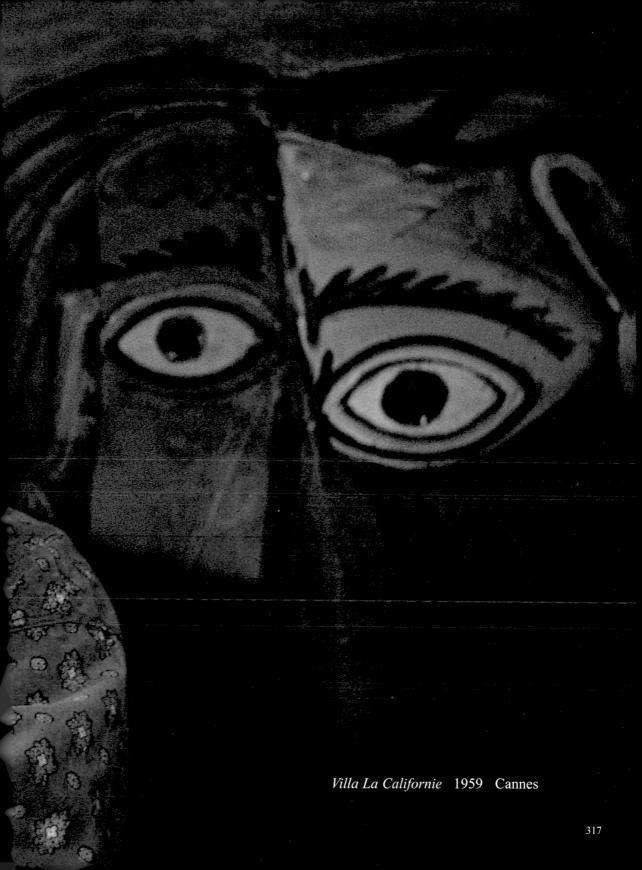

Villa La Californie 1959 Cannes

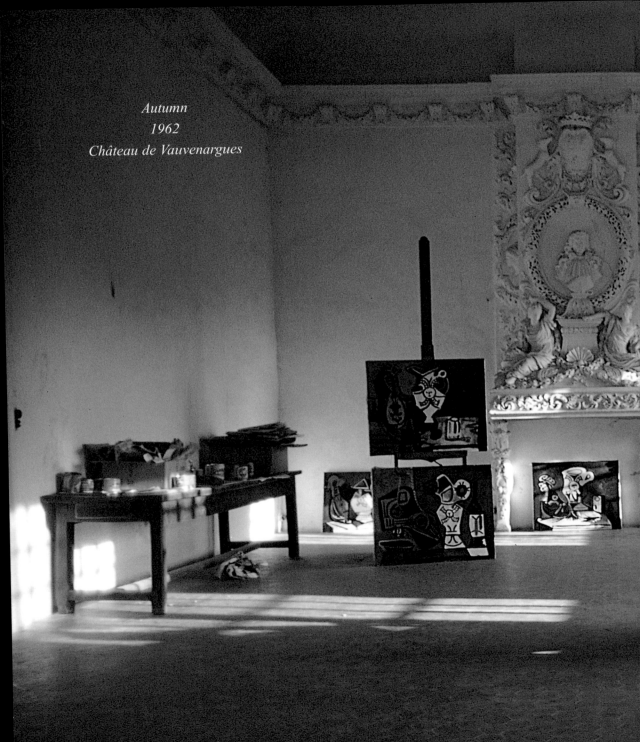

Autumn
1962
Château de Vauvenargues

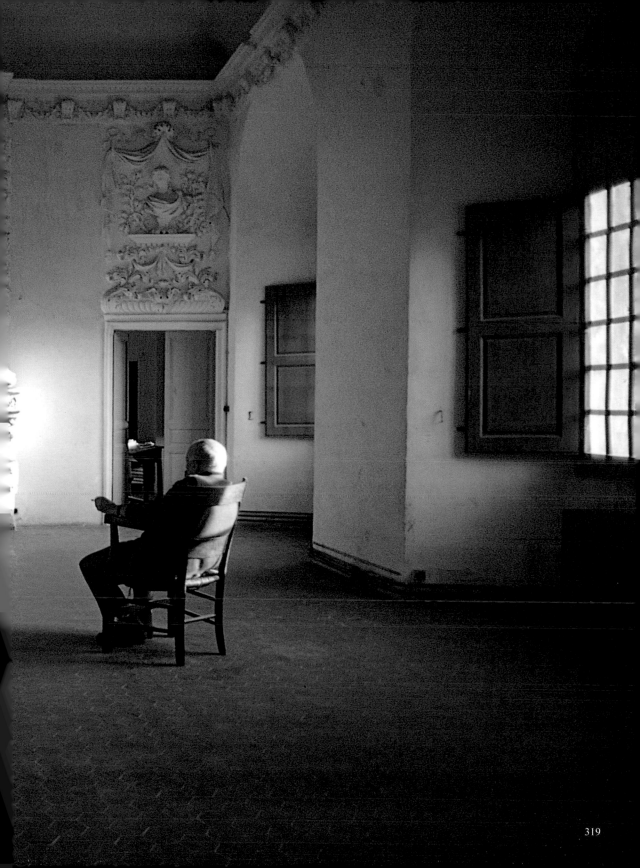

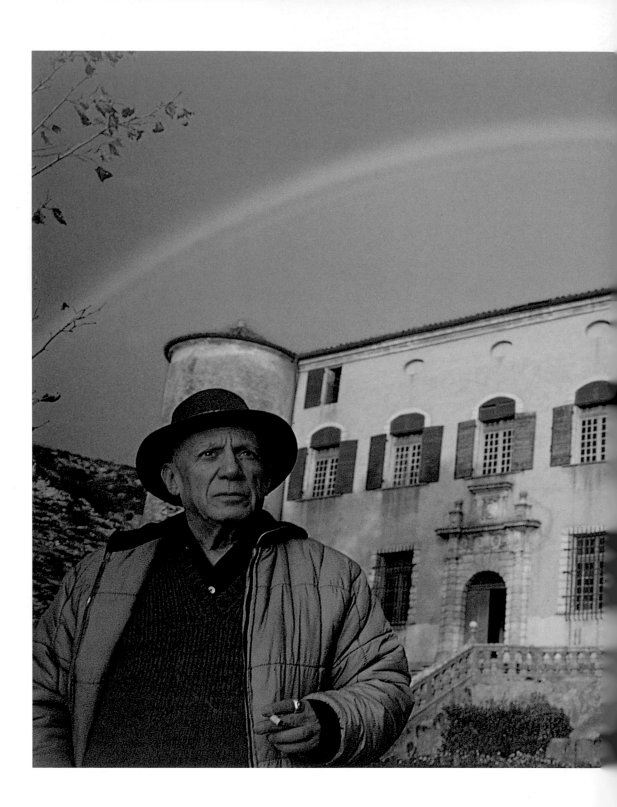

Château de Vauvenargues

September

1959

the day
he showed me
his
new home.

today

Pablo and Jacqueline
are
together
at
Vauvenargues

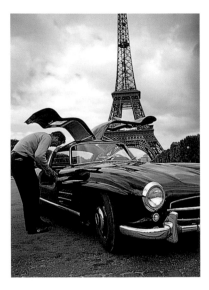

Loading cameras / 300 SL -- my Jeep
photo: Tony Vaccaro / LIFE Paris.

Prismatic

Paris

1962-1967

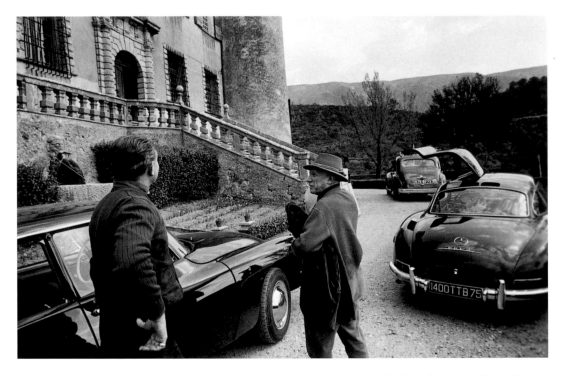

Picasso's son Paulo arriving
Vauvenargues from Paris / 300 SL.

My dream of *Notre-Dame* Cathedral imagined as architects' dream.

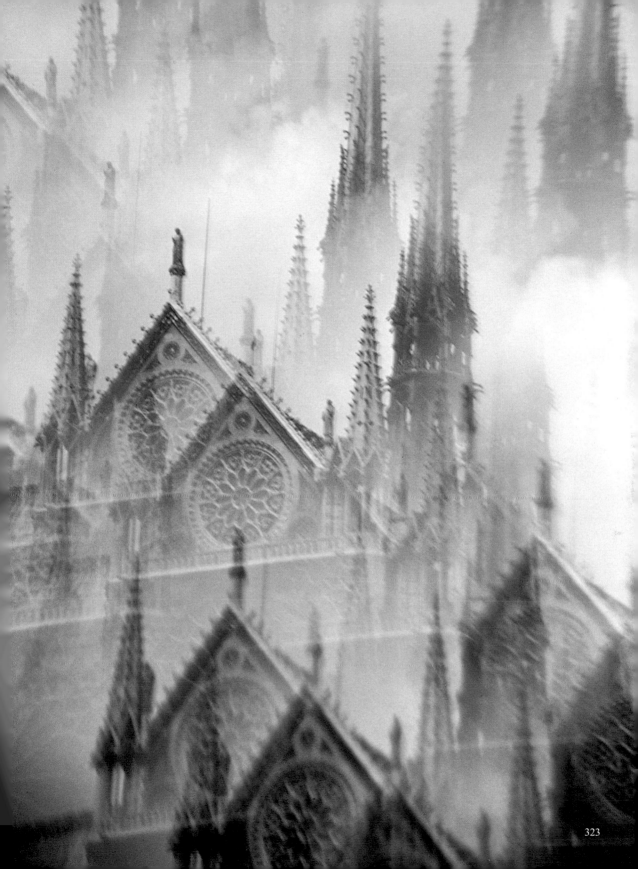

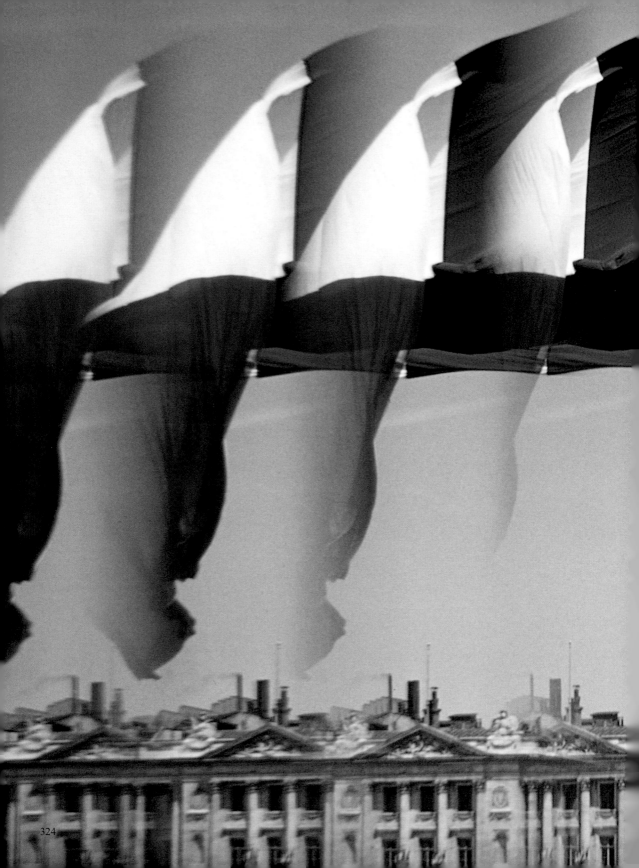

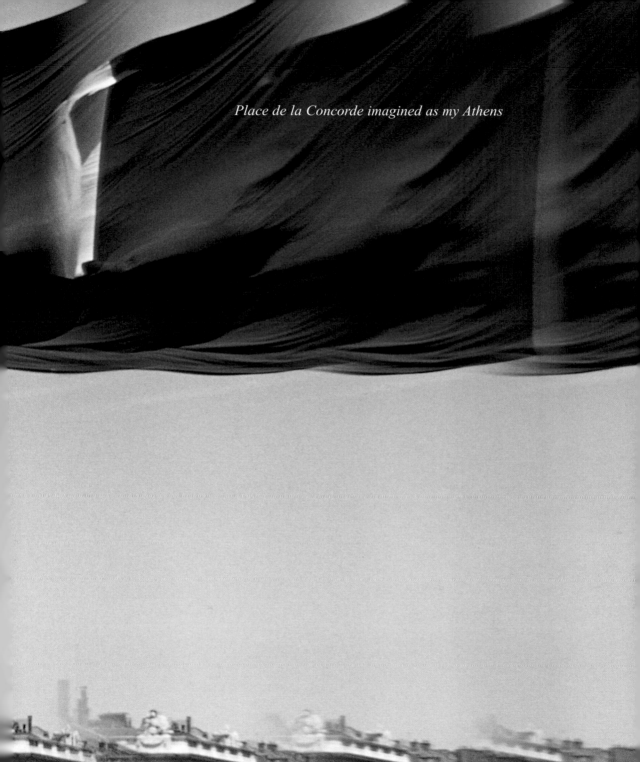

Place de la Concorde imagined as my Athens

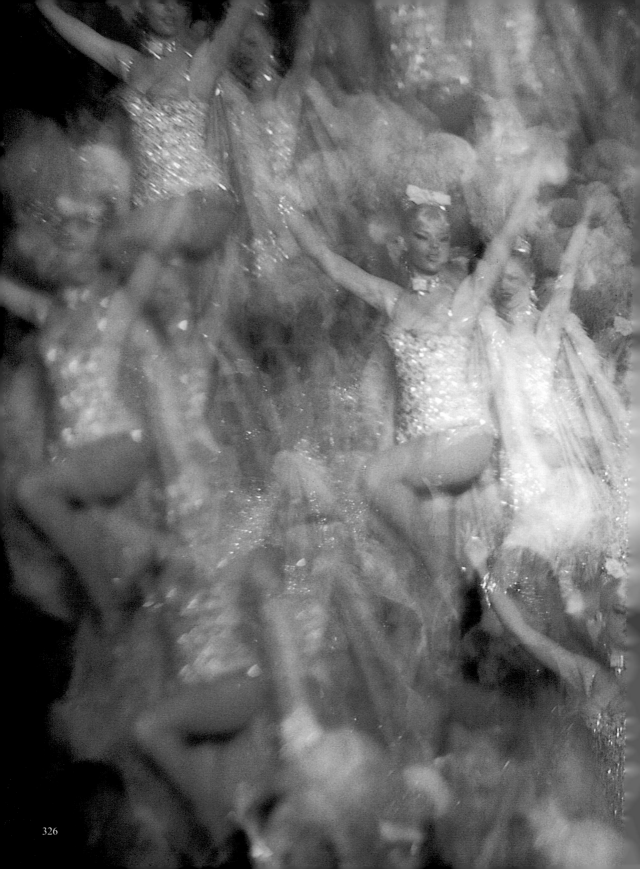

Three Lido Dancers imagined as one-rose-girl.

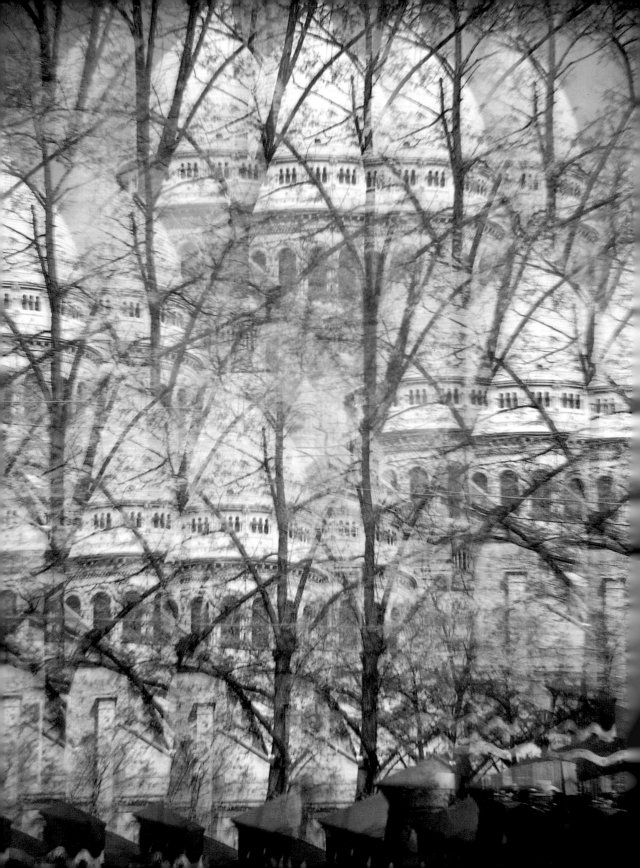

Church of *Le Sacré Coeur* imagined as stained-glass windows.
Le Bois de Boulogne imagined as holiday Garden of Eden.

Paris

Clouds of Spring

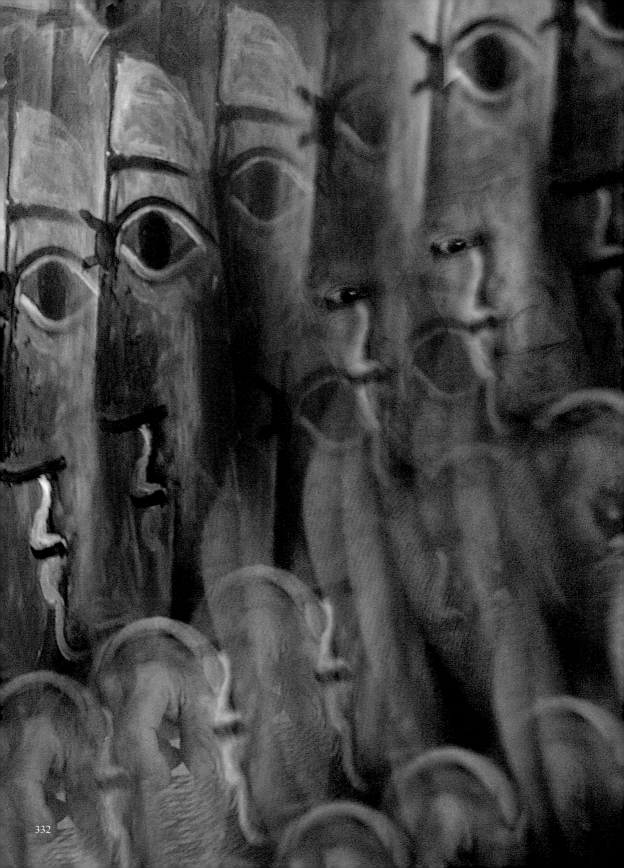

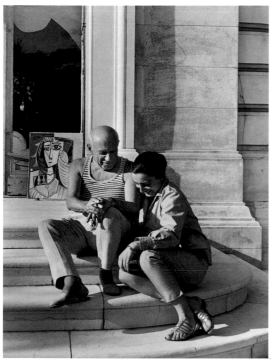

Two Goodbyes

Picasso had just given me a portrait of Jacqueline, leaned it against the door for *"Para mi amigo Duncan"* to dry in the afternoon sun. When Jacqueline joined him in the *Château de Vauvenargues* garden, many years later, this photograph was with her: "Bon Voyage with Pablo" the only time I did not call him . . .

Maestro

After I'd given him a print of himself as a magician -- maybe a bit his way, too, and drove down the hill on assignment to a faraway land . . . for quite possibly, a *very* long time, they stood just as that day we first met.

"This is your home. Goodbye"

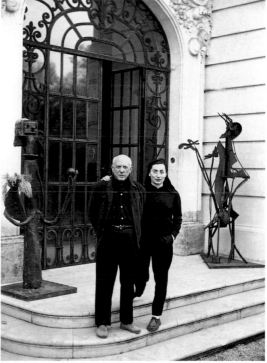

Vietnam
1967—1968
Cua Viet … Con Thien … Khe Sanh

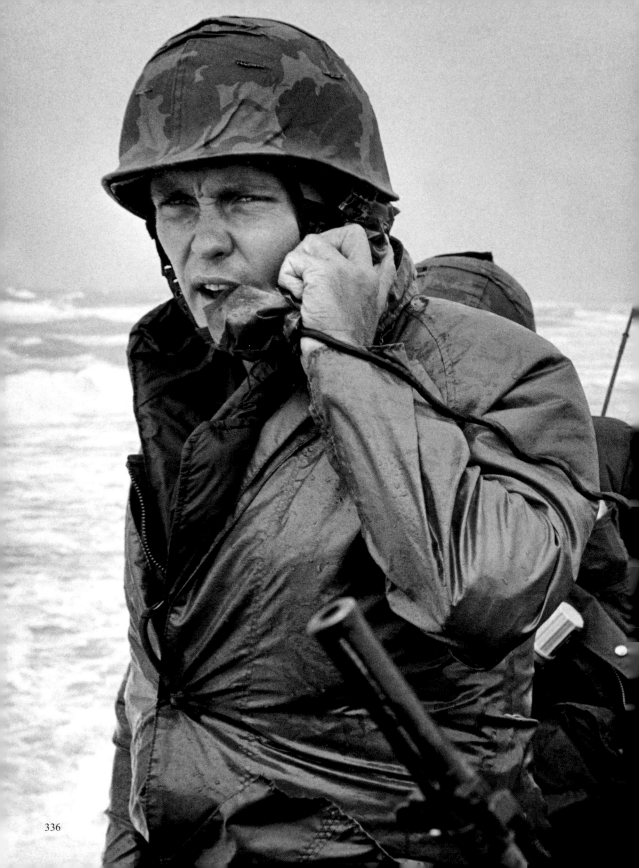

Captain Reginald G. Ponsford III, such a strange name for here, on his amphibious tractor while leading a tank squadron through the surf -- safest place avoiding Vietcong mines -- to Cua Viet River, welcomed shielding monsoon rain thwarting enemy gunners nearby in the not yet DMZ . . . Demilitarized Zone.

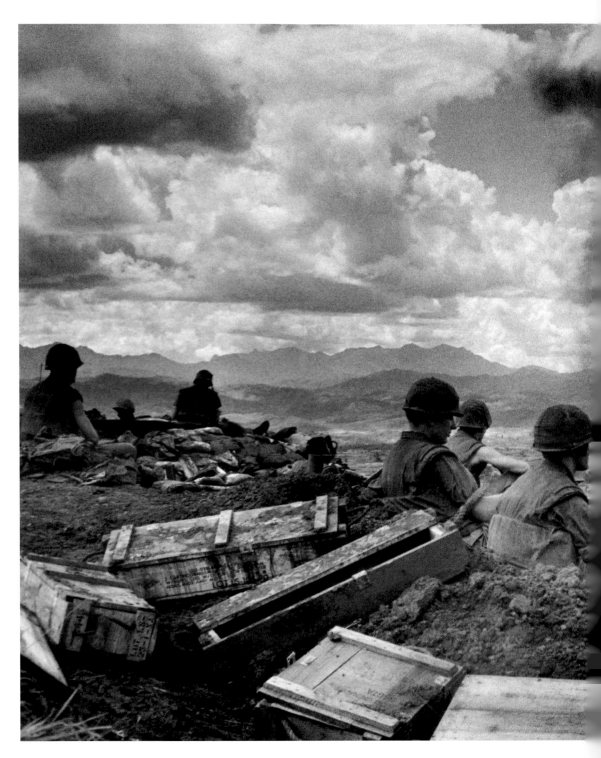

Con Thien . . ."The Hill of Angels" in Vietnamese.
Marines viewed it a bit harshly but grateful when snipers left them unsniped.

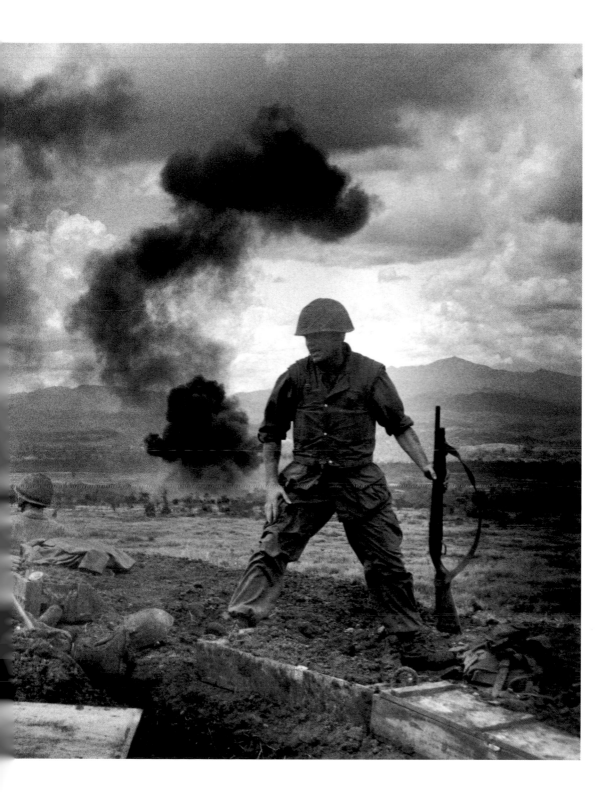

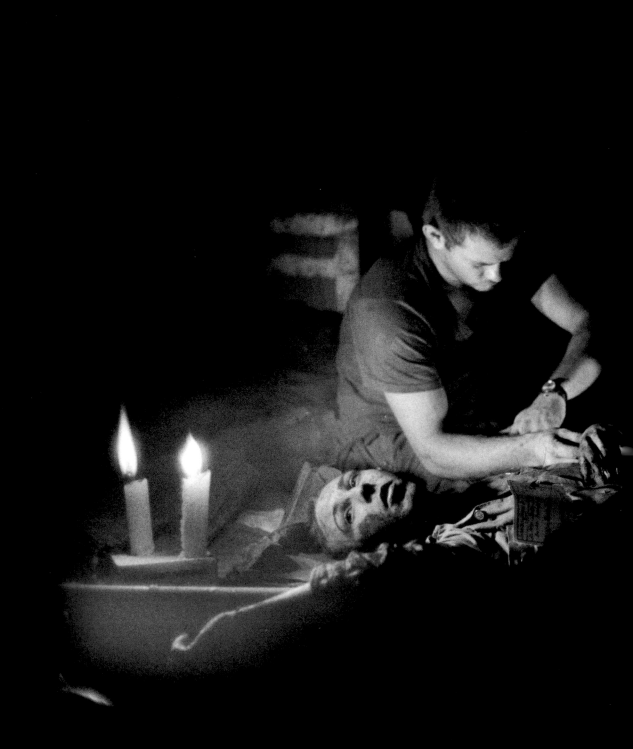

Fifteen feet of sandbags and railroad ties meshed overhead --
sloshing monsoon rainwater underfoot --
stunned surprise with pain yet unknown and strange voices
blending with those of corpsmen . . .

"No sweat Denny . . . just a fender job like a jeep!"

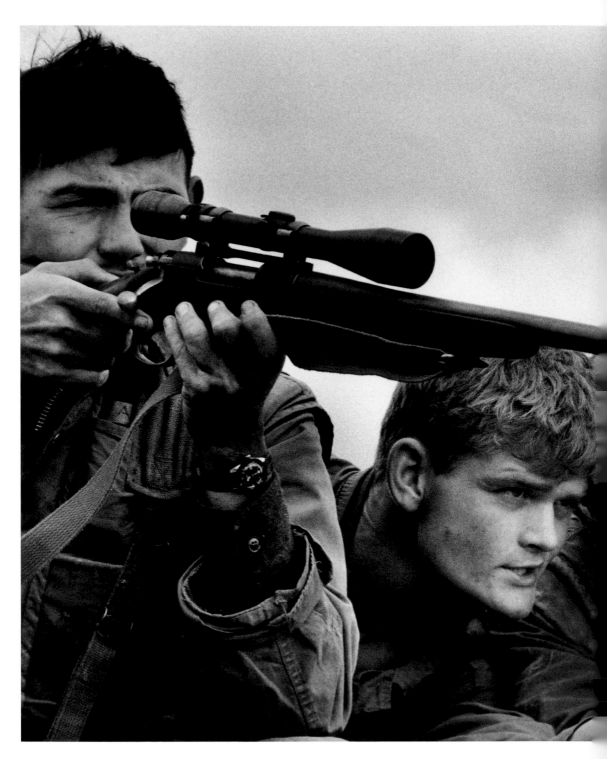

The Snipers of Khe Sanh --
three sharpshooters now in Marine Corps history.

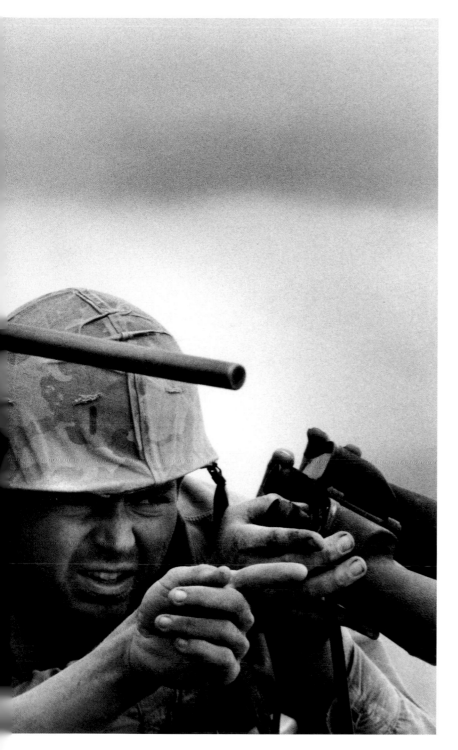

Albert Miranda – David Burdwell – Alec Bodenwiser.

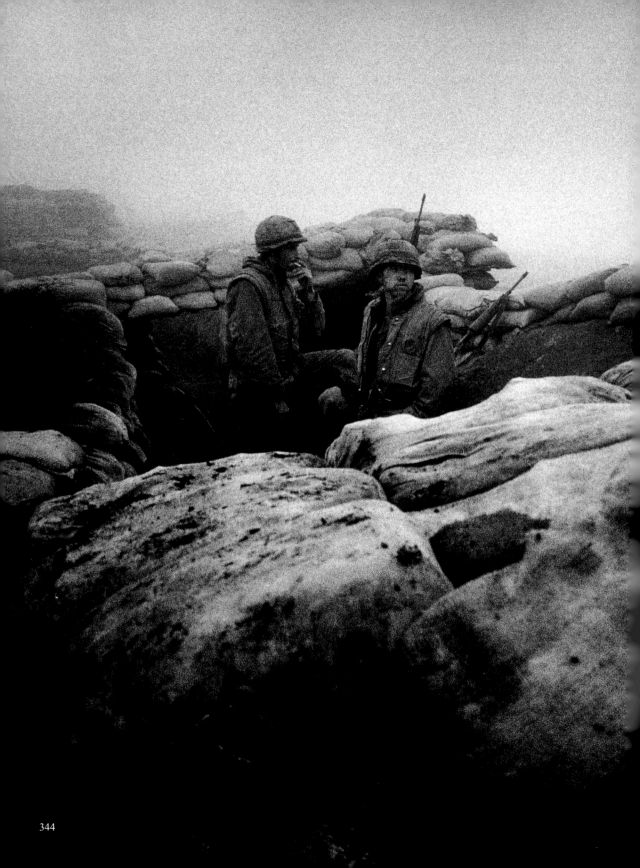

Khe Sanh on a normal foggy morning was a bit deceptive
Six thousand other Marines were nearby – underground.

Another Vietcong attack broken -- fog lifted -- choppers expected
only that stricken face revealed their every dawn heartbreak.

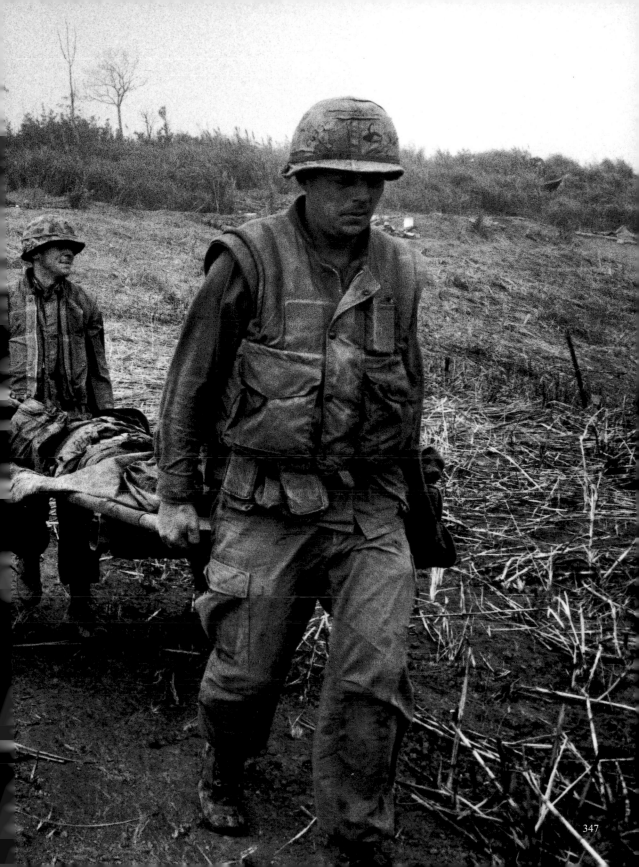

At dusk the Requiem of Khe Sanh a constant dirge for friends --
no-incoming -- soon night . . . that prehistoric monster of war being fed

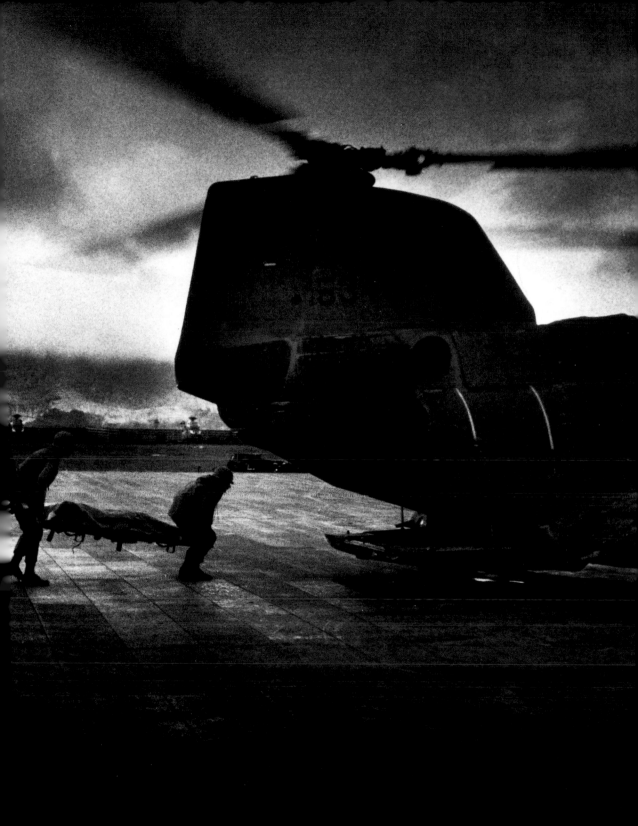

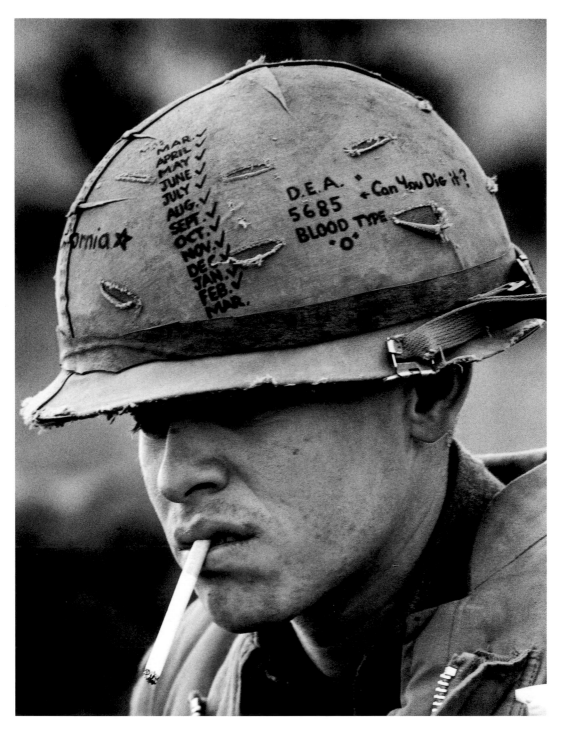

Tonkin Gulf . . . Persian Gulf Khe Sanh . . . Now Iraq
 Beardless children fought wars for combat innocent tycoon-politicians who hijacked America's military --

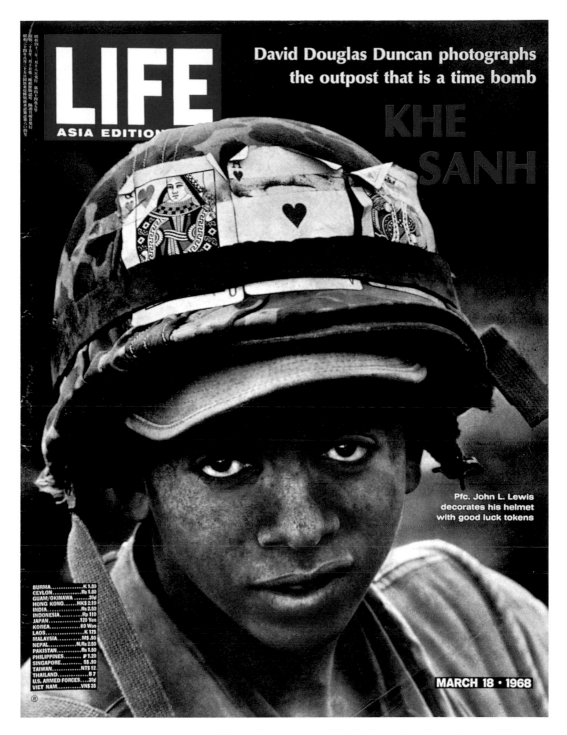

I Protest! . . . again -- while doubting that faces of war really matter.
camouflaged their agendas and ambitions then sold them to a trusting nation through media extravaganzas.

America's
Presidential Conventions
Republican – Democratic

1968

Warfare Wearing Another Uniform

My flight back to America from Vietnam – handcarrying my film from Khe Sanh to LIFE in New York – was the worst worst-of-worst! A giant C-141 troop-transporter loaded with forever-silent passengers awaited by hearbroken families at home was precisely on time at Dover, Maryland Air Force Base. Nobody cheered.

LIFE ran my story and ABC News a photo-film documentary, while I blasted through 18-hour days to write (illustrated of course) a little book, my own United States government its target: *I Protest!* Lyndon Johnson in the White House – Robert McNamara at Pentagon – General William Westmoreland taking orders in Saigon . . . *a voice in the dark.*

My combat gear and all but four M3D Leicas (two in Hong Kong being restored from salt-water damage at Cua Viet) was left on the Danang pressroom floor. I'd expected to catch another — normal — flight back to Vietnam where the battle for the religious city of Hué was reducing that shrine-place to gravel – and more Marines to evermore flights in over-loaded C-141s. I also never returned.

Reuven Frank, President of NBC News phoned offering me – *carte blanche* – the chance to shoot the first professional photo-story of my life in my own country, starting at the pinnacle-peak: The Miami Beach and Chicago Presidential Conventions. It would be an approach never before attempted on national television, and challenging despite the glaring vacuum in my political and television past. I'd only known Latin American dictators and made guest appearances on NBC's "Today Show." No problem! So I pried Carmine Ercolano from the LIFE lab to soup and print my shots, borrowed a unique 400mm lens from Helen Wright whose father owned Leica North America, went to Brooks Brothers bought jacket-tie-blue shirt – had a double chocolate malted over at Schrafft's and headed for Miami Beach where as an amateur fighter humored by my best friend's father – Jack Britton ex-middleweight champion of the world – I would pick up five bucks on Saturday nights at the South Beach arena and then return to classes Monday morning with nose so battered eyes half-shut I figured life with cameras might be a soft touch and with a future I could at least see.

Hard to believe – the All-American Circus – but . . . look around – even through my sniper-telephoto . . .

not a smile in the house – where are the black-brown-young-vets-other Americans?

So this is where Presidents are born
full-grown!
special clinic . . . ear . . . eye . . . nose!

Welcome
to
The Party

Republican
Miami Beach

Governor
Nelson Rockefeller

Big Hope / Big Hand
and
Another Element
Big
Money

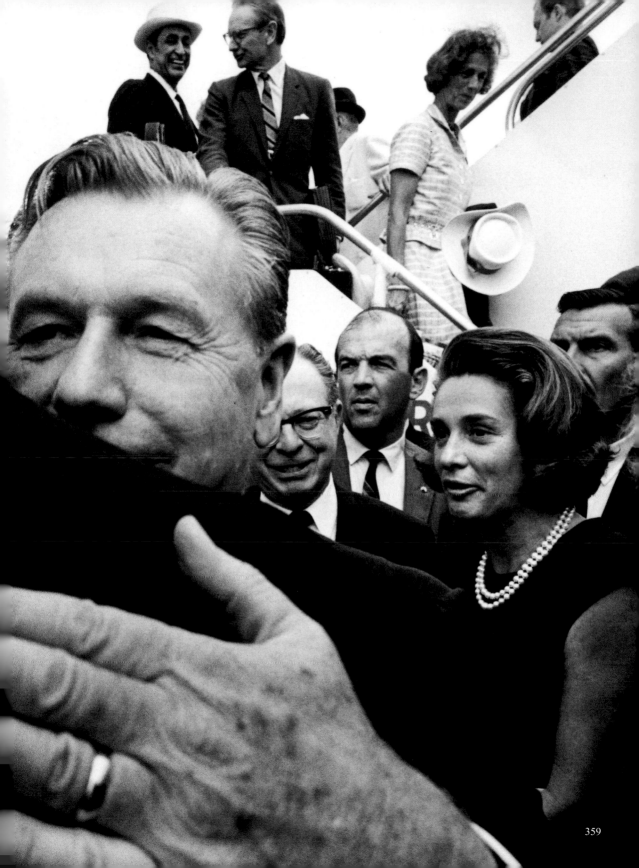

Richard Nixon

History . . . Reputation

Closeup

like all life
another side – another story

I'd like to share one: starting at Torokina, a mangrove swamp then the new American most-forward airstrip on Bougainville where Lt (jg) Dick Nixon had sent Piper Club "pilot" 2nd Lt. Marine photographer Dave Duncan behind the Japanese lines to join a remote Fijian guerrilla unit based at Ibu — many weeks later reequipped him with navy boots and gear jungle-ruined during the embattled Fijian cross-island return from that Japanese-overrun outpost – casuality free – to Torokina where Navy lieutenant Nixon and U.S. Marine lieutenant Duncan had met, starting a friendship enduring until the end of one always turbulent life, including resigning in disgrace from its peak: President of the United States.

The day their Saigon American embassy fell the former Marine lieutenant was again with him, at his San Clemente home, where they spoke of another Duncan friend maddened by brain tumor who had killed an asylum fellow-patient with a swung janitor's bucket: later told of his illness – not insanity – then died after emergency surgery at a US Naval hospital near Kansas City under caring hands of the most skilled available surgeon arranged in a fast ten-minute phone call to Washington, where a boomerang-nosed fixer from Bougainville, by then Vice President of the United States – locked in the final week of campaigning against John Fitzgerald Kennedy of Boston – later phoned Bill Schopflin's widow . . . condolences.

Time and *Newsweek* editors earlier objected to this picture.

"Unfair / disservice to White House."

When Dick Nixon, of Bougainville, saw it -- shrugged:

"That's the way it was -- that's the way I am."

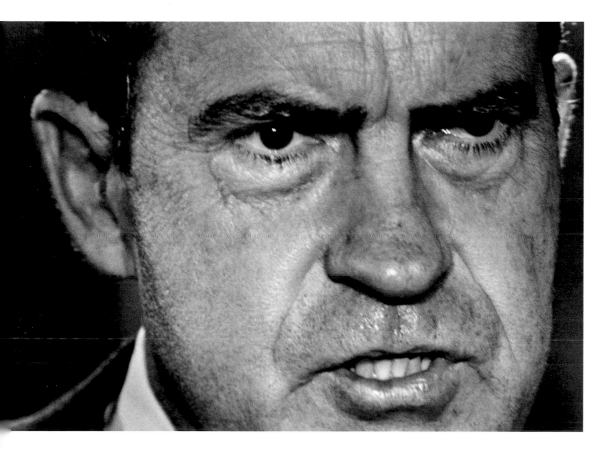

Acceptance speech writer for Nixon? . . . he wrote every line alone.

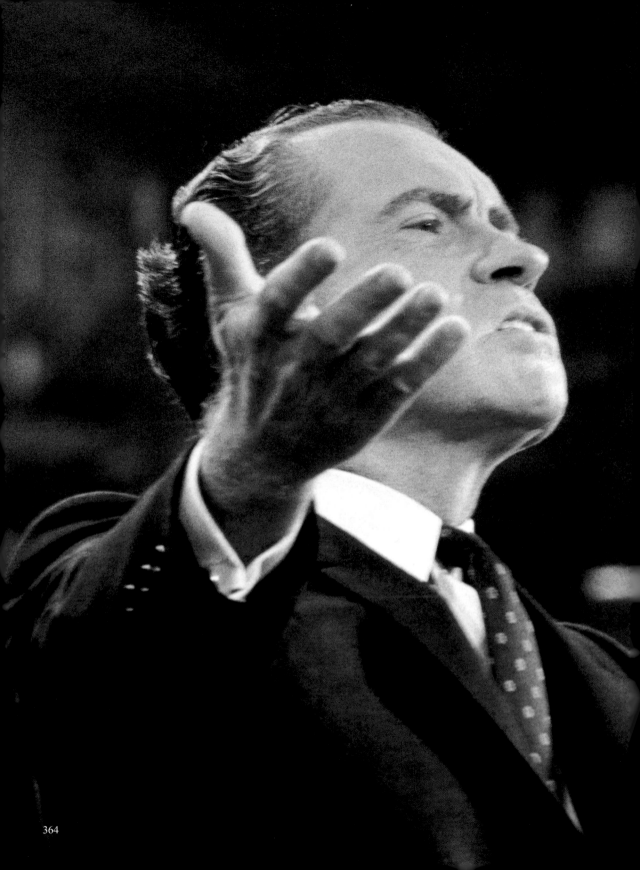

One a US President
and
One a Postage Stamp

Senator Everett Dirksen/Speaker of the House of Representatives.

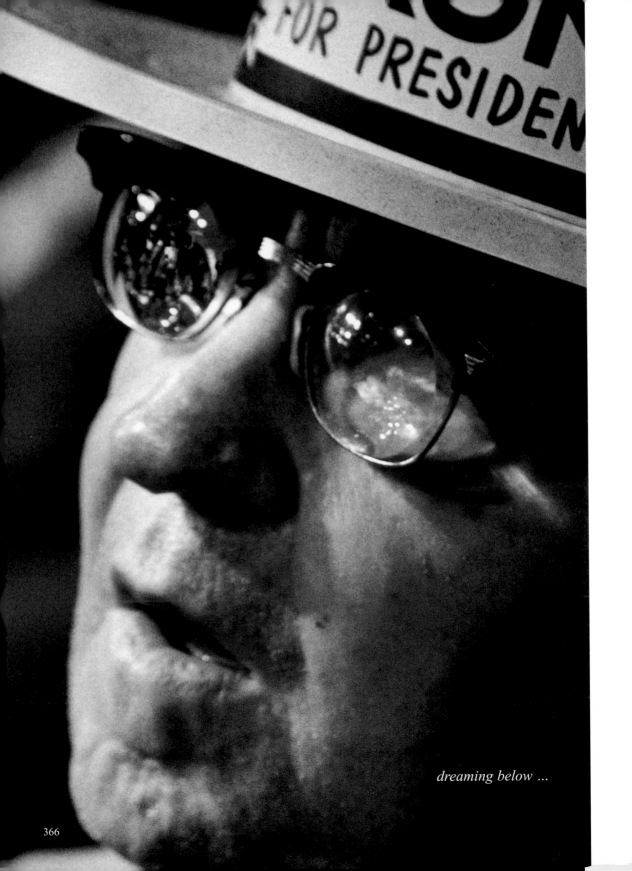

FOR PRESIDEN

dreaming below ...

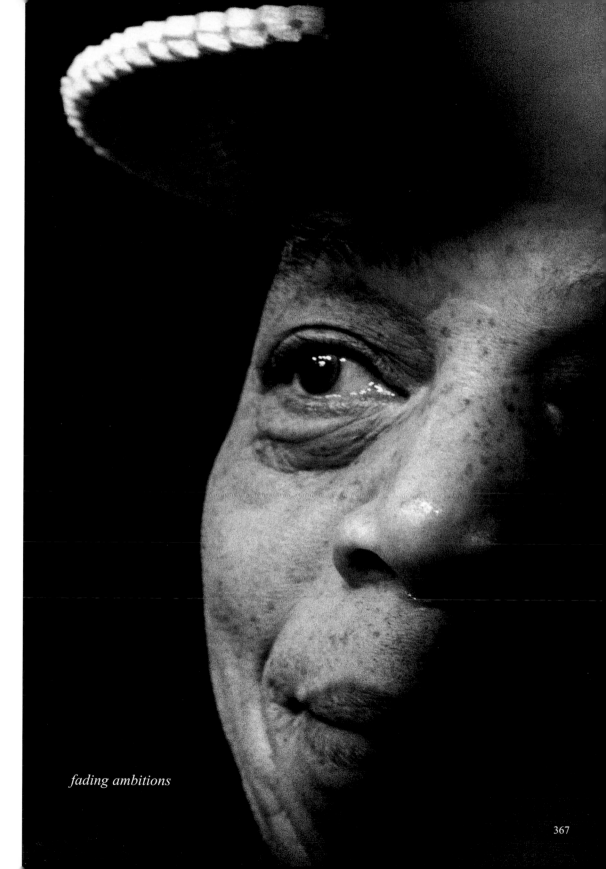

fading ambitions

367

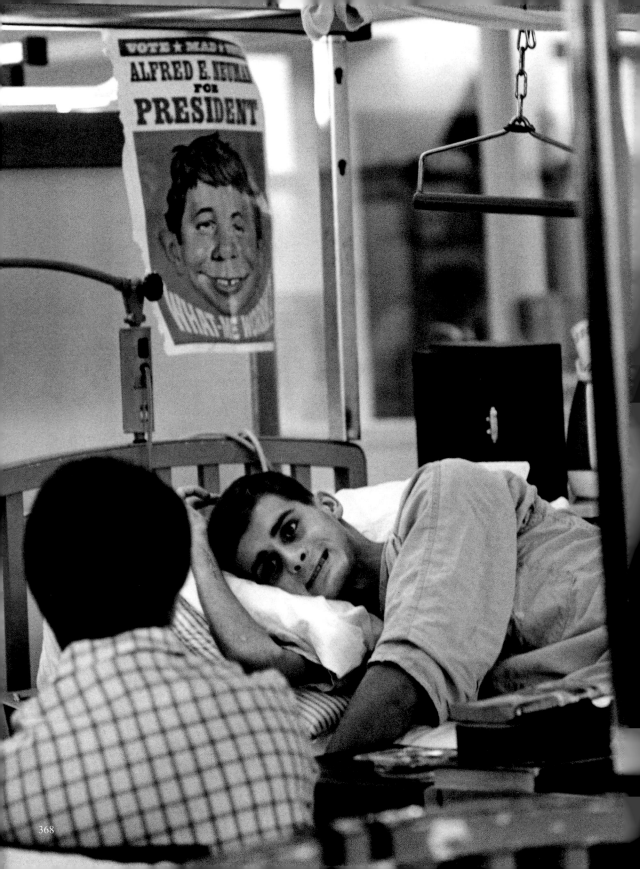

Chicago
— Democrats —
Lyndon Johnson
White House
abandoned
Chaos
The Vietnam War
Maimed veterans-Innocent Dreamers-Professionals
Semi-Civil War

"We shall overcome"

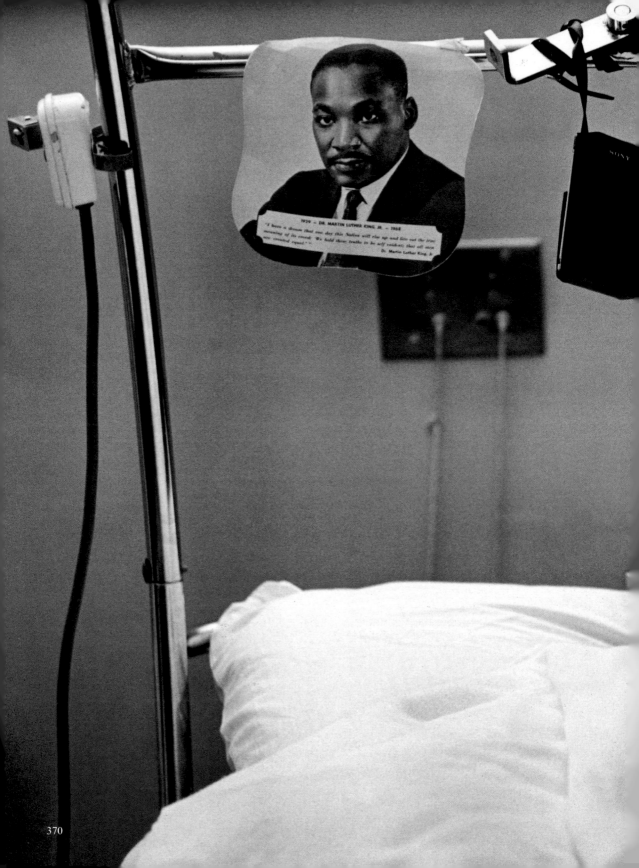

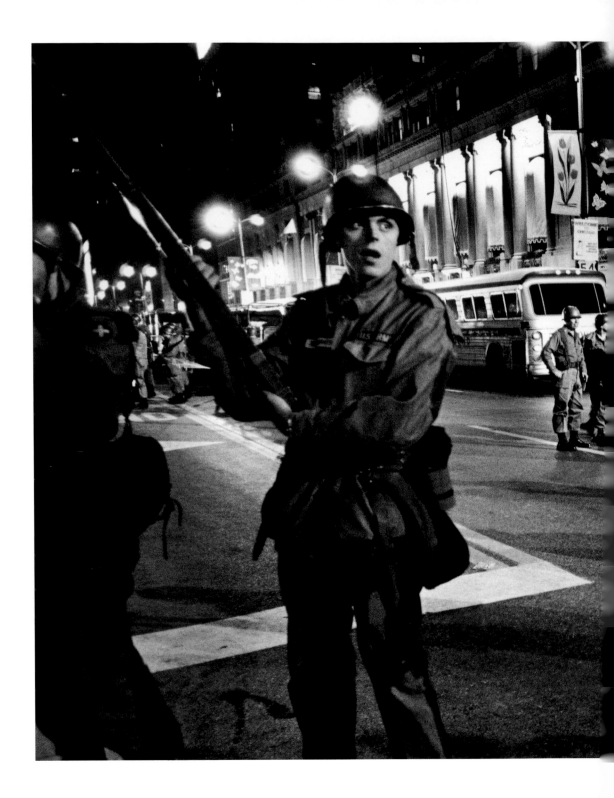

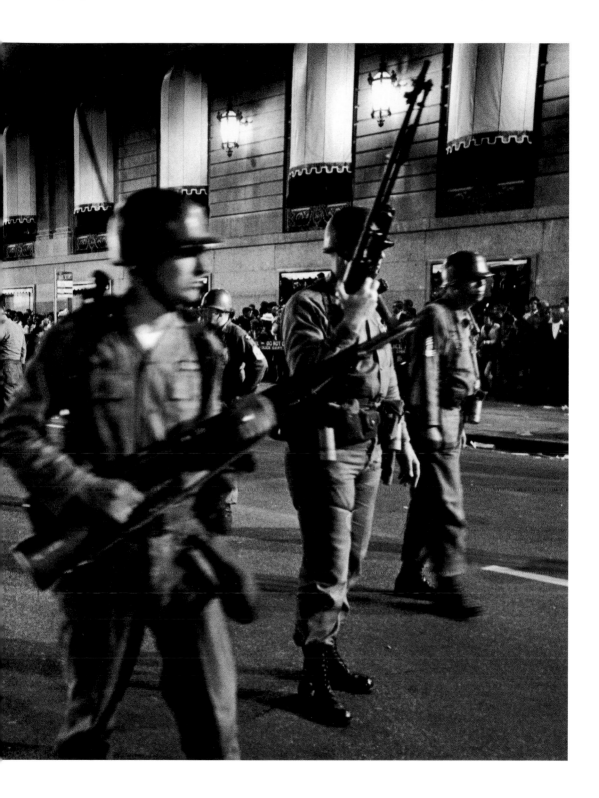

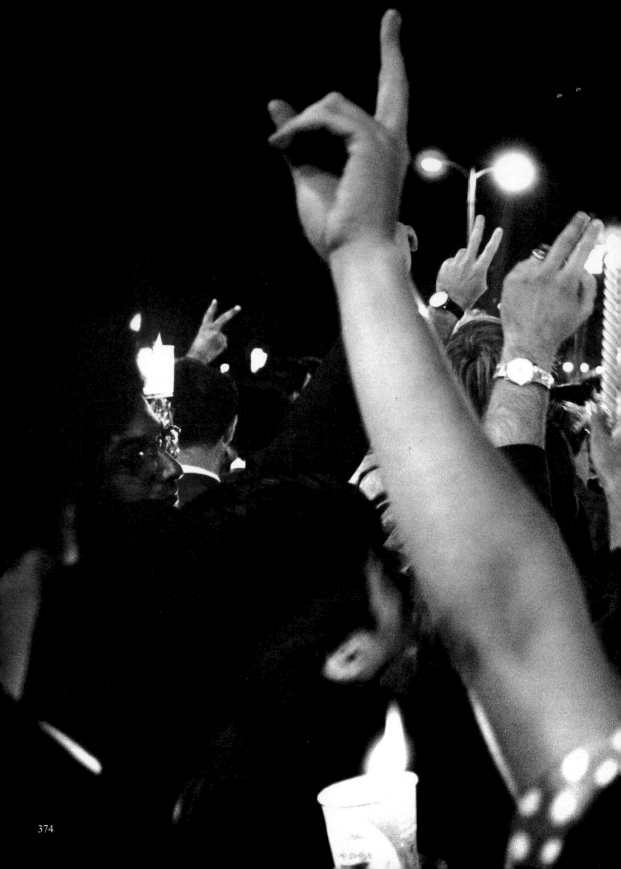

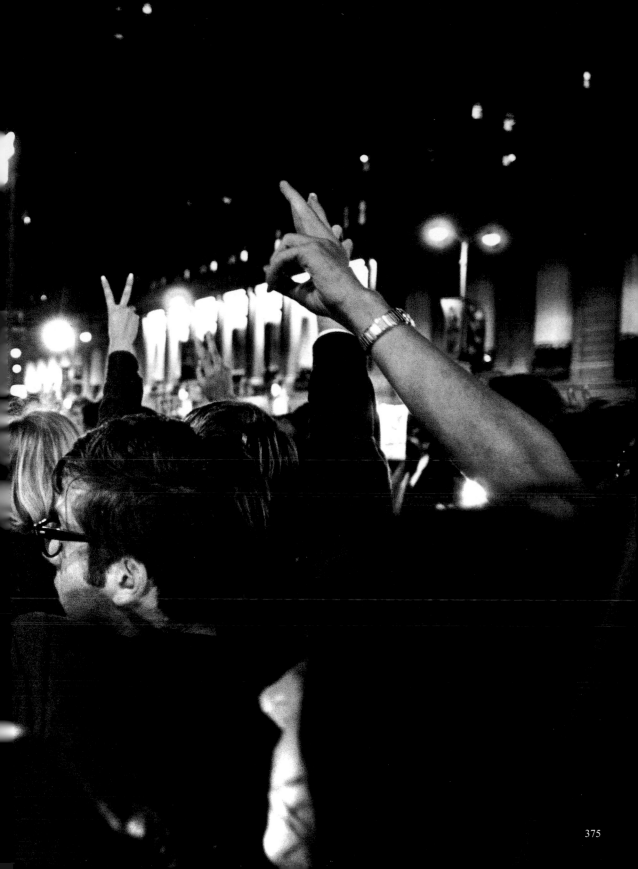

That
fabulous Leicaflex telephoto
reached everyplace
everyone

those troubled citizens
my show

faces
spoke for themselves

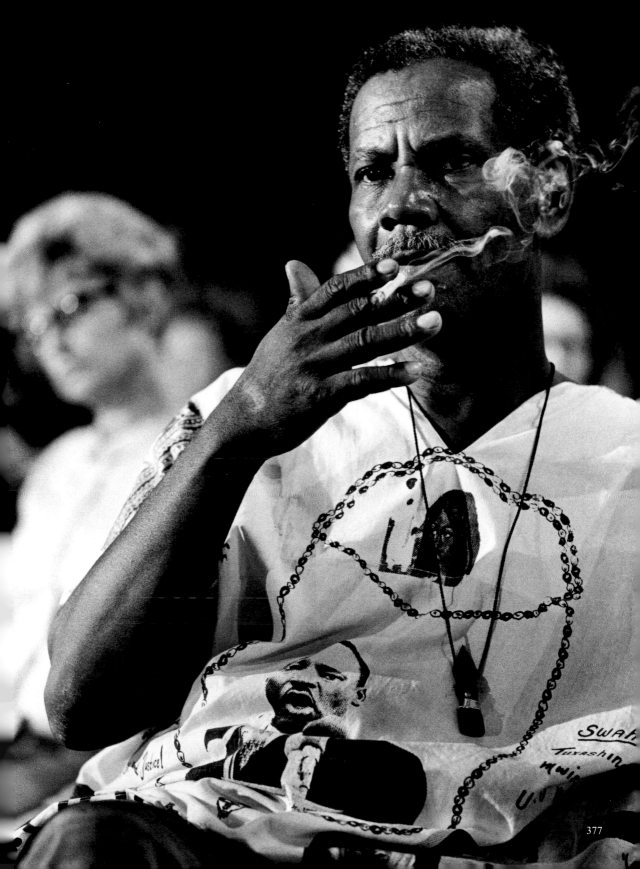

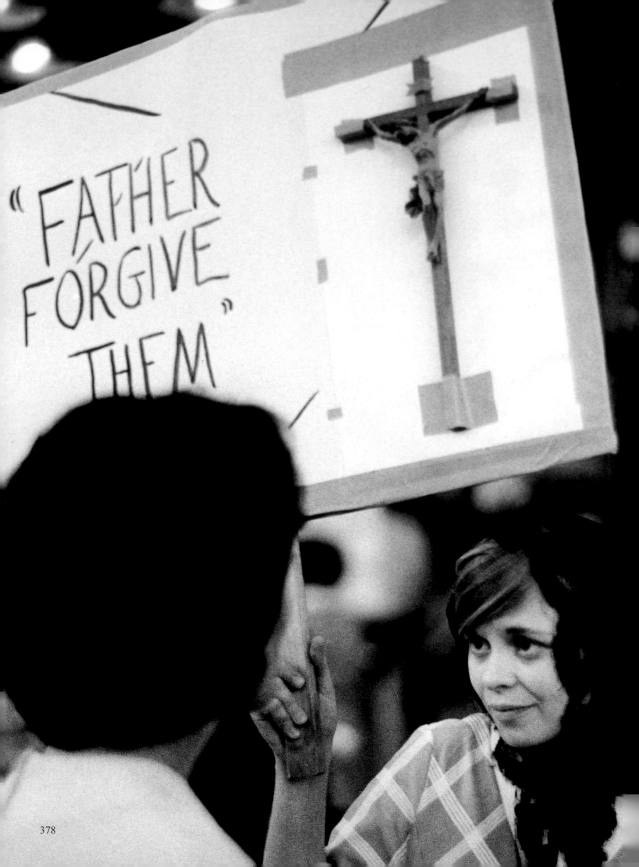

Jesus Christ Superstar

1971

Lee's Summit Missouri / Kaney Farm

"Sally … *What is that music?*"
— Sally, my pre-wars cover-girl neighbor —

"Russell Patterson's Civic Opera practising Andrew Lloyd Weber's *Jesus Christ Superstar* – first time in America – and it's sorta crazy because 14-year Pat Metheny, from Lee's Summit got okay from his Mom to work late during the KaySee show -- the kid's first gig but he really can strum a geetar and will someday go places *like bigtime!*"

LIFE's manager editor: heard it over the phone -- cover story!

Superstar was picketed by those believing the play sacrilegious, their convictions in their eyes confronted playgoers under the auditorium's marquee.

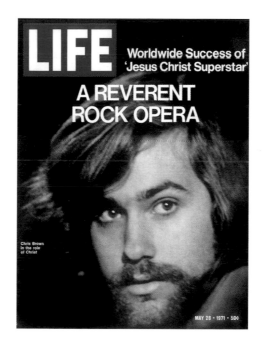

Chris Brown learned his role in three days -- already bearded.

Pat Metheny's first professional appearance, 15-years old. Today, recognized as one of the great guitarists, replaced Chris Brown, of a Michigan University band, who learned his new *Superstar* role in three days.

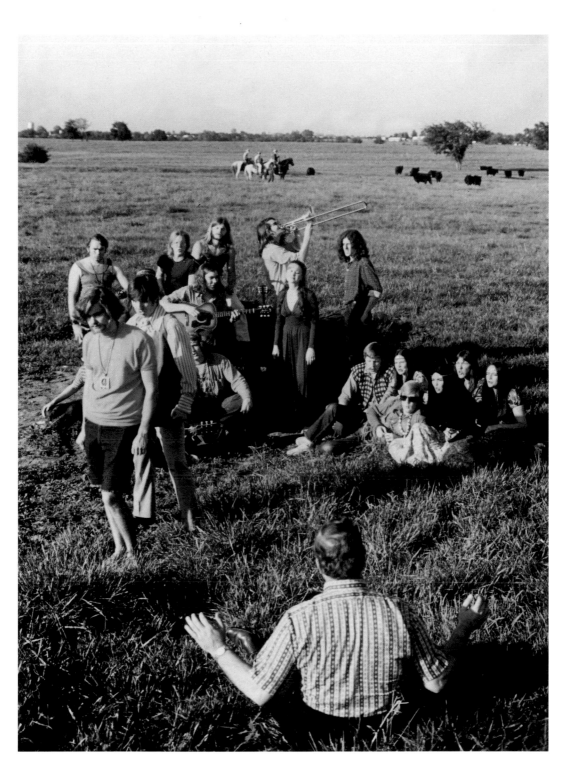

Director Russell Patterson of Kansas City Civic Opera
conducted chorus practise for *Jesus Christ Superstar* on a cattle farm.

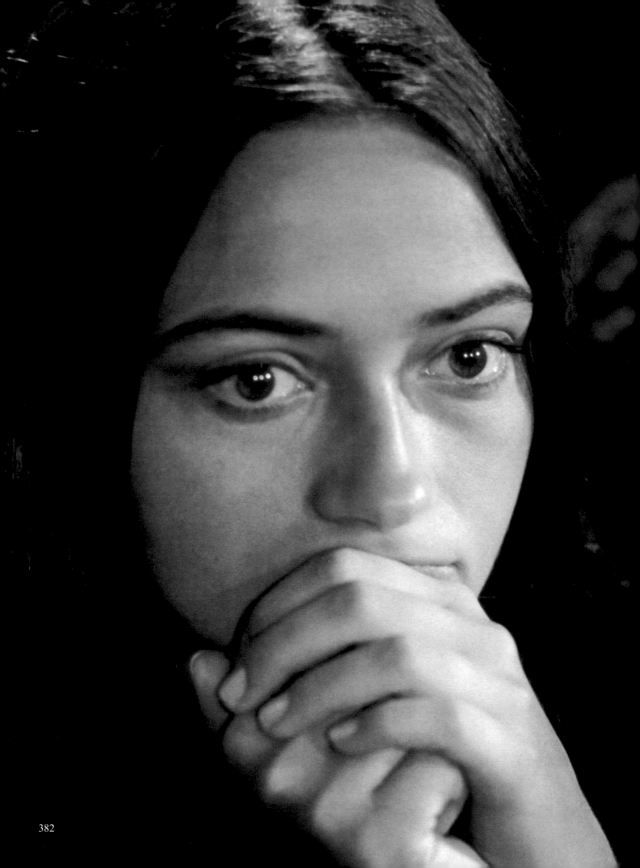

Three Crosses
changed history forever

Martin Gray

— Survivor —

Warsaw ghetto ... Treblinka ... forest fire
knows that word

"forever"

1970 — 1976

*"He was a man, take him for all in all,
I shall not look upon his like again."*

Hamlet

First family ghetto victims of Holocaust. New family: wife, four children, guard dog, just lost in local inferno.

A man must create the world
of which he is the center.

This can be a masterwork:
the painting of an artist,
the piece of a cabinetmaker,
the field of a peasant,
the symphony of a composer,
the page of a writer.

It can be a family.

And when tragedy comes,
as it will, we must take this
suffering into our hands
and, through willpower,
transform it into a fruit
that will nourish us
as we begin life again.

This is the fragile miracle
hidden within us all.

Martin Gray

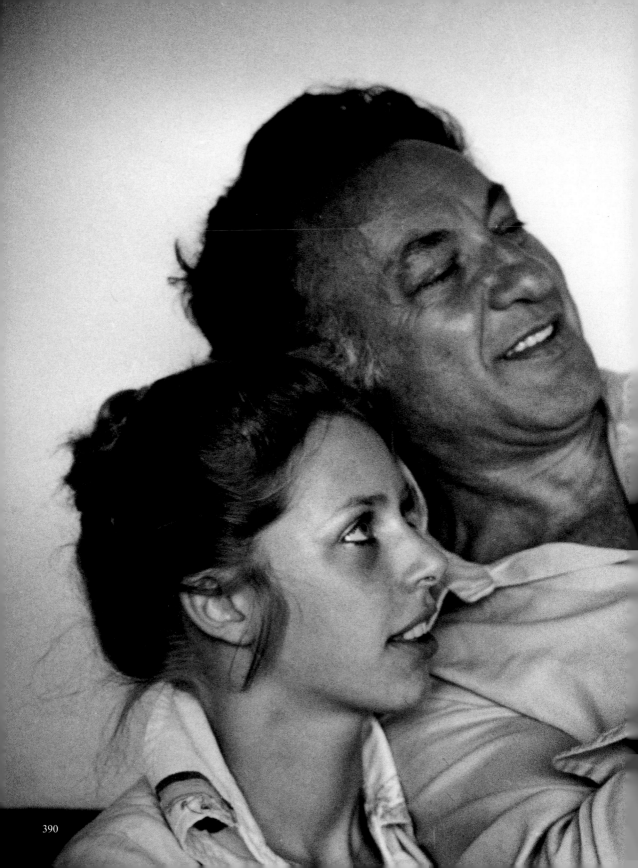

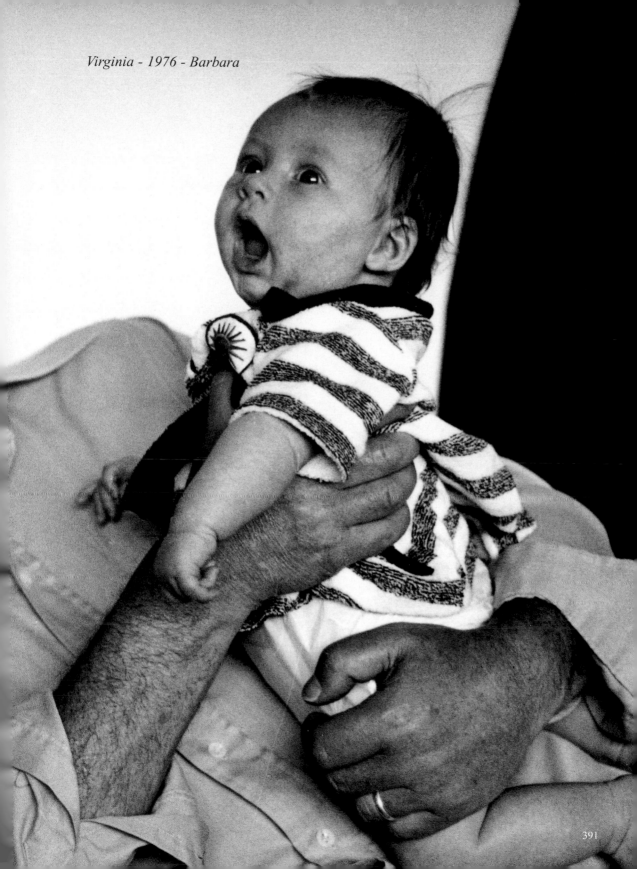

Virginia - 1976 - Barbara

The Birth of Thor

They were shining days, filled with mystery and excitement for Barbara; an idyllic world. Darling paraded her wobbly new family across the lawn, then returned to deadly Samson kept in nearby seclusion when visitors came in the daytime.

He silently stalked shadows by night, tensed, protecting them all, when only Martin and he were awake . . . both expecting the unknown.

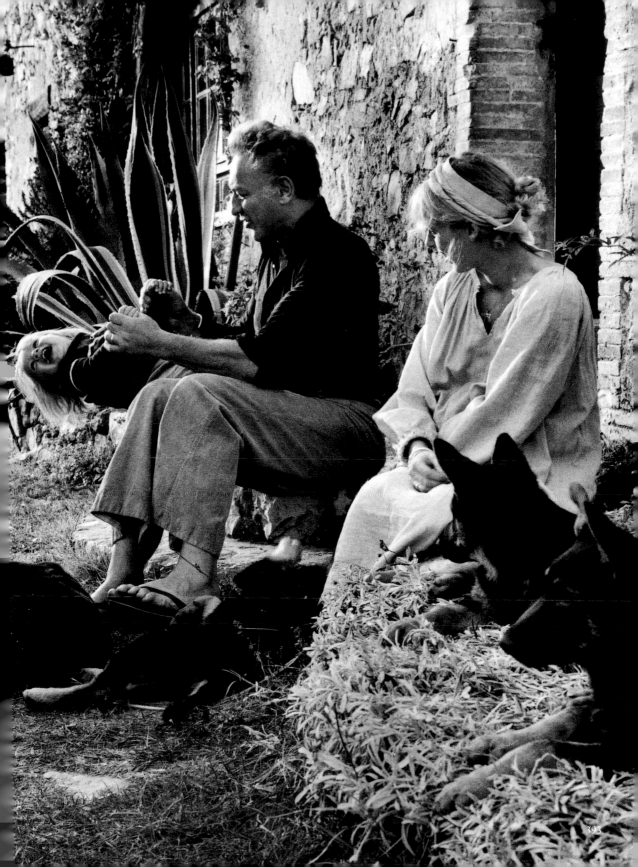

Thor

Childhood and Youth
an
Innocent World

He slowly circled the château atop our hill.

He seemed to know each oak . . . every stone.

He quietly stared across the olive-and-pine-horizon -- toward that sea
where Phoenician navigators once ventured -- Grecian traders once anchored --
Roman legions once sailed west to garrison an empire where
Christian visionaries had raised convents and cathedrals
which Saracen raiders then plundered.

Napoleon's returning army had once landed here, to march north
over the Alps fringing the world that now held Thor's gaze.

He then turned to her -- laughing.

He turned again and led her down the path . . . home.

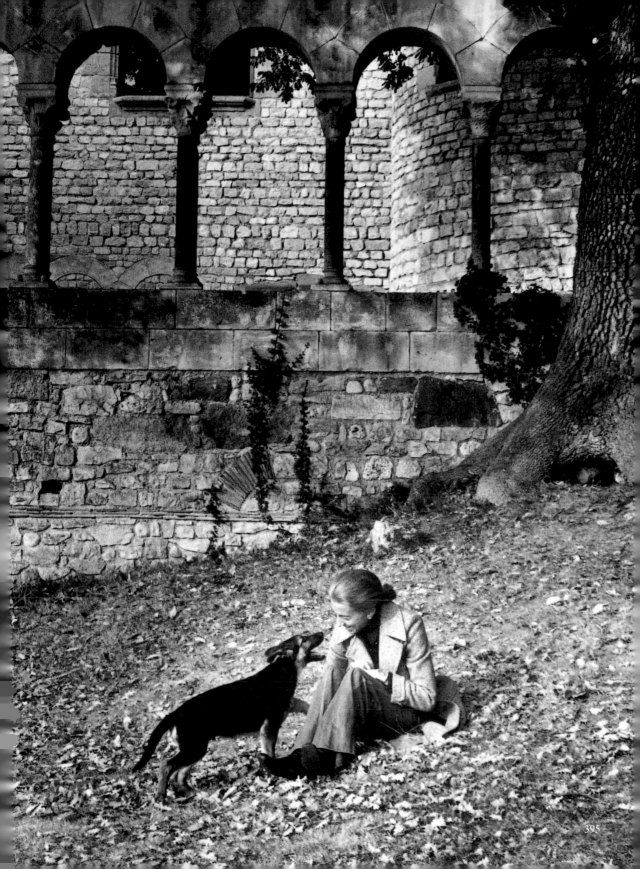

An unheard-of Riviera blizzard brought two discoveries, an all-white world that tickled his toes and tongue, and he could stand on only two feet — as she did. When down beside the olive tree — he danced alone.

Thor cherished solitude . . . never wandered.
His was a private world -- beyond the olive tree he had no friends.

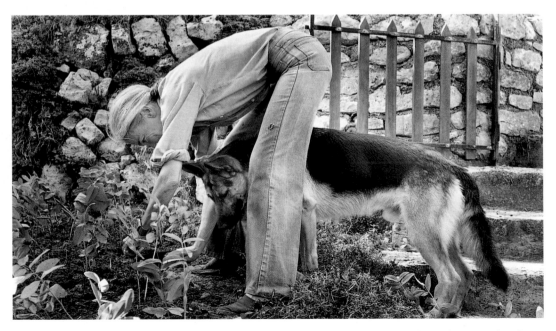

Growing rapidly toward manhood – in physical brute strength and size – he remained
an infant at heart. Later he had neither flirtation nor a fiancee . . . never hunted for a mate.

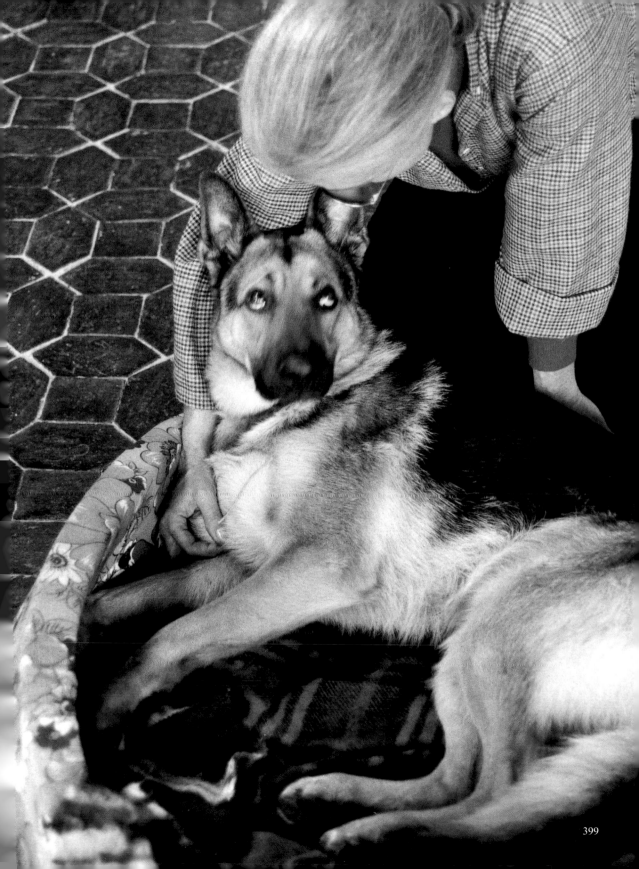

Spring . . . Summer . . . Autumn: Thor's village became an island of escape remote from most all reality -- the anguish and turbulence and destruction threatening so many values and traditions, ancient monuments, rain forest, those alpine glaciers, children's innocence, even the diminishing oxygen sustaining all life on Earth.

Then Winter arrived and sometimes the château atop his village was festooned with snow, creating a fairyland where any dream might come true.

Drifts half-buried his village, the same as the winter when he was born. He gazed out into the storm from behind the same stone wall, under the same olive boughs sagging to touch the same lawn, where once -- on two feet he had danced his snow ballet . . . alone.

His innocent life

filled nearly fourteen years
one dawn in Spring
she held him close

"He's leaving now"

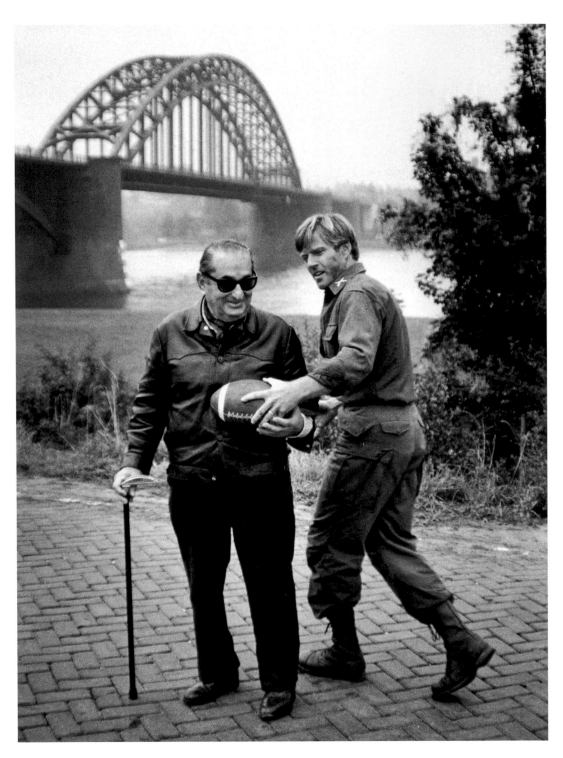

Robert Redford handed movie producer Joseph Levine his football after lunch-break game: back to work.

Mr Henry Anatole
Grunwald
Managing Editor
Time Magazine
Rockefeller Center
New York, New York

Paris
30 September, 1976

Dear Henry :

Here are the photographs taken on the set of "A Bridge Too Far" about which I phoned day before yesterday. Since both Newsweek and People are reported to be closing major stories on the film and on Joseph Levine this week, it seemed like a good time to move in fast and try to cover my old friends and to clobber the opposition. Granted; I had only one day in which to work, but it was a good day. Or so I feel.

Naturally, I based my shooting around Robert Redford – who is getting two million for his four weeks work on the film – in his role as the American Airborne major who leads the hot thrust to the bridge. Joe Levine, as producer, and Richard Attenborough, the director, gave me freedom of the set which meant I could work as close as I desired. And it was quite surprising…it was reality itself. The South Pacific and Korea and Vietnam and all of the others – everything grindingly, crushingly normal. Until the wounded and the dead got up and went home to their hotels to shower off the crud and have dinner. The kind of war Capa would have accepted, maybe even enjoyed. I did. Because of the nature of the men putting it together. Naturally I was touched when Conie Ryan's son Jeff (who is working on the film as an assistant to the production unit) told me what it meant to him for me to appear at Nijmegen, Holland, where the action revolves around five bridges. Conie and I had worked together 20 years ago in Ireland (during my first assignment for Colliers after leaving LIFE) and I'd promised Cathy, his widow, I would try to shoot something on this last book-film of Connie's which might be useful. I feel that the shot of Levine, alone and still lane from a leg operation, walking slowly toward the Nijmegen bridge, and the shots of Redford attacking across a knocked out German bunker which is necklace with American dead, would be acceptable to Connie Ryan – and to the men, American and German, who fell there. And, as in real warfare, identities are almost lost in the action and filth and tragedy. Thus Redford is just another armed man finding that bit of extra strength and gutful of final optimism needed to sustain him during the attack, this time the end of the bridge he'd never heard of a month before.

Joseph Levine is the last of the great independent movie moguls – this is his 492nd motion picture…."among them, some – many – were terrible. But mine is wonderful business: people only seem to remember your good films. And I've made a couple." He has just returned from a session in the hospital in the States, still walks with a cane and with great difficulty. He is living near the set, at Deventer, Holland, and appears almost daily where the cameras are rolling. But he never tells his director (in this case the British actor-turned-movie director, Richard Attenborough) what to do: "Never! Otherwise, why hire a director? Of course, we have consultations regarding the nature of a story – but he's the director."

He feels that the operation upon which Ryan's book is based was "an Allied, British-American, Montgomery-Eisenhower, catastrophe. Montgomery because he conceived it almost overnight; Eisenhower because he approved it. When asked how he hoped to making a winning film of the story (and he feels "it is my best – I've seen every foot of film thus far: It will be great . . . and important, because it tells of a defeat honestly) Joe Levine looked me across a picnic on the table, and said: "That's why I hired fourteen stars – and am spending $ 25,000,000."

Identification is on the back of each shot. I'll be at home in Castellaras tomorrow if you should need me. I hope you lock up four pages. Opening on Joe Levine and the bridge.

P.S. Excuse typos/haste -- I just ransomed my black Mercedes 300 SL
 from Dutch gangsters/aiming that torpedo south across France tonight --

Saludos!

DDD

Reality . . . Fiction

US Marine North Korea
December
Yalu River Campaign
- 40 F

Pure Talent
Seeking Conviction

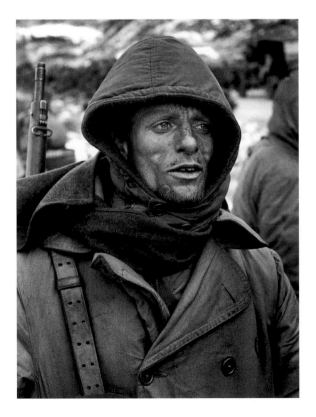

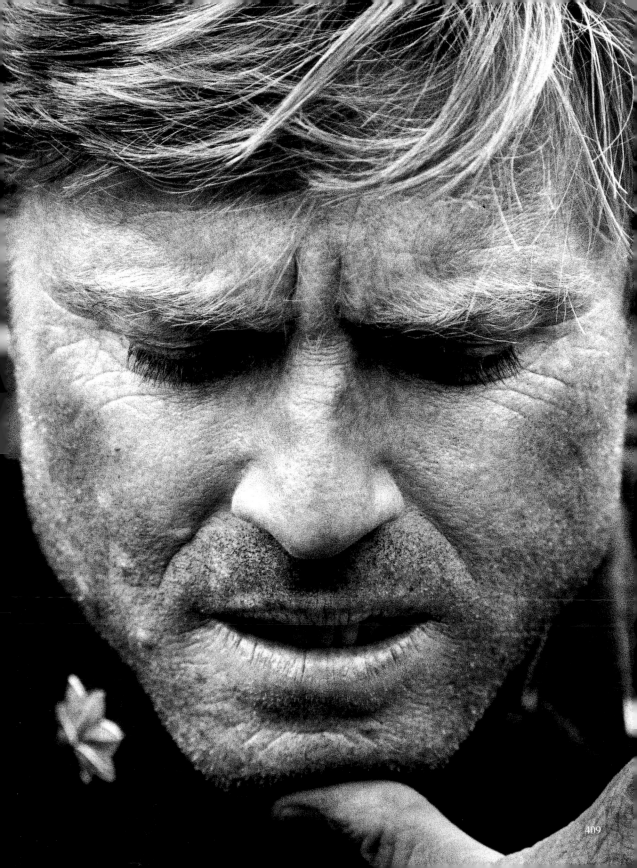

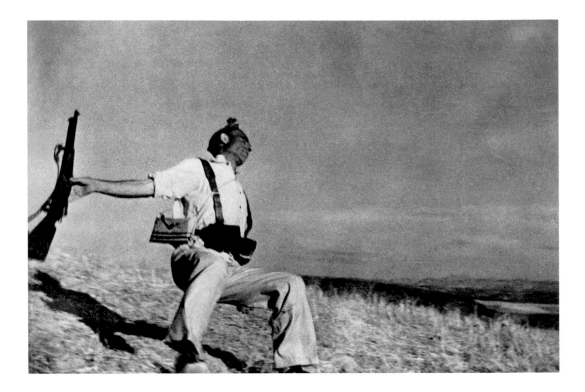

Robert Capa
1936
Spanish Civil War

Robert Redford
1976
Joe Levine's War

choose your war

may I speak for Capa
vote
Redford

*then
Champagne
before
your dinner*

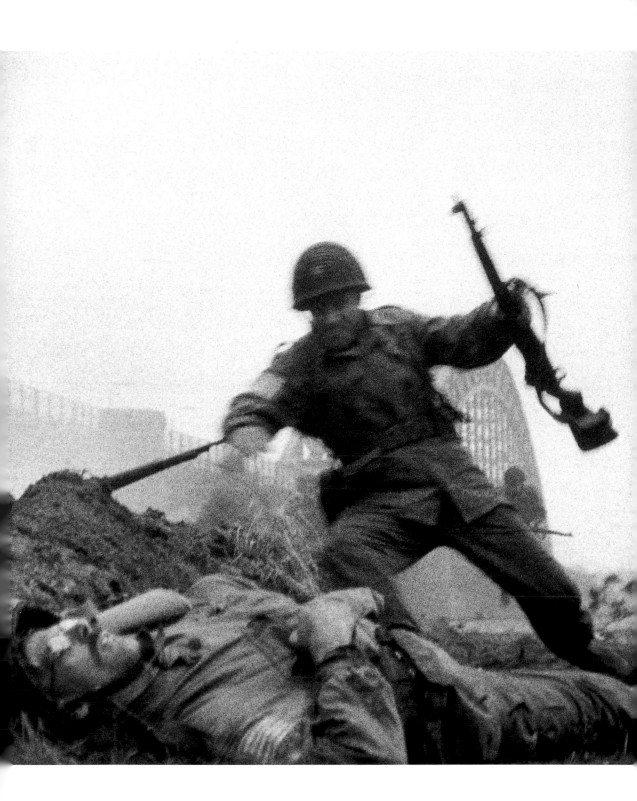

Mougins / France

1990s

Master Photographer

André Villers's
Magic Garden

*Snapshot fun -- cut-cardboard painted with a droll touch
by a neighbor who never laughed.*

Adam as war photographer might have lost more than fig leaf camouflage if in-coming got hot!

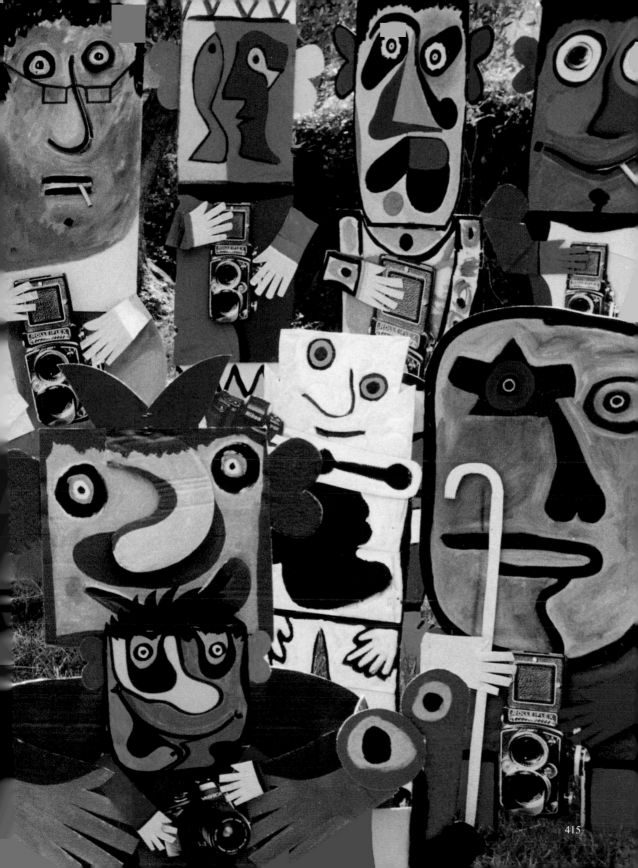

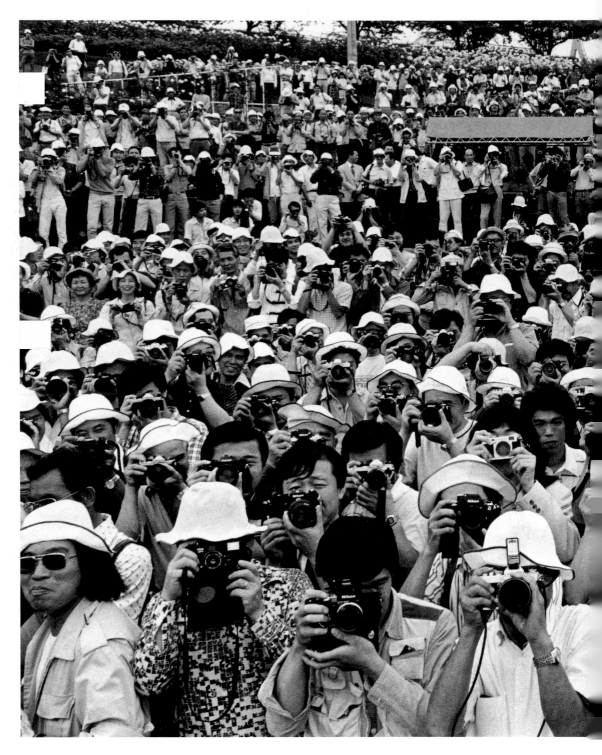

Banzai! . . . Nikon 1980 Picnic "Thank you for introducing our Nikons to the world" . . . *Baanzzzaaaaiii!*

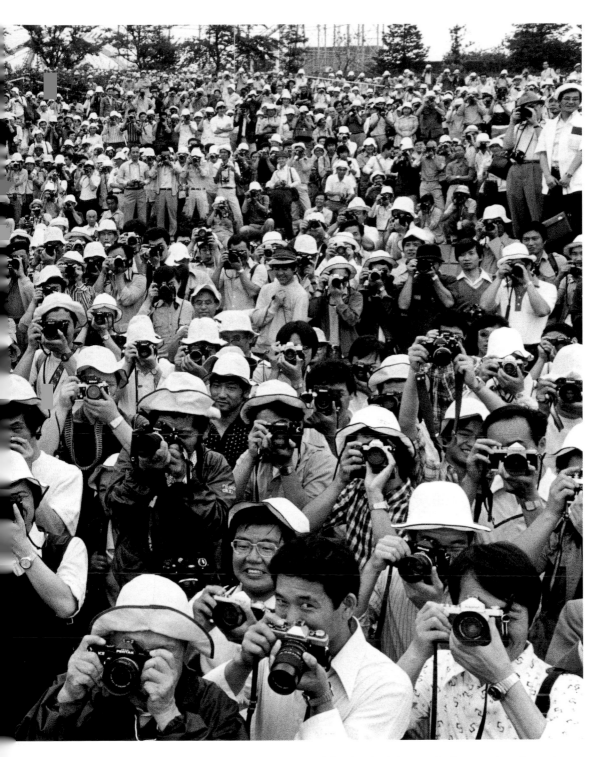

Baaannnnnzzzaaaaaai! . . . Then three thousand five hundred shutters fired a portrait and went home.

Japan

1950 . . . 1980 . . . 1995

Jun Miki — LIFE's Tokyo-based photographer – banged off a new-lens test shot while I sat in the office's evening post-war gloom awaiting prints thinking, Jun-san you're wasting film in this half-light. Really! That negative bombed the foundation from beneath the pre-war miniature 35mm-camera world. Miki showed me the print next morning. I asked him to phone Nikon's president Dr. Masao Nagaoka (never heard of him or his camera before) for an invitation to his nearby miraculously unbombed factory at his convenience, which became — *now!* I postponed my Japanese arts story at the Ueno National Museum, spent two weeks at Nikon's optical bench testing Leitz/Zeiss/Nikkor lens soon adapted to my Leicas. I was ready for culture again but interrupted for the next six months by the Korean War: a sidebar *New York Times* feature about "Made in Japan Nikon cameras."

Years passed, Nikons swept the camera world (Canon had also been phoned but too busy to reply or show me their lenses). Tokyo had become home, always that wild wonderful place where a stranger could pretend shooting my style-on-verticals then ask "What is bird in French?" of a guy still tone-deaf to French after forty-three years there -- home.

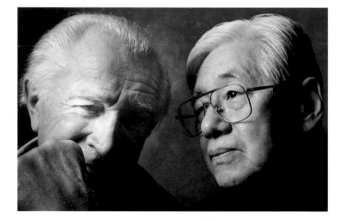

two friends who changed the camera world

Photojournalist?

nomadic
life

cameras faithful friends
remember everything years later

missing
closest friends

Dmitri Kessel Gjon Mili
Russian-American Albanian-American

LIFE

never again like these

on
whom
tested every new lens

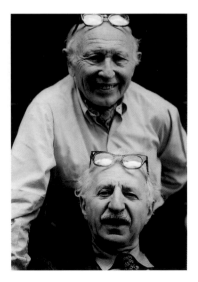

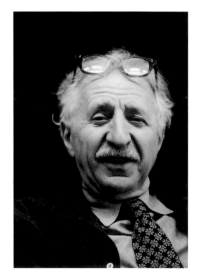

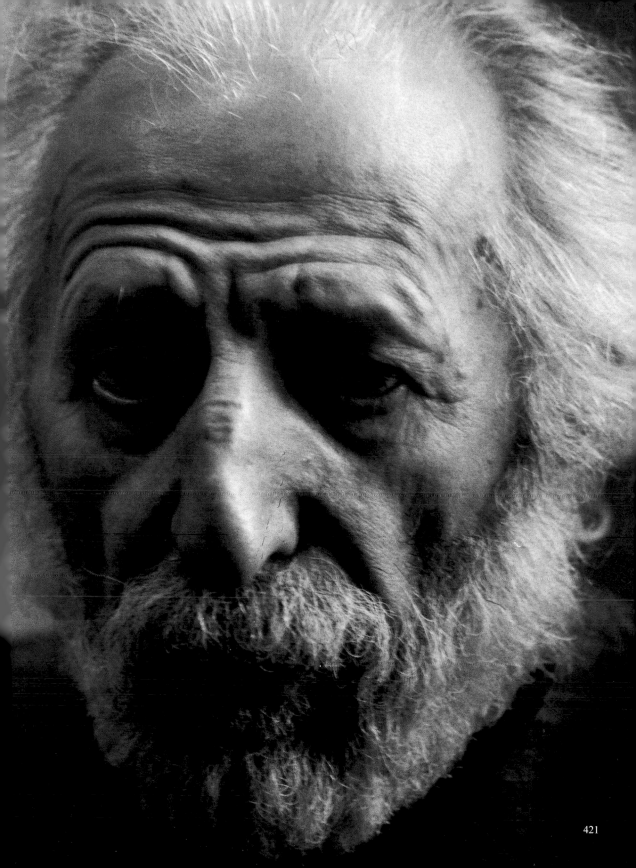

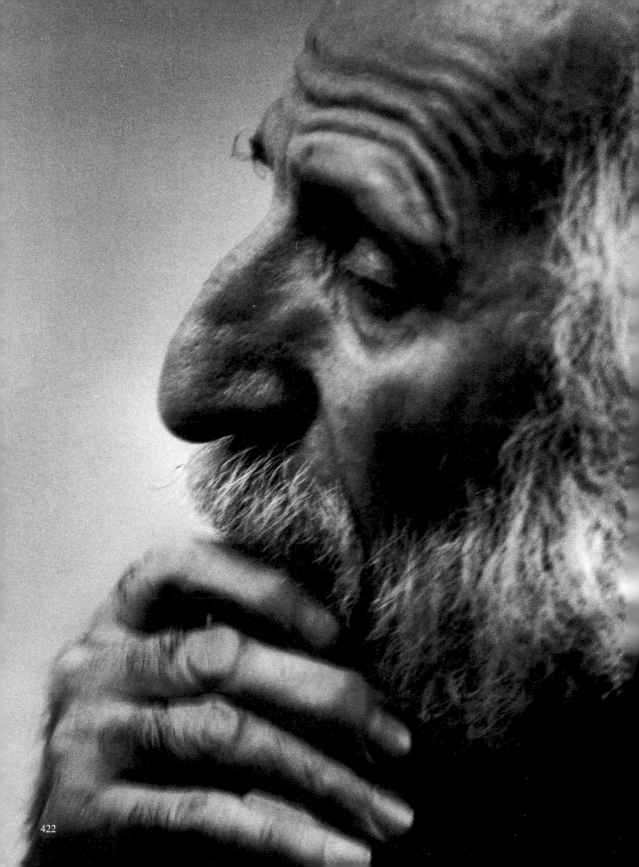

Reality

testing on Mili — struck by taxi
never again Mili

Eisie
German-American

Alfred Eisenstaedt
The Great

Himalayan peaks/valleys
eyes closed

hands at home without cameras

photonomading is better

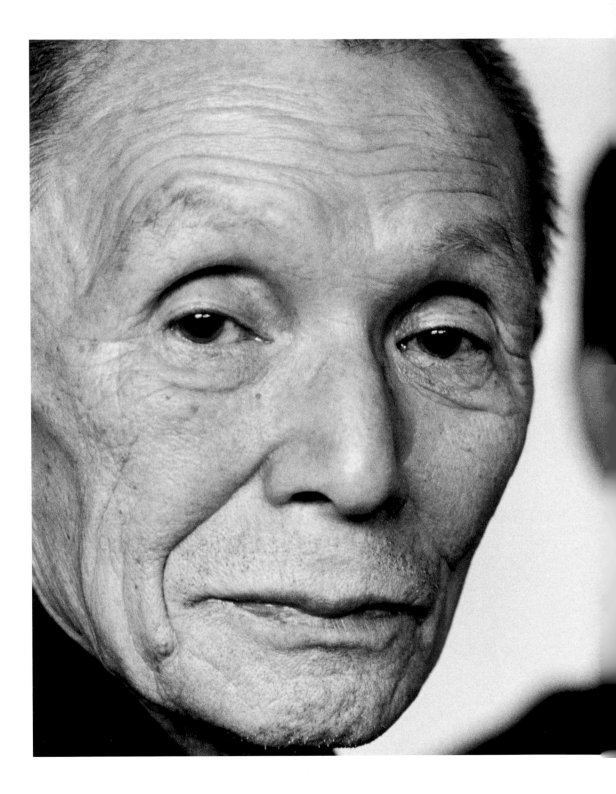

High priest Gyokai Sahoyama of the great Buddhist Todaiji Temple of Nara valued as a treasure of the nation's memories . . . now lost.

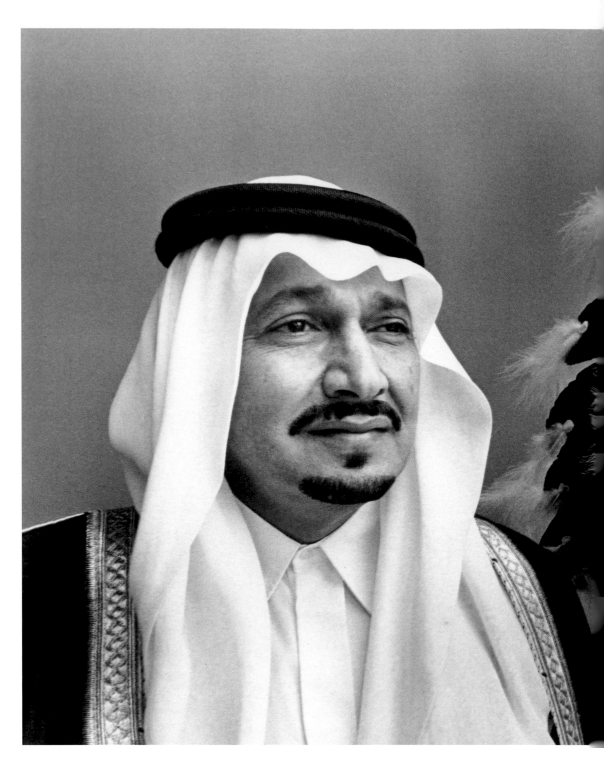

Perhaps only concern for children and their fates could bring such men together.
Seattle / UNICEF / one summer afternoon: Prince Talal ibn Abdl Aziz ibn Saud -- obviously Royal Family

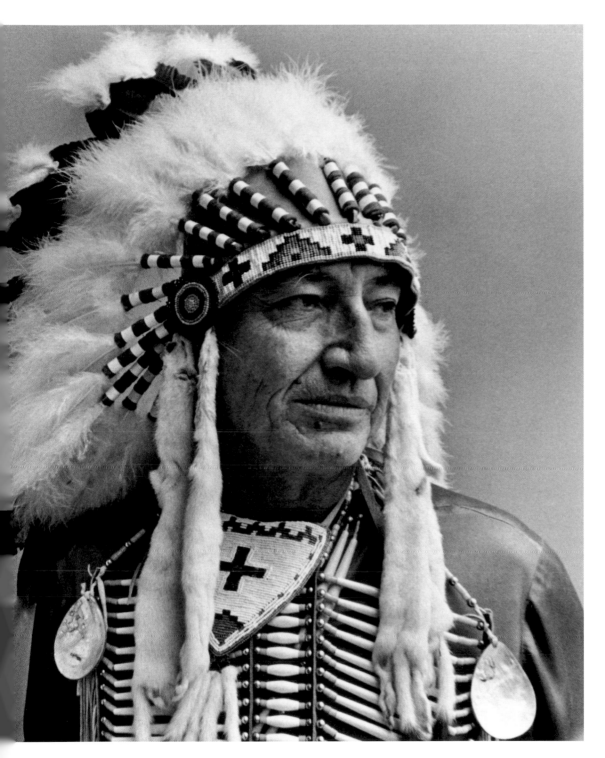

Chief Ben Stiff-Arm flew from his tribal Montana donated his dignity and eagle feathers to a wothy cause.
Their eyes reflected ways of life fast disappearing -- forever-and-forever ... *forevermore!*

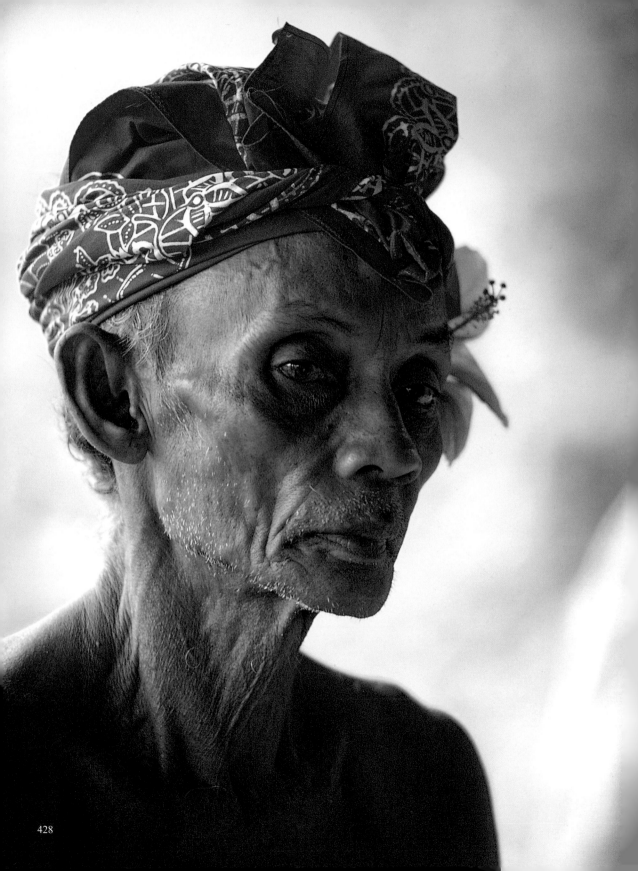

Bali

his name
I've never known
nor his village
which matters not at all
it was in his eyes
where much of his life
was being narrated
and it was only with
my camera that I listened
while awaiting answers
to my challenged curiosity
which I had no desire
to know

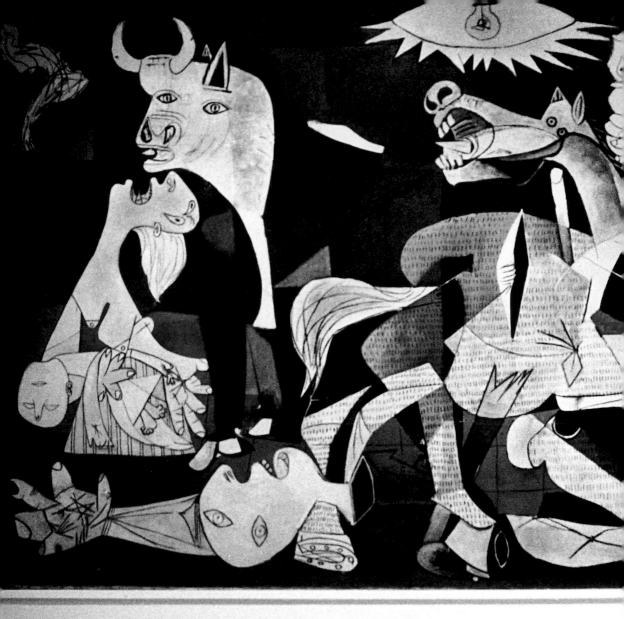

Jacqueline had never before seen *Guernica* … stood for minutes …
looking up across a battlefield she already knew so well – then down –
then straight at me with that broken sword framing her eyes and broken heart.

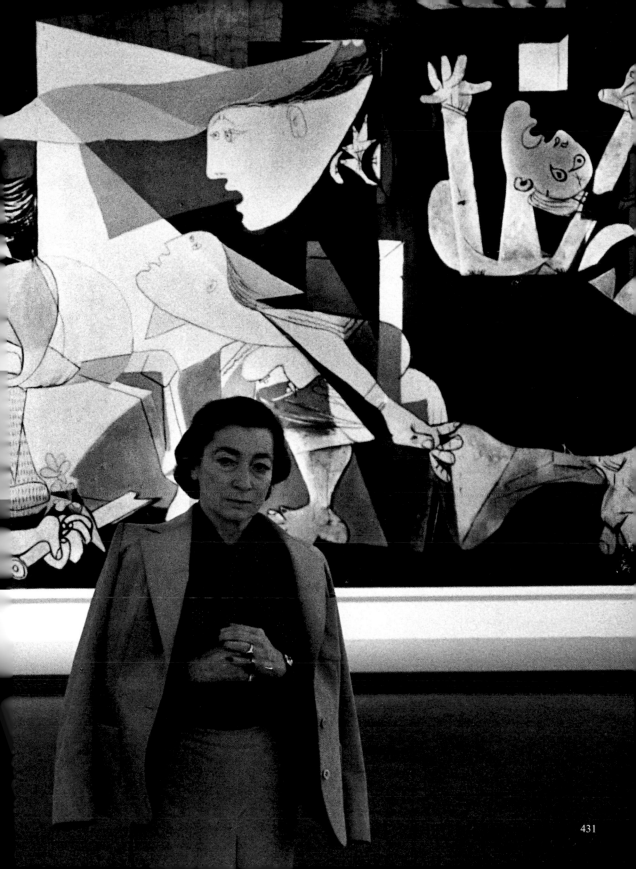

Five Decisive Minutes With Henri Cartier-Bresson

My first photo-story of the new millenium and the strangest of my entire career with cameras was shot with a borrowed zoom-lens Pentax with a half-broken viewfinder (my wife's), a borrowed roll of film (from my subject), in five minutes while seated at a table enjoying an ice cream cone (myself) and a Perrier (my subject) and was so elated I decided to publish the closeups of my by-then infuriated subject, who threatened me with court action to protect his self-proclaimed shooting anonymity, almost his trademark, because he was Henri Cartier-Bresson . . . in the opinion of myself and most vintage professionals, the greatest candid photographer who ever fired a camera, and in his own words . . . "Without anyone's permission -- just shoot and scram."

An American magazine had assigned Henri (friends for half a century since meeting in Cairo, after he ground-looped a car driving his new bride from Indonesia toward France) to photograph a couple of lens-slingers who had hit eighty and were still clicking away and vertical. He chose the Picasso Museum in Paris as a background because of my friendship with the artist. I had no camera, no assignment, and no objections, of course. We really had fun. Then went into the garden for refreshments. Sheila had taken a roll of color shots as souvenirs. I heard the camera rewind. Looked at Henri in his English driving cap and trench coat, with his Leica on the table while he leaned on a walking-stick umbrella thinking his own thoughts. I asked for a roll of film, figured out how to compensate for the broken viewfinder, zoomed in and fired away without a word spoken between us, not even when he picked up his Leica and nailed me. We were five feet apart. Georges Fèvre, who later made these prints -- Henri's master printer for forty years -- looked up across the set of portraits in his Paris darkroom, and said: "Dave -- I have never seen this man before." Nor had I . . . and that is why they are in this book.

Fifty years ago, he published *The Decisive Moment*. It became *the* sacred book for generations of candid photographers who accepted his theory that all subjects, at some fleeting instant, arrive at a point in time-expression-movement-geometrical composition which is *it*. Fire! Then search for your next subject.

Except . . . for myself -- life is a constantly flowing river of time-expression-passion-promise-tragedy . . . and a vast array of elements beyond any human anticipation or sense of timing or design, no matter how deft the shutter finger or sensitive the eye. Life remains static for no one.

This is why I shoot as I do -- waiting, always waiting. For that fleeting touch of magic on the face of life itself . . . and it will always elude me.

Paris

Picasso Museum

25 May 2000

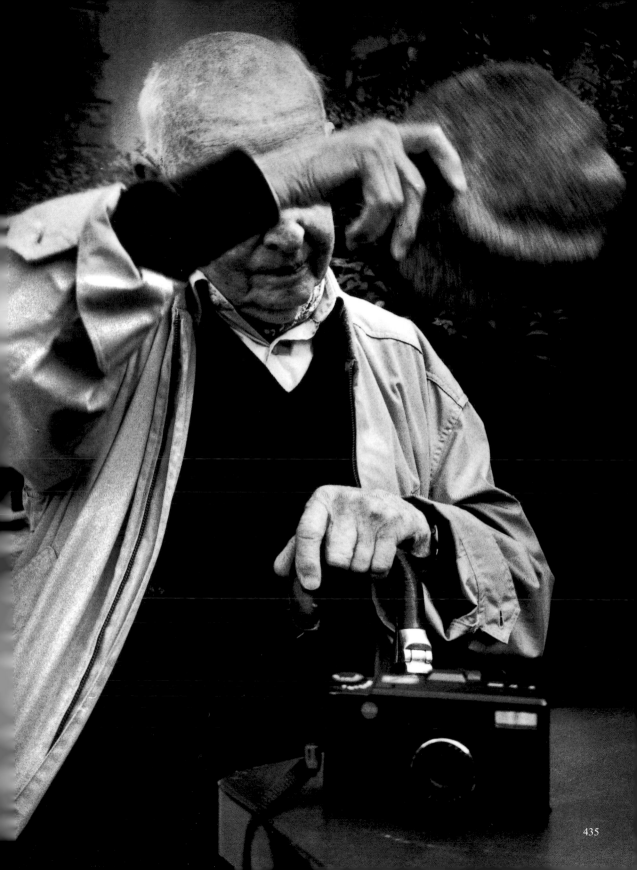

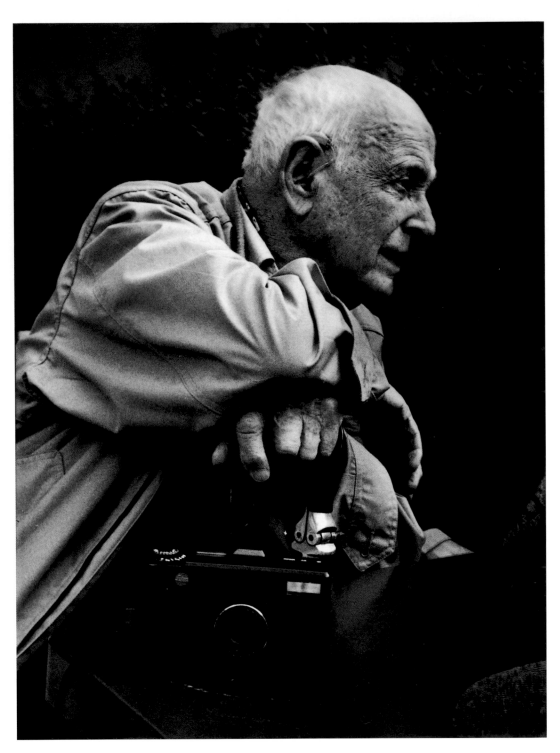

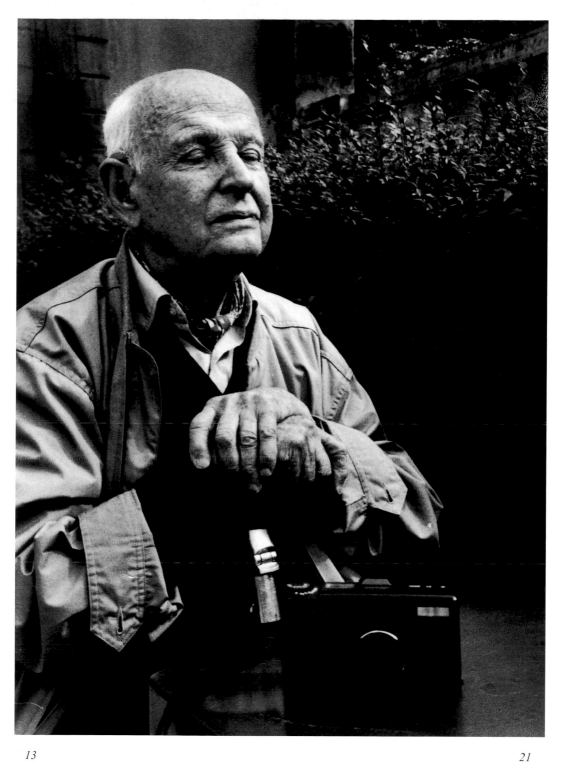

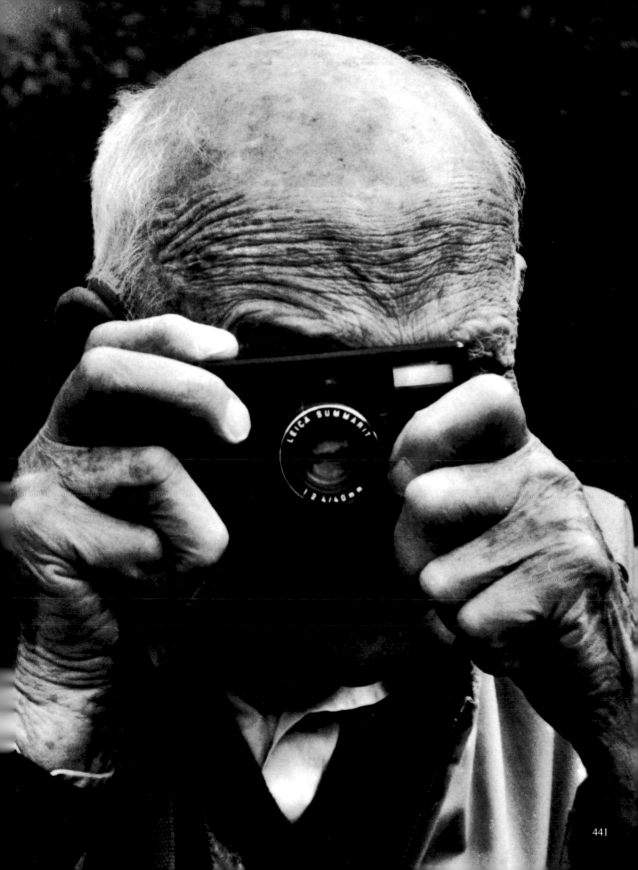

Life
Remains Static
for
No One

five minutes
on
his own watch

35

Sunflowers
of
Van Gogh

Mortality and Immortality

One hundred years after a tormented Dutch painter in Provence ignored Impressionism —
slashing firestorms of tube-pure colors across his canvases, creating bouquets of sunflowers
as never had been seen before -- I dedicated a blast-furnace summer and all of my curiosity to
his radiant subjects.

I fell in love . . . I believe Vincent loved them, too. Sunflowers in full bloom lived about
twenty-seven days; in *his* bouquets, forever.

Vincent?

Yes -- Vincent . . . and his tumultuous fields of flowers, as I worked in the same suffocating
120-F heat bent nearly double by eighty-mile-an-hour *mistral* winds lasting three-six-nine
days (dawn to dark) often lunchless, dinnerless, too, he painting, I photographing, side-by-side
without speaking: foxhole, wartime, shared-suffering comradeship, but this time shoulder-
deep in molten gentle blossoms, not that agony of too many stricken friends and also
perhaps more than a trifle mad -- Vincent, my tireless never satisfied new friend.

I wished he might have turned and called me David.

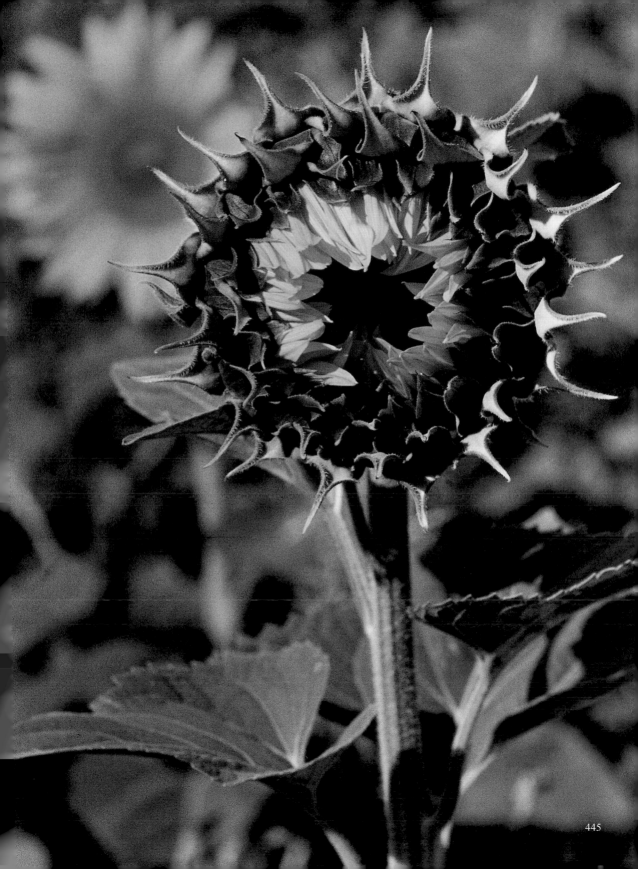

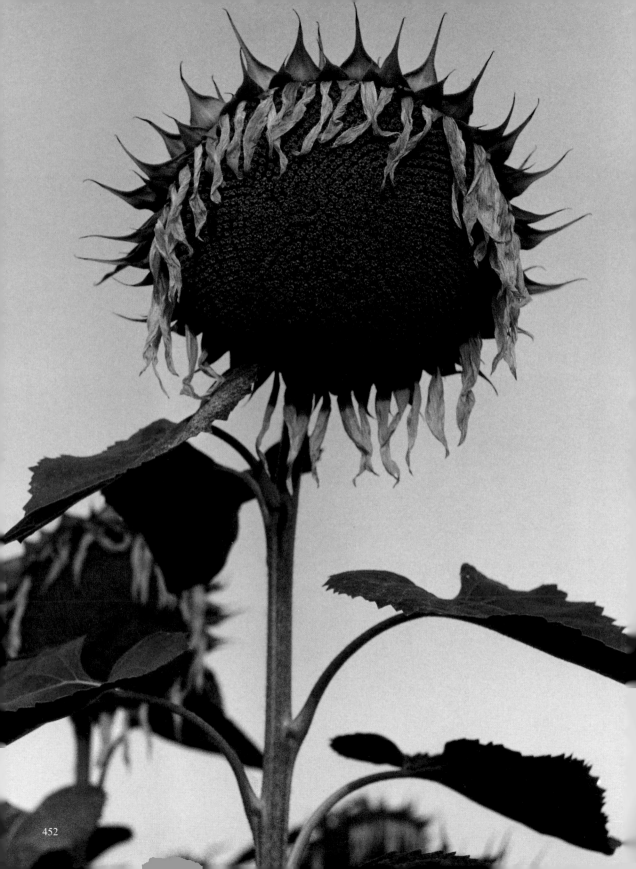

a
Crown
of
Thorns

a Storm of all Storms

Then it was Night

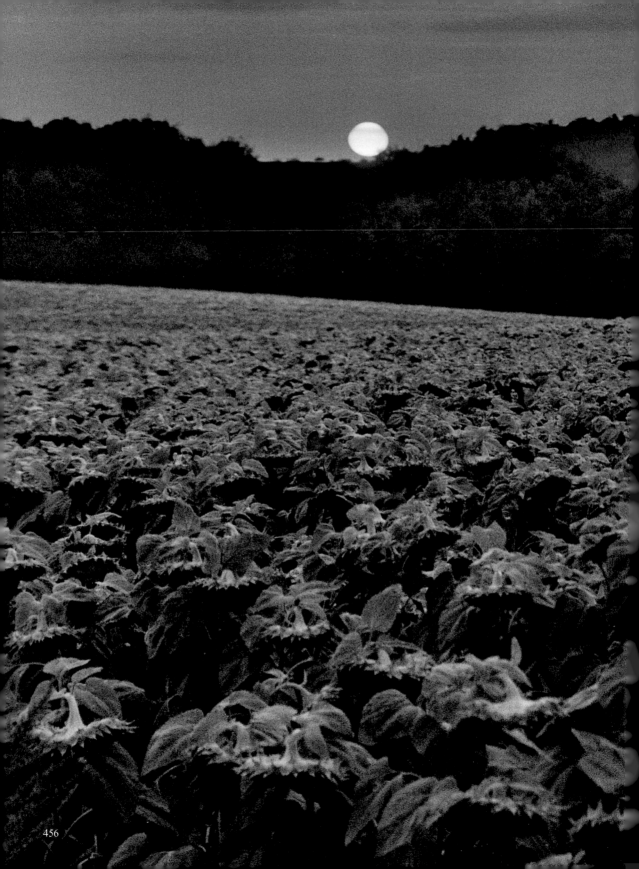

1958 1960 1961 1966 1968

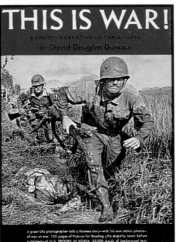

1951

One Life

1969 1971 1972 1974 1976

1978 *1979* *1981* *1982* *1984*

1999 *2000*

1986 *1988* *1992* *1993* *1996*

my
birthday gift
to
myself

23 January 1916
Kansas City, Missouri

23 January 2003
Castellaras, France

In Memory
of
Fallen Friends
and
My Family

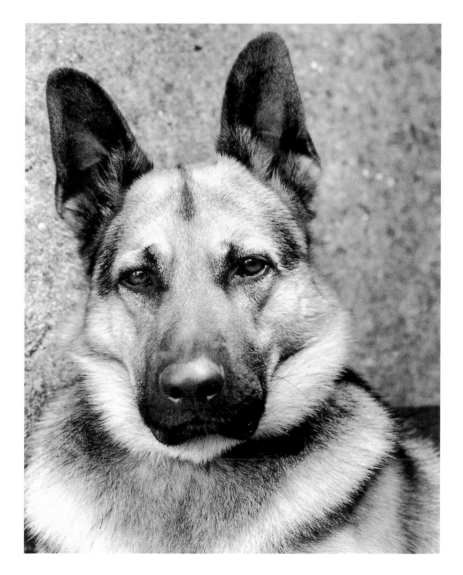

Goodbye Once Again
Thor
Your Portrait Is Still My Favorite

Photo Nomad

book composition: Times New Roman
photographs: duotone & 4-color offset
paper: Deluxe 150 gsm Gardamatt
by
Mondadori Printing
Verona

A Postscript Note of Explanation

I dreamed of the editorial concept for this book twenty years ago, made my
first coffee-table format dummy fifteen years ago, went through years of on-
and-off publishers' contracts until this spring, reduced the format, decided
to publish this autumn against almost impossible production deadlines.
Sold rights for American, Japanese, German editions, with fixed schedules,
all copies to be delivered no later than 1 October. *For a 464-page book - -*
written in twenty-six, eighteen-hour days on a venerable portable typewriter.

Photo Nomad is off press in Verona, at the bindery. Every deadline met.
Thanks to quality controller Enrico Battei at Mondadori Printing and those
teams of experts on their giant offset machines. The results are the most
technically complex, dramatic, reproductions of my work ever published.

And now, after all of these victories . . .

Page - -3/ That is a 50 mm lens; (I was thinking of 35 mm cameras).
Page -27/ thousands // sundown // Pearl Harbor (the cost of deadlines).
Page -33/ When switching pages in the Preface, 1993 was lost.
Page -72/ Just one more Humboldt legend?
Page 106/ (Incredible! -- blinded by familiarity): Pearl Harbor.
Page 360/ Nixon controlled a few Piper Cubs: " The Piper Club."
Page 380/ Pat Metheny was still 14 years old.
Page 427/ Chief Ben Stiff- Arm was indeed worthy of all respect.

I shot these photographs, wrote every word, made the typos.

Welcome to photo-memories of my century - -

DDD

12 August 2003
Castellaras, France